D0121738

The Fine Artist's Guide to Marketing and Self-Promotion

The Fine Artist's Guide to Marketing and Self-Promotion

Revised Edition

Julius Vitali

ALLWORTH PRESS
NEW YORK

07 06 05 04 03 5 4 3 2 1

Published by Allworth Press
An imprint of Allworth Communications, Inc.
10 East 23rd Street, New York, NY 10010

Cover/interior design by Milan Bozic
Page composition/typography by Sharp Des!gns, Inc., Lansing, MI

ISBN: 1-58115-281-7

Library of Congress Cataloging-in-Publication Data
Vitali, Julius.
The fine artist's guide to marketing and self-promotion / Julius Vitali.—Rev. ed.
p. cm.
Includes bibliographical references and index.
ISBN 1-58115-281-7 (pbk.)
1. Art—United States—Marketing. 2. Art—Vocational guidance—United States. I. Title.
N8600.V57 2003
706'.8'8–dc21
2003010095

Printed in Canada

Table of Contents

Acknowledgments

This book would not have been written without the invaluable assistance and creative direction of the following people:

Frank Shifreen: He is the creative link to most of the artists profiled in this book. Because of his creative insight and indefatigable networking abilities, he has curated numerous seminal art shows during more than a twenty-year period, written essays and catalogs, and has given subsequent artists a forum (sometimes their first) where they can be professionally exhibited.

Beth Ann Diamond: I extend my inspired appreciation for her tireless support in looking over the manuscript, and for her encouragement as an artistic partner.

Matthew Blanshei, Ph.D.: I am indebted for his excellent feedback and guidance in the countless hours he spent shaping the manuscript.

I am also grateful to all the artists who spent countless hours generously sharing their professional experiences with me.

I extend my appreciation to the staff at Allworth Press for their support of this project.

Introduction

The Benefits of Marketing and Self-Promotion

Since the publication of the 1996 edition of this book, the Internet, new digital technologies (especially databases and print-on-demand publishing), the stock market's severe decline, and the aftermath of September 11, 2001, have created new arenas and creative challenges for the fine artist. Many of the promotional and marketing strategies remain intact while other refinements are now needed to adapt to a changing world. What appeared creatively meaningful and important in 1996 takes on a fundamentally different significance in 2003. The destructive events of 9/11 altered how we view our art and the way we imagine a viewer might respond to it. As I write this, the U.S. government is creating the Homeland Security cabinet post and incorporating numerous other similar cabinet departments, resulting in the arts receiving less federal, state, and local funding. These cutbacks pose a chilling effect on nonprofit organizations and individual artists.

However, newspapers and magazines are continuingly writing about 9/11 and its aftermath since the consciousness of the country awakened to continual concerns over security, terrorism, and war debate. If artists create artwork based on the events of 9/11, then this trauma is likely to change the whole temperament of an artist's work. In the near future, there will be an art museum devoted to 9/11, and I predict that it will be the most popular museum in the United States.

Getting Your Name Out

How do fine artists create a reputation and a career that will ultimately allow commercial galleries to sell their work? Persistence is certainly one of the keys

to success; but many other factors contribute, such as publicity, marketing, a clear and articulated aesthetic vision, networking, timeliness, and luck. In analyzing famous artists' careers, one sees a pattern emerge. The artists share an ability to find their way into the public eye through exhibitions, performances, commissions, publications, and other means. Appearing in a public forum allows newspapers, magazines, radio, television, Web sites, and the Internet to comment, both formally and informally, on the artist and the work. These media create reputations over time, via face-name recognition and through reproductions of the work.

If you look on the Internet or in the yellow pages under "Public Relations," you will find listings of companies that use the media to help shape careers, but it is costly to hire professionals. They tend to use expensive methods, like advertising, to achieve success. This book is a complete guide to reasonably priced, low- and high-tech ways to achieve the same success on your own—even on a small budget. It empowers fine artists by explaining promotional and marketing strategies that work, with an emphasis on the importance of documenting artwork through digital processes as well as conventional color slides and other photographic reproductions; maintaining copyrights; assembling proposals, grants, articles, and résumés; exhibiting and publishing work in the United States or international markets; attaining eligibility for Arts-in-Education residencies; and functioning as your own press agency.

I proposed in the first edition that you have articles published in magazines and newspapers to further your career. With the event of Print-on-Demand (POD) Internet publishing, it is now possible for the fine artist to use creative resources to self-publish a thirty-two-page color catalog (for the emerging artist), a two-hundred-page color art monograph (for the established artist), or a large, group-exhibition catalog under the guise of a limited-edition art book. The cost is affordable: $2,352 for two hundred color catalogs that are twenty-four pages long ($11.76 each) and $8,500 for two hundred monographs that are two hundred pages long ($42.50 each). These figures don't include the costs of layout and copywriting, but you can have an intern complete a layout and a "cultural journalist" draft the writing. Use only digital images in the production, and you'll then bypass printer's fees for shooting images. With a bit of inventiveness, you can add to the catalog or monograph a limited-edition print, boosting the final retail cost to between $100 and $400.

When artists sells their work in a gallery exhibition, the value of their work has to at least double, due to the apparent prestige that comes with having a color monograph available at the opening. In short, if an artist at age forty-five-plus has amassed a body of work and has writings, reviews, and articles, then he should be able to sell pieces in the $500–$5,000 category. By publishing a significant monograph with perfect binding, an excellent color cover, and good paper stock, he should see his artwork sale prices increase to the $1,000–$10,000 range. One only has to sell two artworks in the higher range to break even (depending on the business arrangement with the gallery). If the book sells in the $75 range without a limited-edition print, then 115 books have to sell to break even, and with a limited-

edition print at $400, one has to sell 20 books to break even (all depending on where it is sold). The artist is now empowered to exhibit in better galleries. People willing to buy the $75 book (without a limited-edition print) are potential collectors. If they do buy a limited-edition book with a print included, they become your collectors and will now be more likely to purchase more of your work at a higher cost. This "vanity" investment overshadows any previous appraisal of the work.

Self-Sufficiency

Most artists want to have their work taken on by a reputable commercial gallery that will give them solo shows, sell their work to important collections at hefty prices, receive commissions, print catalogs, and increase their chances of developing a significant reputation. Many artists, however, cherish a return to an era they learned of in art books, in which a reputable gallery owner will discover them during a fall outdoor show at "Community Day." At the same time, sensing how unrealistic this is, they claim they "just want to do their work."

This book offers a method whereby artists can realistically increase their chances of being taken on by a reputable gallery and develop their own contacts for selling their work. This method focuses on building a significant résumé and a reputation through one's own efforts, with the ultimate goal of printing a monograph. In fact, even a good gallery will not necessarily guarantee sufficient income. Artists need ways of discovering various sources of income from their work without depending on regular gallery sales, and without selling the actual work. I have found that it is possible to construct a forum parallel to the established art-world market. However, any fringe activity relies on inventive tactics, sometimes ingenious and uncommon to achieve; it has been through trial and error that I have found some successful "guerrilla" approaches.

Reproductions, not the work itself, are the medium through which art is generally judged and publicized. In addition to slides and other traditional photographic media, CD-ROMs and e-mail provide the forum for distributing reproductions. The savvy artist can take control of this aspect of the art market, ensuring the quality of the reproductions and minimizing the costs, thereby reaping important benefits.

This book also stresses the importance of being able to articulate what one's art represents. By doing so, one can make the work more marketable, accessible, and interesting to a wider audience—including some audiences and markets artists normally wouldn't consider open to them (national and international magazines). Artists are, by their very nature, creative and critical thinkers. They critique their own and other people's work and utilize critical thinking whenever a new project is started. Any project they undertake is a form of creative problem solving with a beginning, middle, and end. If they apply these skills to the task of explaining their art to a buying public, they can more successfully publicize and market their work.

Publicity and Marketing

Picasso was not born famous. He had the same concerns as you regarding the possibility of becoming successful. Media and technology were more limited during his time than they are today, but that did not diminish the work that was involved. Photographs had to be taken; releases had to be written, mailed, and followed up on. This is still an integral part of the process of becoming established as an artist.

There is an accepted standard for the use of the press release, which in this book I'll refer to as "the release," since it can and should encompass much more than just the press. The artist sends digital files via e-mail or a CD, color slides, black-and-white photographs, audiotapes, videotapes, and other previously published material (if available) to publications and galleries. After your first correspondence, follow-up happens through e-mails, phone calls, faxes, appointments, or additional postal mailings.

For example, imagine you are having your first solo exhibition. If you chose to print two hundred color catalogs comprised of twenty-four pages, you will spend $2,352, or $11.76 each. This catalog can establish your minimum sale prices. Then, you would e-mail releases ("e-releases"), send other notices via snail mail, and fax releases and other supporting materials to magazines, radio, newspapers, and local television stations. As a result, some of these materials may be published, and you might earn a spot on a television news clip. You should obtain as many original copies of the publications (especially if they are in color) as possible and document the news clip.

In this scenario the publicity both supports the current exhibition and serves as a form of marketing. Appearances in public forums like newspapers, magazines, and television can result in name recognition, sales of the catalog and artwork, additional media interest in the work, or talk show appearances. If this exposure generates interest, other parties may contact you directly or through the gallery. You will perhaps be invited to exhibit again and elsewhere.

Any published materials, including printed and online reviews, should then be snail-mailed to other galleries and publications, and CDs or video news clips can be sent to other cable and network television stations. This will help you to obtain future exhibits, receive more publicity, and be reviewed repeatedly.

Rather than doing an enormous and expensive mailing, it is often better to think strategically about what kind of publicity in which specific venue will be most effective. You should then develop databases of important mailing addresses (both postal and e-mail), which will allow you to regularly update select individuals and institutions of your activities.

A single item published in a magazine or newspaper with a national audience can result in a significant response, due to the circulation of the publication. Whenever you or your work appear in a public forum—newspapers, magazines, billboards, posters, on television, on the radio, on the Internet via numerous Web

sites (especially if a release, publicity photo, catalog, or monograph is available online)—you have received publicity. Having control over how you and your work appear in these public media is the art of marketing.

The Art of Marketing

The dadaist Tristan Tzara was a master of publicity and marketing. There is probably, in all the history of art, no clearer example of how publicity can make an art movement than the case of the dadaists. It is notable that this art movement, which produced relatively few actual artworks (with little stylistic consistency, except the intention to shock), became one of the most influential art movements of the early twentieth century.

The dadaists were so radical and controversial for their time that traditional art world venues (galleries, art magazines, awards, competitions) ignored them. The dadaists, however, set up their own cottage industry, which allowed them the forum for exhibitions, performances, and limited-edition magazines.

First centered at the Cabaret Voltaire in Zurich, Switzerland, they published manifestos (catalogs) and held exhibitions that were perceived as shocking. At an April 1920 exhibit in Cologne, Germany, for example, visitors had to walk through a men's room to arrive in the Brauhaus Winter gallery. Needless to say, the dadaists broke down the traditional barriers that had prevented emerging artists from attaining recognition and success. Turning art into a scandalous, newsworthy item, the dadaists gained an artistic reputation by means other than reviews of their work. The art critics were aghast. Meanwhile, Tzara documented everything and acted as the dadaist spokesperson via releases and correspondence out of Zurich.

The substantial amount of literature about dada and the Cabaret Voltaire might lead one to think that the cabaret was a large hall. This is not so; it only held fifty people. However, the Cabaret Voltaire was in a city where the international press was located, due to the country's passivity during World War I. If the art world had not eventually recognized its value, dada would have faded into oblivion like any other news scandal. The dada artists created this parallel market in order to survive.

We can learn from the history of art movements like dada; they provide models whose uses we can practice today. Dada achieved recognition because Tzara knew how to use the media to communicate its message. That is, in part, why dada is where it is today in the annals of art.

Persistence

For the last twenty-four years, the demystification of media methodology (how somebody becomes an overnight sensation) and its relationship to art has been my obsession. This book describes techniques and goals that have been a way of life for my work and myself. I have been a professional artist living off my wits

for more than twenty-four years. My approach to publicity and marketing offers artists a method for getting their work enough public recognition to increase their chances of building a successful career; it also gives them the opportunity to at the same time make a living from their art.

There are many different types of fine artists: watercolorists, collagists, painters, printmakers, performance artists, conceptual artists, photographers (digital), sculptors, combinations of these, and many others. No one approach will work for all. You may not want to follow my methods exactly. Instead, modify them to meet your needs; take what you want and apply it to the type of artwork you are creating. Persistence is the surest way to achieve the long-term goal.

In addition, as one navigates the art world, especially openings and after-opening dinner parties, one meets a wide selection of creative people, some of whom will end up being new collaborators, artist colleagues, writers (aka cultural journalists), business associates (curators and critics), and fine art friends over time. When it is necessary to "cash in" your favors, one leans on a stand-by writer for an artist's statement or an introduction to an art monograph; a videographer to document the opening or help create a promotional video; or a photographer for digital photography services. Perseverance will give your career an idiosyncratic dynamism and opportunities to meet the people necessary for subsequent professional accomplishments.

The barter system allows you to save time and money by exchanging services for resourceful favors. Example, try trading/bartering with offset printers to produce your monograph for your artwork. Use it judiciously!

Describing and Documenting Your Work: Writing, Photography, and the Digital Revolution

In later chapters, we will discuss how to get publicity, but it is important to be prepared beforehand to market yourself to your best advantage when you do receive publicity.

Unfortunately, in today's world too many people say, "It's all been done before," "There's nothing new," or "It's just a restatement of an earlier idea." Because of this cultural jadedness, significance and originality in art can be overlooked. Newspaper and magazine editors, as well as television and radio news directors, are bombarded every day with releases, faxes, phone calls, and the occasional publicity stunt. Why shouldn't they be leery? Look at all the hype continually generated by Hollywood, either through advertising, reviews, or pre-release publicity. This leeriness filters into the art world, and it is a bias that is hard to overcome.

As a result of this jaded attitude, fine artists who e-mail, snail-mail, cold call, or design their own Web page are allowed an opportunity (out of politeness) of about thirty seconds (a sound bite or Web bite) or approximately one hundred words (a word bite) if they get an initial response. If you can adequately describe your work in thirty seconds, the window of opportunity remains open for as long as a dialogue is necessary. If not, the window closes and the response is, "It's not for us," or, "Call us again when you have something new."

Therefore, I recommend developing a "rap" of about thirty seconds or one hundred words. It will help you exude confidence and persuasiveness. Then telephone calls (thirty seconds), letters, and e-mails (one hundred words for the latter two) can be successful tools. You need to be able to make your work accessible,

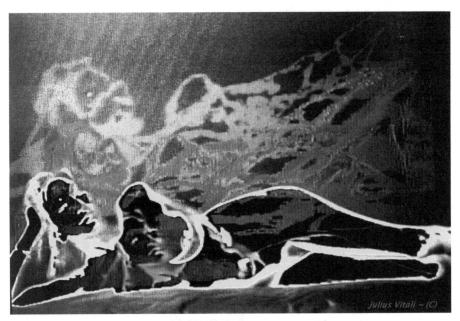

Orbital Landscape, Digital Photography, Julius Vitali 2002.

understandable, likeable, and ultimately saleable. Remember, there is always a chance that your art will appear boring, typical, or crazy to people who know nothing about you or why you do your work. It takes a Herculean effort to appreciate something new (you cannot expect others to have the knack for valuing your mythic effort), so you have to be prepared to be met by lackluster resistance.

If you have a Web site (and you should, since it has become the new standard for research and communication!), the hundred-word rap should appear on the splash page (the first Web-page). The viewer's eye has to be stimulated and soothed by the compositional elements (text and image) in order to notice all your important information and then continue to link to the other pages. The best-quality images have to be quickly downloaded, due to the typical Internet user's short attention span. An image should be no larger than 50 KB, considering the bandwidth most people have on their computer modems (a detailed explanation is in the Digital Resources Appendix).

The hundred-word rap should define the style of your art and the subject matter; indicate the medium; give a brief account of influences and or studies; mention major awards, exhibitions, and collections your work might be in; and explain your aesthetic—that is, what you are trying to creatively accomplish in your work.

To be a successful artist, one needs a personal aesthetic philosophy. In order to write an artistic statement or define your art, you must come to terms with this. If you do not have an aesthetic then it would be advisable to start thinking about it. Without this foundation, the art will be viewed as superficial or shallow.

Reviewers, critics, curators, editors—the "word bite" people—want and need to know this information, and the better prepared you are for this, the easier it will be to advance your career through the various media.

It is unlikely that one artist will spend his or her whole career working in one particular style. Artists try different mediums, whether oil paints, ceramics, and photography, conceptual, or Web-based art. They can experiment freely as long as their aesthetic foundations allow them to choose the right venue for their ideas. Take Picasso as an example: using a wide variety of media (oil paintings, collages, drawings, sculptures, ceramics), his style fell under an umbrella loosely defined as cubism. However, he went through different phases. In the 1920s he tried realism, and in the 1930s surrealism. Then he went back to cubism but in a form that was very different from his early work. He was able to translate his ideas in a multitude of ways. However, he defined his goals via an aesthetic, and since he knew the gallery scene better than most artists did, his various artistic methods were regularly exhibited, which served as a basis for numerous monographs (with limited-edition prints), catalogs, portfolios, or editions that became affordable to the public.

Examples of Artists' Raps

I am a digital photographer, and this example of an artist's rap successfully introduces both my artwork and my personal aesthetic:

> While many artists use modern technology, I explore digital synthesis to produce still images in a single electronic photographic collage. This method digitizes live portraits into computerized frames. Techniques include digital hardware and software and analog methods (using colorizers, keyers, and special effects generators). I explore the interrelationships between audio and video, photography and computer graphics. While this might seem different from the spontaneity and creativity normally associated with artistic processes, this is precisely what gives this collection of modern equipment its liberating potential. The *New York Times* has described my work as a "one-man frontier for the avant garde."

If it is successful, the artist's rap will change the way one perceives the work; it can be helpful to think about whom the rap is directed at and to tailor it to the specific situation. My own rap, for example, may help someone looking at the work to appreciate that it is not simply a colorful photograph but part of a thoughtful, ongoing, creative process.

William Rabinovitch Describes His Art

I am not interested in long, involved explanations of what I paint. Working intuitively, spontaneously, and symbolically with the elements of time and space that often shift illogically, strong colors, gestures, and brushwork all come together in

dramatic, energetic, and often feverish compositions of my own particular iconography. I am fundamentally interested in conveying a sense of pain and struggle about life, art, and relationships between men and women, tempered with my native ability to find beauty in the ashes. The warm happy colors I choose often contradict the underlying fierce emotions I wish to convey.

It is rare for a painter to articulate in clear, precise language his own theory of art, but Rabinovitch is able to do just that. This is authentic, original work, the point of which is to leave the viewer moved by its elegance and drama of its creativity.

The rap works the same way with any kind of art. Imagine a fantasy landscape painter who needs to distinguish his work so that it will be examined and judged fairly. The hundred-word rap for such a painter might say:

> My name is Mr. Daydream Palette, and I prefer working from nature by hovering in the clouds. Though natural light gives me inspiration, I work both on location and in a double bed using oils and watercolors. I live in a sleepy New England town, and my original signature style is the Be Miles Away River School, which is influenced by the American BedPost-impressionists, but I have also studied and taken wistful classes with many established mattresses in New York City.
>
> The subject matter of my paintings ranges from catnap landscapes to moonlit sleepscapes, which are scratched in an illusion of deep space using the delicacy of the feline chiaroscuro style. Primary sketches on pillowcases, made on undemanding locations, are a leisurely component of my relaxed process. Each sketch is used as the foundation for a series of forty winks variations, and the pillowcases are often exhibited along with the finished work on many award-winning refrigerators. I cherish someday winning many prizes and honors in respected magnet competitions around the faraway United States.

It is the artist's aesthetic, communicated through the rap, that helps the listener or reader to understand what is unique, distinctive, and of interest in the work. Mr. Daydream Palette draws attention to his peculiar style, especially his moonlit sleepscapes, as well as his interest in the artistic process and the relationship between the pillowcase sketches and the finished product. He presents himself not as just another landscape painter, but as a minor artist with his own nascent style and process.

Artists attending art-in-education workshops (through various state arts councils) conduct mock telephone calls in order to learn and master this technique of the "art rap." Test your art rap. If it proves unsuccessful, then modify the information until it begins to work. Create a sample list of ten galleries or other sites to call or write. Determine what sort of positive and negative responses you receive. Based on this sample, adjust your rap to create a higher percentage of success.

A rap that succeeds in winning the ear of the listener will become the model for the other kinds of writing you will need to do, including releases, artists' statements, grant proposals, and articles. You may find that the time you put into

developing your hundred-word rap is productive not only for marketing your work but for the work itself. Having a clear aesthetic can help your artwork become more articulate and forceful.

Fear of Writing

One concern for many artists is a fear of writing, as they are visual rather than verbal thinkers. There is an obsolete French phrase, bête comme le peintre, which means "stupid like a painter." This is an unfair stereotype, like the absent-minded professor who wears two different colored socks and mismatched shoes.

Everybody who goes through the educational system has a rudimentary knowledge of English grammar and composition. However, like any other technique, writing has to be practiced on a regular basis. Most artists' writing abilities are simply unpolished, raw, and neglected.

The first thing to remember is that you are not writing the "Great American Novel." Releases and artists' statements are normally one page, or about 250 words at maximum. In a typical grant application, for example, "Description of Proposed Project" should be four hundred words, typed and single-spaced. When filling out these grant application forms, by the way, you are not required to fill up the whole application. If you can describe your project in fewer words and still be understood, that is sufficient. The trick to this type of technical writing is to be as clear and concise as possible; no falsehoods or flowery language. Follow the instructions carefully and tell your readers what they want to know. Stick to writing about your technique, aesthetic, and the style of your project. The more simply and clearly you describe your ideas, the more likely people will understand you and your work.

If you cannot seem to refine your writing ability with practice, then get help. This can take the form of a ghostwriter, a critic, or a cultural journalist, even if you have to barter your artwork in return for someone's writing skills. Too much is at stake, career-wise; articles, releases, artists' statements, grants for individuals or special projects, artist-in-residencies, artists-in-education, and corporate support all require writing ability.

You can also try buying a voice recognition software program. In this way, you can speak in a natural conversational manner instead of typing your ideas into a computer. This software program has to be trained to the inflections of your voice, but it ultimately saves enormous time. In addition, mobile dictation is an option as you can dictate into a handheld digital recorder while away from the computer, then later transcribe the recorded speech to text. Recently, I was able to purchase at a Staples store an older voice recognition software called VIA Voice for $2.50, a closeout price from the normal $100–$300.

You could also have someone interview you about your upbringing, work, and aesthetic. All interviewers use tape recorders as a backup for interviews and keeping notes. Why not do as these writing professionals do?

The more you understand about the kinds of writing necessary for advancing an artist's career, the easier it becomes to tackle each writing chore. Breaking down each writing assignment into its components will help you to overcome this obstacle.

The Release

One of the most important writings is the release. A release always begins with the most important information. The first paragraph indicates the date, time, and location of the event; the nature of the event, whether it is an exhibition, workshop, or performance; the name of the artist or artists; and information that is of a practical nature (address, e-mail, fax, your phone number and that of the site, admission cost if applicable, and the like).

Next, the release should give a brief history of your achievements. Basically, what you need to do is to expand your one-hundred-word rap for this part of the release. For example, a brief description of any grants you received for this project and past reviews of exhibitions should be added. Include information about the specific works being displayed. Anything out of the ordinary, such as a site-specific installation, demonstration, workshop, or lecture in conjunction with the display, should be highlighted. Keep in mind the purpose of the release: to inform the media of the public display of your work and to convince them of the newsworthiness of the event.

Finally, a closing paragraph should include any pertinent information needed to explain technique or concepts that might be of interest to the media. (This can even be a how-to explanation detailing the steps to the finished artwork). The release should not be longer than three typed pages. A one-page, double-sided release is usually sufficient.

Often, a gallery will ask the artist to write preliminary information that its staff will rewrite into the actual release. You will need to be familiar with the components of a release in order to do this and to exercise control over the content of the release the gallery prepares. It is your show, and the success of the release and the enclosed material—i.e., images and other printed info—is intended to further your career. Being empowered is what this book is all about.

Be creative when sending out these releases, since newspapers, e-magazines, magazines, radio, and television get flooded with them. If you choose to e-mail your release, you should realize that e-mail users have created a new category below the status of bulk snail mail. "Spam" is unwanted, electronic junk e-mail that is usually deleted before it is even read. Although it costs almost nothing to send, this convenience does have a price: Will it even be read?

Regardless of how you send your release, the writing should be straightforward. You might want to incorporate an image as a heading. This breaks up the traditional release format and adds an artistic touch. If you are sending snail mail, the envelope can have a computer-generated image printed on it to "grab" the recipi-

ents' attention, or you can include a small, one-of-a-kind artwork as part of the package to distinguish it from the deluge of releases the press receives.

The release is e-mailed or faxed to the media, if time is short, or to television stations, on the day of the event. If you are sending out a CD or video news clip to television stations or magazines (if the video adequately explains the art), you should also include a written release. More about releases will be explained throughout the book.

Documenting Your Work

Along with developing your aesthetic philosophy and writing ability, you will need to document your artwork. You must first become aware of the fundamental dilemma the latest technology poses for the artist. During this century, the rapid growth of technology has brought with it new breakthroughs in convenience, but at a price. Artists must now not only rely on the actual objects they produce (oil paintings, sculpture, and so forth), but must also consider the way those objects are reproduced: e-mails, Web sites, CDs, slides, faxes, photocopies, videotapes, or DVDs. How best, then, can you represent your work, and in what medium?

The commercial worlds of books, magazines, newspapers, and printers have all embraced digital photographic files and e-mail correspondence. One reason is that computers, e-mails, and digital files have set an inexpensive and convenient standard for the industry. Every business and school uses them, and thus the fine artist is required to use such technology to participate in this twenty-first-century arena.

Most organizations and media personnel require digital images. Even if photographs or slides are accepted, they are eventually converted to digital files. This requires digital hardware—i.e., digital camera, slide scanner, flatbed scanner, and computer.

However, once you've obtained this equipment, you must still hold on to your slides and other traditional means of documenting your art. The nonprofit world of state arts councils, foundations, and residency grants (through artists colonies) have not yet embraced—for a variety of financial, political, and panel reasons—digital photographic files. For example, when you are applying for a visual grant, you must still supply 35mm slides to these organizations for panel viewing. This conundrum is not likely to change in the immediate future, since the cost of upgrading computers to accommodate new digital technology in this current economic environment creates an impasse.

For the next few years, at least, you will need to rely on a combination of formats when you submit work for review. Imagine, for example, a peer panel (made up of artists and nonprofit gallery administrators) that looks at five sets of slides simultaneously, which means the viewers see 2' × 3' images projected side by side. It looks great. Now, if the panel uses digital technology, the members will likely view images in one of three ways (or some combination thereof): (1) the panel

physically meets, and a Microsoft Power-Point software program is used to project digital images through a digital projector (rather than through a slide projector); (2) the individual panelists interact on a secured Web site, simultaneously viewing the same artwork for evaluation; or (3) the panelists are sent a CD, and they e-mail votes to select the grantee. Some version of this scenario will eventually be embraced and become the new evaluation standard. In the meantime, artists need both digital and older traditional photography technology, for we are in this twilight of the old technology and the new digital dawn. It is now more expensive to remain competitive, because the number of necessary documentation formats has only increased. (To lean more about traditional photography, visit the Allworth Web site (*www.allworth.com/Catalog/AC291.htm*)to view my older appendixes from the earlier edition of this book.)

Digital Methods and Practices

The new digital standardization has a Janus face. While digital files are a convenient way of showing people your work, you must invest a significant amount of money and time to create superb digital images that represent your artwork in the best light. Digital files or slides are an illusion as much as they are a rendering of the art object. Poor-quality images will give the impression of poor-quality work. Although a visit to your studio or a gallery exhibit is preferred, most people will become familiar with your work through a Web site or other media reproductions (if you've done your publicity homework) before finally seeing the exhibited work.

Unfortunately, in the art business these illusionary means of representation are necessary in order to start a career. If a business can find a way to standardize images, then your business has to match this in order to keep up or be left out. In order for a business to grow, prosper, and be creative, it must seek out customers, keep them, and then find new customers and new markets on a continual basis. Initially this is daunting, since most artists do not think of themselves as being in business and therefore do not market and publicize their work in a business-like fashion.

Many artists believe that everything attributed to the art after it is created is just hype, advertising, or commercialism. However, there is no way around the fact that artists need to have nothing less than the best-quality digital files, color slides (and black-and-white prints) for presentation and reproduction. Today, there is fierce competition for galleries, grants, and publicity. You do not want to make yourself ineligible due to poor quality images. Therefore, you must know how to control the quality of the digital photographic reproductions of your work. This requires understanding how a computer works, knowing the properties of digital and conventional photography, and having the tools—camera, tripod, lenses, cords—to achieve superb results. The documenting of artwork is not difficult. Start thinking of photographic documentation as an integral part of the artistic process. The best way to maintain quality and reduce expenses is to do it yourself. Digital files can be easily e-mailed in the jpeg format or "burned" on a CD for submission.

Traditional Photography

Artists need to send out duplicate slides for submissions unless many copies are made of the originals. Because great-quality slides are necessary for grant panels (see above), it is especially important to own or have access to a good 35mm camera body, a normal lens with macro focusing, and a sturdy tripod. When you take slides of your artwork, the exposure should be exact. If the lens aperture is only ½–1 f/stop off, it can deepen the color (underexpose) or lighten the color (overexpose) of the artwork, yielding unsatisfactory results. This can be corrected when making duplicate slides (or if it is downloaded to a computer via a slide scanner), but you will lose some quality and time.

To document your artwork, you will need a fixed-focus lens like a 50mm with macro focusing capability. You should have this feature because it is sometimes necessary to shoot from closer than three feet, and a macro focusing feature allows this. This is especially important for small works or fine details. For a detailed explanation of how to document your artwork by taking great quality color slides, go to *www.allworth.com/Catalog/AC291.htm.*

I have found 35mm Nikon cameras in thrift and pawn shops for a fraction of their original cost. These are the places to look for older equipment.

Henry Wilhelm—Color Photography and Digital Paper Testing

In the first edition of this book, Henry Wilhelm's photographic archival research added significant information for the fine artist. Since then, in 1995, Henry Wilhelm and Carol Brower established a new company, Wilhelm Imaging Research, Inc. (*www.wilhelm-research.com*), to expand their image stability research activities. They now concentrate on testing inkjet materials and other types of digital hardcopy. Their standards have been adopted by other organizations; for instance, Inkjetart.com refers to Wilhelm's archival paper ratings. See the appendix at the end of this book for more information.

Photography is a critical part of documentation, and, due to the impermanence of slides and photographic paper, it is important that you read *The Permanence and Care of Color Photographs,* by Henry Wilhelm with Carol Brower (1993), currently out of print but available as a reference book in libraries. Studying it will give you an understanding of the permanence and archival stability of color photography and its standards. Mr. Wilhelm took twenty years to research portions of this book, and he is well known as an expert (one of the founding members of the American National Standards Institute) on photographic films, papers, and equipment.

Duplicate Slides

Wilhelm recommends using Fujichrome Duplicating film. This is usually only available at professional labs, therefore the cost of the duplicates is much higher (up to $3 per image). Fujichrome is superior to Ektachrome visibility, Wilhelm writes, because its colors do not fade as quickly in a slide projector. On the other hand, the much cheaper Ektachrome duplicating film is readily available at commercial labs, and if you are not projecting it and know how to store it archivally, it will not deteriorate.

The only way around the Ektachrome slide-fading dilemma is to order enough duplicates at the lower price, since they will fade faster when projected. Never project originals; if you do, they become throwaway items. If you order ten dupes from commercial labs, it is almost the same price as one dupe from a professional lab. So, if you are, say, planning to snail-mail slides to galleries and magazines, my advice is to order twenty-five dupes from a commercial lab. For slides-to-CD transfers, by the way, commercial labs charge $5–$20 an image.

Archival Storage

Do not use PVC (polyvinyl chloride) slide sheets to store slides. They can, according to Wilhelm, contaminate, stick to, and destroy films and prints. Use surface-treated polypropylene, which is acceptable for mounted slides, or high-density polyethylene, which is a naturally slippery plastic with little tendency to cling to the slides. High-density polyethylene is preferable to surface-treated polypropylene because it is less likely to cause scratches when sliding film in and out of the plastic enclosure. The Icon Company distributes archival slide sheets, plus fine art archival products, such as Clear File, Print File, Ultra Pro, Prat Savage, and Nielsen Bainbridge, at reasonable prices. (Contact Icon Distribution, 3956 Town Center Boulevard #122, Orlando, FL 32837; 800-801-2128; fax, 407-944-0408; e-mail, *icon@iconusa.com; www.iconusa.com.*)

Film Protection

Since 9/11, it has become important to invest in a new generation of travel gear, which helps unprocessed slide, print, and motion picture film guard against x-ray damage emitted from the high dosage CTX5000 (computer tomography) or the newer CTX9000 series scanners recently installed at airports worldwide. Scanners have absolutely no effect on processed slides or prints.

As the conveyor moves each bag through these machines, the system creates a scan-projection x-ray image (a CAT scan–like beam) to analyze dense masses. Under normal conditions, the CTX9000 scans 542 bags per hour, or approximately one every seven seconds. The security operator views the screen image to determine whether a real threat exists and then follows established protocols for threat resolution.

Damage to film occurs during this screening process, since a single roll of film may trigger the high-dosage x-ray scanner to take a closer look (for up to two

minutes at a particular object). The scanning beam leaves a permanent stripe or line on any unprotected slide, print, and motion-picture film, a stripe that remains after the film is developed.

Thus, if you plan to travel with unprocessed film via air, it is very advisable to purchase a film shield bag made by the SIMA Company. (Contact SIMA Products Corporation, 140 Pennsylvania Avenue, Bldg. #5, Oakmont, PA 15139; 800-345-7462; e-mail *info@simacorp.com*.) The FilmShield® XPF20 is the company's maximum-strength soft lead bag, which protects up to ISO 800 film under normal conditions. The XPF20 is made of a flexible lead composite sealed in black, textured PVC that is water-resistant, tear-proof, easy to clean, and holds fifteen rolls of film; its size is 15¼" × 13", and it costs $39.99 (smaller sizes are available). If, through the course of your air travel, your baggage were to go through these specific scanners ten times, there would not be damage, since the leaded bag nullifies the negative effects of x-ray passes, effects that otherwise tend to accumulate over time.

However, now that you have solved the problem of damage, you have introduced a second problem of inconvenience. In this precautionary and less accommodating climate, if your checked luggage includes a film shield bag, it will look like a dense mass to the operator, which should, if he or she is doing the job correctly, prompt the operator to remove the luggage and ask you to open it, most likely delaying both you and the flight.

In order to avoid both damage and delays, SIMA recommends that all photographic film be kept in your carry-on luggage, first placed in a see-through bag (for easy retrieval), and then placed in SIMA's shielded bag. Or, if desired, place your film or loaded camera (add an ISO1600 or greater roll of film to indicate that high-speed film is included) into a see-through bag and request a hand-inspection of these carry-on items. Be prepared to wait for a hand-inspection if lines are long at the security checkpoint. And be advised that hand-inspections of carry-on items and bags are not always granted in the United States, even with approved new TSA (Transportation Security Administration) regulations. The problem worsens at airports outside of the United States. Be prepared for the standard security operator's line of "our machine will not harm film." Be firm and polite, and remind them of the posted regulations; in fact carry a copy of the regulations with you, referring to item *49CFR1544.211(e)(4)*.

To see examples of damaged film via these scanners, visit the SIMA Web site (*www.simacorp.com/fieldtest.htm*). Alternatively, *www.f-stop.org* is a Web site that offers information about film safety for traveling on planes.

Writing and Selling Articles

Your images have several purposes: to be included with applications for grants and exhibitions; to serve as publicity in newspapers and magazines; to sell to publications for articles or other uses; and to embellish a portfolio. Most artists do

not realize the sales potential of their copyrighted images. For many years I made a living just selling articles about my work to magazines all over the world, whether or not it was in conjunction with an exhibition. This is also a way for artists to develop a reputation. The media notices your work because it is in a public forum. Even a small mention in a national magazine can be significant in terms of publicity.

Your hundred-word rap, together with slides and photos of your work, provide the foundation for a very brief article. A release, together with photos, can also become a brief article. These are essentially press kits that can be snail-mailed out as they are or expanded and tailored to fit the needs of an article. Sometimes, one thousand words is the maximum for a feature article (four typed pages or a five-minute conversation). You should provide information that can be published as is. Newspapers and magazines can take whatever they want out of it, or rewrite it if they want to; and if more specific information is necessary, they can contact you.

Once you have articles, reviews, or notices about your work published in newspapers or magazines, these can be sent out as the basis for other articles about yourself. I recommend this for two reasons. One, it provides an objective view; and two, it gets you off the hook about writing it yourself. Remember, this published text is just the base, which can be tailored to fit another article's needs. You may be able to interest a publication in doing a similar article, an expanded or updated version, or an entirely new article. Whenever you use published material, make sure you give the appropriate credit and clarify or update the information as necessary. If you read general-interest publications like *Time, Newsweek, People, Wired, Rolling Stone,* or the *National Enquirer,* you can get a feeling for what needs to be included in such an article. If you are able to generate interest in your work, you will open channels for publicity outside of the very competitive art press.

The most easily written component of an article is your personal history. This includes any childhood stories pertinent to the art, your education, apprenticeships, private instruction, any record of achievement, influences, and travel that pertains to your artistic development. Any humorous art situations or anecdotes, which can make the article colorful and snappy, should be included. Here is an example from an article of mine that was published in *Newsday:*

> "I had a few frames of film left one day, and I had a little toilet bowl, and I put it in the puddle, and when I got the slides back, I realized that it really looked like a light bulb in the sky . . . this was the beginning of puddle art." In Vitali's world, carrying around a miniature toilet bowl is not an absurdity.

Remember, it is important to show the interrelatedness of your personal history, the development of your work, and your mastery of technique. This is especially true if you create a new art form or significantly add to an existing art form. The point is to give the reader an understanding of how you became interested in art and what attracted you to a particular medium.

The most difficult part to write, but the one that should take up a major

portion of the article, has to do with your aesthetic. Again, this is the philosophy behind the work, the reason it is being created. This foundation can be drawn from your own personal techniques, experimentation, or from an established school of art. You can make this more interesting by relating it directly to the images included with the article. Using the images, you can define explicitly the significance of the aesthetic as it relates to practice. This simplifies and grounds your writing, putting the work in the context of the artistic journey, from the inception through development and into maturity.

Interview with George Schaub

George Schaub is the editorial director of *Shutterbug* and *eDigitalPhoto.com* magazines. The author of sixteen photography and imaging books and over 1,500 magazine articles, Schaub began his career in photography as a custom black-and-white printer. He continues to conduct photography workshops internationally and throughout the United States, including at the renowned Palm Beach Photo Centre. For ten years, he was a faculty member in the photography department at the NewSchool/ Parsons School of Design in New York City. In 2003, *Using Your Digital Camera* (Amphoto), will be published. Other recent titles include *The Digital Photolab* (Silver Pixel Press), *Professional Techniques for the Wedding Photographer* (Amphoto), *Using Your Camera* (Amphoto), and a second volume of digital printing techniques entitled *The Digital Darkroom in Black and White* (Silver Pixel Press). A graduate of Columbia University, Schaub lives with his wife Grace in Sea Cliff, New York.

J.V.: What I would like to know from your fifteen years' editorial experience is, are artists and photographers using e-mails to pitch story ideas or to show portfolios in order to be published?

G.S.: Yes, but not to show portfolios. The attachments would be too large. But there are many queries received this way.

J.V.: In addition, do you read your own e-mails, or are they screened? How many do you receive a week?

G.S.: I receive and read the e-mails myself. I receive about ten per week on unsolicited queries.

J.V.: As a result of an e-mail, do you open an attachment (since a virus can enter the computer this way)?

G.S.: I do not open attachments. I do not wish to clog my computer with downloads. If I am interested, I may call or usually e-mail back requesting a CD.

J.V.: If an e-mail is sent, does it ever prompt you to go visit a photographer's Web site? As a result of visiting the Web site, is the photographer contacted?

G.S.: Sometimes, if time allows. The link should be put right into the e-mail, rather than me having to type it or copy and paste it into the address area.

J.V.: How much time do you devote to all of this?

G.S.: This is part of my job, so I devote as much time as it takes to do this.

J.V.: I did a sample, cold-query e-mailing and then faxing to magazine and television shows to see what kind of response I would get; cold faxes received more response than a cold e-mail. Is this your experience?

G.S.: I do not accept faxes anymore; that's old tech. I rarely see slides anymore. I look for a CD with a contact sheet.

J.V.: When you say you do not accept faxes anymore, does the magazine no longer have a fax machine?

G.S.: The magazine has one, but like many offices, we share it, and it is likely that [a fax] might get lost in the shuffle.

J.V.: I sent an e-mail to one of the associates at *Late Night with David Letterman.* The response I received was, "We received the e-mail, but, due to the volume we receive, we cannot respond to all of them, but we do read them." Does the magazine have an office e-mail and then personnel ones that will direct you to the right person?

G.S.: Well, we are not the *Letterman* show, and we use 90 percent freelance work to do the magazine, so we rely on queries to find new talent and writers with specific story ideas and images that fit the publication.

J.V.: I would like to ask for clarification regarding how many images you would like to see on a CD and in what format [JPEG].

G.S.: If it is a query CD, any format will do. I can open most anything here, but not exotic file formats.

J.V.: Although you rarely see slides, you do still view them. I believe that the resolution of slides is better than pixels. If you are going to publish a digital file, what would be the minimum requirements for this type of file?

G.S.: The resolution of slides is fine but raises liability issues and handling concerns. In addition, we do not return the CDs, and if we get slides, we feel bound to return them. All queries should expect no return of materials. The published file needs to be 300 dpi (dots per square inch) at 8" × 10".

J.V.: I recently bought a Polaroid Sprint Scan 4000, and it looks great when you download a slide to a digital file, as the software allows for a variety of changes to the image. When you ask for a CD, what are the guidelines?

G.S.: We assume that the writer-photographer will know how to do this in their query letter. But we do send guidelines for submitted materials once we accept the article, etc., and when we send the writer's contract/ agreement.

This chapter has armed the fine artist with two media: writing and digital and traditional photography. Having control over these two marketing and pub- licity tools (text and reproductions) will create many professional opportunities in both the publishing and art world. The ensuing chapters are structured to help you disseminate your text and reproductions and generate publicity.

Chapter 2.

Editorial and Advertising Publicity: Newspapers, Magazines, and Databases

What constitutes a significant art event and, therefore, the need for publicity? This depends upon whether a show is held in a major city, suburb, or rural area; and beyond that, in what type of location—whether a gallery, library, or restaurant. A solo or group show should always be publicized. Publicity is also necessary for art performances, artist-in-residencies, artist-in-education, employment, workshops, master classes, demonstrations, fundraisers, lectures, commissions, and guerilla events. A master plan has to be envisioned with a timetable for implementation. This might require asking several people to work with you to complete the task, since you want at your disposal all the various media options, including newspapers, magazines, cable and broadcast television, AM and FM radio, and the Internet. You might have to depend on friends, lovers, relatives, or assistants (see chapter 4) to coordinate these tasks. The first time you attempt to organize publicity, it might seem daunting! Do not get stressed from the anticipation; once you are involved in the process, it becomes much easier to complete and modify the tasks. The techniques described in this chapter are specifically designed for fine art events, but many are also classic strategies that could be modified to publicize any activity.

Location

When you are contemplating having a solo exhibition, you should carefully consider the location of the gallery or site where your work will be shown. If

it is not in a city that is defined in media terms as having either its own television stations or newspapers, then the likelihood of achieving any regional or national success will rest on how successful you are in having national magazine articles accepted. National magazines have no audience boundaries, whereas newspapers and television do have limitations in coverage area and in travel distance.

A solo or even a two-person show coordinated with an event offers the best potential for publicity success. However, there are many variations on this theme. You can receive significant publicity for your involvement in a group show or other art event or fail to receive any publicity even for a high-profile solo exhibition. No plan of action is guaranteed to work, but many tips will be offered here to maximize your success.

Even if you are just beginning your career, the best way to approach the media is by having previous or present materials such as articles, releases, and images available to coordinate with an exhibit, particularly if you are trying to solicit an exhibition via snail-mail and e-mail or by visiting commercial or non-profit galleries. As your career advances, however, you will want to be more particular and choose to exhibit in locations where you will receive the kind of publicity that will best benefit your career.

I'll give you a general hierarchy of the importance of location for media exhibition coverage.

1. **New York City.** It is best known as the location of 9/11 or ground zero; it is the U.S. publishing capital, as well as the fashion and art center, five major newspapers are also published daily; and many foreign correspondents cover the United Nations and New York City news. In addition, there are feature syndication news services (both American and foreign), New York correspondents, out-of-town newspapers, television network broadcast stations, cable systems, and commercial and public radio. New York is a media heaven or hell, depending on whether you succeed or fail. In addition, the three major art magazines (*ARTnews, Artforum,* and *Art in America*) have editorial offices in New York, and the major museums and galleries are located there.

2. **Los Angeles or San Francisco.** Much of what was said about New York applies here as well, except it is not as fiercely competitive. It lacks many foreign correspondents and does not have as many daily newspapers, but it still has major television and cable stations as well as galleries and museums.

3. **Washington, D.C.** Every major newspaper, both foreign and domestic, has a correspondent located in Washington, but they are usually politically oriented. This means that political/social/humanitarian art would have an edge in this city. Two newspapers, regional weeklies, and major museums are also located here.

4. **Other major cities.** These can be defined cities where the four major broadcast networks—ABC, CBS, NBC, and FOX—have affiliate stations, or cities with one or two newspapers and a city magazine. Another way to determine whether a city is in this category is if a major sports team is located there; examples are Philadelphia, Chicago, Cincinnati, Miami, Dallas, and Seattle.

5. **State Capitals.** Due to the regional political importance of these cities, television, and newspapers cover events, and sometimes the AP (Associated Press) has a correspondent located there. Usually, though, these towns are not cultural hotspots.

6. **Everywhere else.** This includes small cities, towns, suburbs, and rural areas. There might be a local television station, which could be affiliated with CNN and newspapers with "Neighbors" sections. These are regional pullout sections devoted to news of that area. Unfortunately, only that region—a limited market—sees these sections. There might be a local city magazine in color and lots of free community newspapers that run small filler articles about art events.

If you have an exhibition in any of these locations except number six (there are exceptions), I would advise you to attempt to do a major publicity push for your exhibition or other art-related event. After you have sent out snail-mails, e-mails, slides, or proposals for shows and have been accepted, it would be very helpful to know at least nine months or more in advance when the show is scheduled to occur. This gives you enough time to write an article (which can concentrate on either recent or past work), photograph the work, and make digital files or slide dupes.

Success of a publicity campaign cannot be measured by a single standard, since your materials can range from a single-page release without any supporting images to a mega-release (an article with supporting materials, including CDs and videotapes).

Preparing the Release

When the dates of the event are set, the first thing to do is to ask the exhibition site for a release. This can take the form of a general (preliminary) or a specific (finished) release. If the site cannot work that far ahead, then ask for their blank letterhead stationery and write your own release. If a Web site is available, either yours or the site's, include it in the release (more on Web sites in the Digital Resources appendix).

Many sites just do not understand the significance of publicity; consequently, everything is done at the last minute. This is especially true of the nonprofit alternative spaces, which tend to have little money and underpaid, inexperienced, and overworked staff. These galleries tend to operate in a continual

crisis situation. No event or exhibition has any more significance than the last or next one. This is democracy at its best and worst.

Every site will do a minimum of publicity. This usually consists of e-mail and snail-mail releases with accompanying digital files and maybe a follow-up phone call. But if everything rests on one or a few people who write grants, curate, hang work, deal with the daily issues of a gallery, and cultivate patrons or collectors through leisurely lunches, not much else will be done.

Do not expect these people to contribute more than they are used to doing unless something has been specifically arranged. If they do not follow through, it is usually because they are not aware of the necessity of creating time-tables for publicity campaigns (give them a copy of my book). Under these conditions, you must direct the publicity yourself. This is why you ask for a release as soon as you know the show is on a calendar and the date will not change. Then you will have enough time to formulate and implement an effective media plan with the least amount of stress.

In formulating your plan, you will have to weigh the options we have discussed so far and determine where you are most likely to be successful in receiving coverage—whether the exhibit is at a nonprofit space, commercial space, or museum, and in a city, suburb, or rural area. Sometimes it is best to wait until you are ready for a major publicity effort. If you start planning many months in advance, you will have the time to research and understand the media options available in a particular area.

It is important to know how to receive national coverage by focusing upon certain cities within each state. While state capitals are often not cultural centers, they do have AP offices. To illustrate, if you exhibit in Harrisburg, the Pennsylvania state capital, it is possible to have national success, but you have to understand the market. Because Harrisburg has an AP office, it is possible that an AP article written there will be syndicated nationwide. In addition, Harrisburg has the local *Patriot* newspaper, as well as cable and television stations, either of which could do a news spot, which again, might be syndicated on national television. This is not as unlikely as it seems and has happened to artists before.

At least six months before the exhibit, you need to have a clear idea what artwork will be used for releases and what work has to be digitally photographed or transferred to digital files via a slide scanner. Images have to be captioned and a decision made as to which magazines should be sent material.

Three to four months before the exhibit, you should have photographed the work to be exhibited, made duplicate CDs, and written text about yourself, your aesthetic, and the artwork. Magazines are often prepared several months in advance, so you will want to be ready to approach them well before your show opens.

If the exhibition site is preparing the release and the announcement card (discussed below), do not leave the process entirely up to the site personnel. Have them send you a proof to make sure all the information is correct. The announce-

"GROUND ZERO"

DECEMBER 5-13, 2002 & JANUARY 16-FEBRUARY 6, 2003
RECEPTION: THURSDAY, DECEMBER 5, 6-8 P.M.

This exhibition, curated by artists
Julius Vitali, Frank Shifreen, and
Daniel Scheffer began with a call to
artists to create works in response
to 9/11/01 only days after the attacks
on the World Trade Centers in NY.

Orginally titled as "From the Ashes,"
this encompassing body of artwork
"SOVEREIGN MOTIF" has grown to include over 300 works.
The work is boundless, collected and contributed to by nationally
renowned artists. Please attend, and taste a spectacular display of
works which have traveled this way following an exhibition at the
Museum of New Art in Detroit, MI.

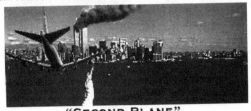

"SECOND PLANE"

Example of an e-release, for the Freyberger Gallery exhibit *Ground Zero*.

ment card does not have to be completed as soon as the release is done, but I would
have it finished three months before the exhibit, in order to be included in the mag-
azine press mailing. Also, if the site is doing an announcement card in color, it is
important that you see a printed proof before the finished card is printed.

Images on Releases

I like to create my own release (with the approval of the site), since it
becomes a little art piece itself. If you are using a computer, you can select a digital
image of your artwork and incorporate it into a release. Usually, the image will be
no larger than 4" × 5" (color is best but expensive).

The same image that is on the release might be on your press-kit s ...
mailing envelope. A 6" × 9" envelope can be mailed for $0.37 and is large
to feed through a computer printer.

E-mail

The original release can be pasted to the e-mail. You might want to add a low-resolution jpeg image in the body of the text or as an attachment. Also you should add any Web site information as an easy link. Avoid characters that do not translate well between different operating systems—such as letters with accents and curved quotes and apostrophes. Errors can occur in your text e-mail being sent between a PC and a Mac computer or between different word processing programs.

A Faxable Version

When you are creating the release, a fax version should also be made. This might be different from the snail-mailed release if you are having an opening event and want to stress that event in conjunction with the exhibition. The fax release is usually most effective if sent to newspapers and television (covering newsworthy events) the day before or morning of an opening event. A superb-quality photo on the fax will save you the trouble and expense of faxing a long description of the work and provide an eye-catching piece of promotion.

Announcements Cards

One of the most important components to an exhibition or other art event is the announcement card. These cards are used to attract people to the exhibition and opening and should also be included in any press kits you snail-mail out.

Announcement cards sometimes simply give the names of the artist or artists exhibiting and sometimes reproduce examples of the artist's work. Which image is chosen for this card is very important; the single image will signify the entire exhibition. The image should be strong and representative of the work being exhibited. It should also be a piece that reproduces well and will look good on a card. Generally, museums, universities, commercial galleries, and some nonprofit galleries design and pay for the announcement card. Some small commercial galleries, co-op galleries, and artist-organized shows leave the responsibility for the cost of the card to the artist. In these cases, artists usually use a black-and-white card or, if they have the money, produce their own color card. There are many eye-catching or elaborate versions of announcement cards that have been created by artists; some are handmade or hand-printed, others may have expensive die cuts in the paper, and some are snail-mailed in envelopes rather than as postcards.

Information, such as date, location, Web site, and opening information, has to be the same on this card as on the release. The "right" number of cards to be printed depends on the galleries and your snail-mailing list. Some printers have established minimum printing runs, and this number differs for black-and-white and color images. As an example, in my area one thousand black-and-white cards

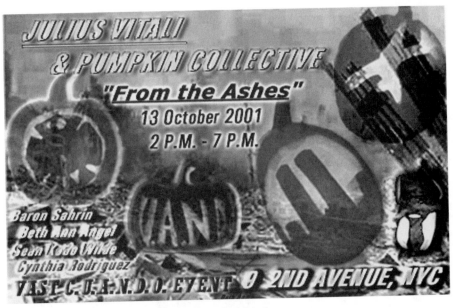

Example of an announcement card from the *From the Ashes* show.

cost about $100 for the halftone adjustment, typesetting, ink, and printing, while one thousand color cards can range from $300 and up. Two printing companies, Kolor View, 800-225-6567, and Modern Postcard, 800-959-8365, print five hundred full-color postcards from a variety of formats for about $100. Call for up-to-date information.

Whatever the amount printed, the artist should have one hundred additional cards for themselves, which can be used as part of another press package and as part of a promotion piece in placing other exhibits.

The post office has certain regulations regarding the size of the announcement postcard for the $0.21 price to apply. Cards larger than 4¼" × 6" will cost an additional $0.16, or the $0.37 first-class rate. You can use the image and written information on the announcement card to make a poster (at least 11" × 14") by computer printer, photocopier, or other inexpensive method, and put it on walls or in storefronts before the opening. This is a low-cost way to further promote the exhibit.

Premium Postcards

Since 1999, the post office offers Net.Post Business Services. Now one can combine the ease and speed of the Internet with the power of hardcopy snail mail. Use Net.Post Business Services to create and send black-and-white or color postcards, letters, newsletters, or flyers from your computer. Simply upload your documents or choose a design from the gallery, upload your address list, pay with a credit card, and the postal service does the rest. The cost is $0.79 for any amount, and this includes first-class postage and twenty or twenty-one lines, depending on

your Internet browser. As a trial offer, you can get one free sample postcard. The postal service subcontracts to AmazingMail.com for this service. It is an interesting and quick way to create a small mailing, as the postcards will be sent within one business day after the order. Usually it takes 3–4 weeks to use an economical printer and then you have to address and add postage. (Contact Net.Post Business Services at 877-740-1042, *www.usps.com/mailingonline/postcards.*)

AmazingMail, Inc.

As of this writing, this company offers a special postcard service for first-time purchasers. It is a two-for-one special on one hundred postcards. Get two hundred postcards for $83, including postage. (Contact AmazingMail at 888-681-1214, *sales@amazingmail.com,* or *www.amazingmail.com.*)

Using Print-on-Demand to Produce a Catalog or Book

Print-on-Demand (POD) services refers to digital-based printing, both monochromatic and color, that enables fast turnaround (some projects within twenty-four hours) of high quality (600 dpi), lower cost (far less than photocopying), customized documents, even on shorter print runs such as a catalog. Here is how this works: Once a manuscript is created in a digital format (PDF), and the editing and graphics work is completed, it is ready to be printed *on demand.* In essence, the type is so sharp it rivals the quality of any traditionally offset-printed text. If you are not told it's POD, you will not be able to tell the difference. The digital files of the catalog are stored in a secure database at the printing location. Once the catalog is available online (through a gallery or your own Web site), the customer places the order electronically to the printer. The catalog, whether in a small run or even a single copy, will be produced and sent directly to the buyer within a few days.

There are a variety of papers (acid-free is best), bindings (adhesive, wire-bound, plastic coil, saddle-stitched, and perfect bound), trim sizes, and cover materials available. If you have a previously published catalog and need more copies, this can be turned into a digital master. Scanning in the pages of the previous edition treats each page as a graphic file. The quality is about that of a good photocopy: in short, it is only as good as the original material, once removed. See the appendix for comprehensive information about POD printing.

Opening Events

You might consider doing something special for your show's opening. This could be a lecture, performance, or demonstration of technique—anything that might be considered newsworthy. The release should emphasize the significance of

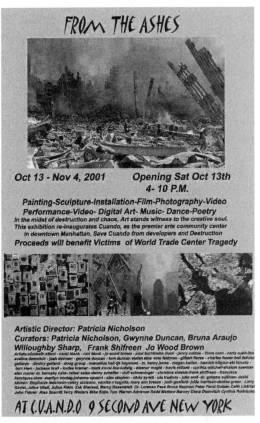

FROM THE ASHES

Oct 13 - Nov 4, 2001 Opening Sat Oct 13th
4- 10 P.M.

Painting-Sculpture-Installation-Film-Photography-Video
Performance-Video- Digital Art- Music- Dance-Poetry
In the midst of destruction and chaos, Art stands witness to the creative soul.
This exhibition re-inaugurates Cuando, as the premier arts community center
In downtown Manhattan. Save Cuando from developers and Destruction
Proceeds will benefit Victims of World Trade Center Tragedy

Artistic Director: Patricia Nicholson
Curators: Patricia Nicholson, Gwynne Duncan, Bruna Araujo
Willoughby Sharp, Frank Shifreen Jo Wood Brown

AT C.U.A.N.D.O 9 SECOND AVE NEW YORK

Example of a poster from the *From the Ashes* show.
Designed by Frank Shifreen.

the opening due to the planned special event. The sooner a notice, article, poster, or photograph appears on the gallery Web site, in the newspaper, or on television, the sooner more traffic will flow into the gallery.

Slow news days are usually Saturday, Sunday, or holidays, with the business week—Monday through Friday—being the busiest for journalists. For that reason, an opening held in the afternoon (when journalists realize they've had a slow news day) or on the weekend is more likely to attract the media. Although events on Friday night might work if they are before 9:00 P.M., you have to give television or newspapers time to edit and process the information. I believe that Saturday is the best day to run an event as a news item, as it will appear in the Sunday paper, which is more widely read than any other day.

Knowing Where to Submit Materials

When deciding where to send materials, you should make a list of all local and regional publications that might find your exhibition or other art-related event newsworthy. This list can often be expanded to include national publications,

which might be interested for any number of reasons. Depending on the type of art that you create, you may find many opportunities. By using *The Reader's Guide to Periodic Literature* (available in most libraries), you can research references to articles on subjects related to your work. Take for instance, a popular topic like the environment. *The Reader's Guide* lists articles appearing in these magazines: *E Magazine, Earth Journal, Environment, Harpers, Whole Earth, National Geographic, People*, and the *Utne Reader*. Either they have columns devoted to the environment or they do features on this topic. Checking on the *Art Index* gives you additional magazines: *Audubon, The Conservationist, Defender, Ecology USA, Friends of the Earth, Greenpeace, On Earth*, or *Sierra*. (For information on *Art Index*, see page 41.) If your artwork deals with environmental topics, you might query all of these magazines or send out your article/release with photos and wait for a response.

Do not rule out large newspapers, as they often have region-specific sections that would likely carry an article about your work. For example, the *New York Times* is a national newspaper and no one can doubt the significance of having an article, review, or photo in the *Times*. They do art reviews on Friday, and they tend to cover more museum shows on Sunday, although not necessarily New York City museums. You might not think the *New York Times* would be interested in reviewing your work, but you should know that the paper publishes five regional editions on Sundays for New York City, New Jersey, Long Island, Westchester, and Connecticut (designated section 14). These regional weeklies have their own art critics, and they do reviews in their region. There is one drawback: If you had a solo show in New Jersey and got a review in the New Jersey section of the *Times*, the review would not be seen outside of New Jersey. Although the *New York Times* is read around the world, you can only get the New Jersey section in New Jersey. (Furthermore, these five regional sections are not provided to the Web site). This is a bit of a pitfall as a lot of important people never see these five regional weeklies. The regional critics are, however, first rate and a review by one of them, I believe, is very important for long-term strategies. Visit the *New York Times* Web site at *www.nytimes.com*.

During the summer months, the Hamptons, located in Suffolk County on Long Island, have traditionally been the vacation spot for the art crowd from the New York metropolitan area. During the summer, the Long Island edition of the *New York Times* concentrates on reviewing the shows in the Hamptons and de-emphasizes the rest of Long Island. Hampton galleries are busiest in the summer and, consequently, the exhibition calendar takes on an added significance. Galleries know the *Times* will review them, and it is a social scene where networking happens for projects occurring later in New York City. If you were going to exhibit on Long Island, this would be the best time to do it—as long as you are exhibiting in the Hamptons!

Databases

One of the most exciting publicity and marketing developments is Internet databases. I originally discovered them while doing research at a local pri-

vate college. Currently it costs thousands to pay for a database subscription. There are three major Internet databases: Bacon's MediaSource at *www.bacons.com*, Ulrich's Periodicals Directory at *www.ulrichsweb.com*, and Thompson/The Gale Group at *www.galegroup.net*.

Each database derives from a variety of sources, and their collective results allow the fine artist to use the Internet to e-mail direct text and images to *the right people*. To find the right people, it costs money. Unfortunately, there are no yellow pages for e-mail addresses, and while the Internet's search engines find your information, the business of searching is time consuming. These databases, on the other hand, have the information, because this is their business, and they are successful at it.

Bacon's MediaSource

All the content in Bacon's print media directories is yours to access with *MediaSource*, including all U.S., Canadian, Mexican, and Caribbean daily newspapers and magazines; more than 14,000 magazines and newsletters; all U.S. and Canadian community newspapers, news services, and syndicates; national and regional daily newspaper supplements; college and university newspapers; U.S. and Canadian national and regional broadcast networks and cable TV stations; news, talk, public affairs, and interview programs; U.S. TV and radio syndicates; more than 4,000 major magazines' and daily newspapers' editorial calendars; and nearly 6,000 Web site listings, organized by media type, geography, and subject matter. The following information is taken from this company's press releases:

> Are you reaching the right journalists at the right media outlets? Are you sure your media contact information is the most current and up to date? If you're not using Bacon's MediaSource, the industry standard for media research, there is a good chance your media lists are not the most accurate. That is because over 4,500 updates are made to Bacon's proprietary media database each day, that is nearly 23,000 updates a week!
>
> Bacon's MediaSource is a powerful, yet easy-to-use online software application that lets you research and build the most accurate media contact lists available. MediaSource has helped thousands of businesses and organizations receive maximum coverage of their key messages in the media. Bacon's proprietary media database contains nearly 45,000 editorial contacts. It connects users to in-depth editorial profiles, over 100,000 pitching profiles, allows users to research, build, and output targeted media lists in a manner of minutes with a few simple keystrokes. Users can also send releases and announcements right from their desktops. One can get the most targeted placement opportunities as their Media Calendars function to maximize your chances for coverage by allowing you to target your news or story ideas to publications with the most appropriate editorial features. Search by keywords, subject matter, issue dates and more.

If you want a MediaSource CD instead of the database, then most of the same list-building, contact management, and distribution features as MediaSource

Internet will still be available. The program and database are furnished on a CD, with quarterly updates.

This information is also contained within their twelve print directories, some of which include: *Newspaper/Magazine Directory, Radio/TV/Cable Directory, Media Calendar Directory, Internet Media Directory, New York Publicity Outlets Directory, Metro California Media Directory,* and *International Media Directory.*

Minimum system requirements are Windows 98 with a Pentium processor, 64 RAM, 24× CD-ROM drive, a Super VGA monitor, and 30 MB free hard drive space. Macintosh users' minimum system requirements are Mac OS 9.x or OS X, 256 RAM, and 600 × 800 dpi or higher screen resolution.

Other info to know: You have to log in and enter your username and password. You might have to download an updated version of Microsoft Virtual Machine. A choice exists between the PowerSearch and QuickSearch functions. PowerSearch details multilevel searches, while QuickSearch has a broad sweeping search of database lists. It is necessary to use the function tools of *MediaSource.* Use their "previous" and "back" controls rather than the Internet browser's functions.

There are eleven categories, including magazines and freelancers. When you choose the magazine category, there are sixteen possible criteria to choose from, and you have to highlight one of them. If you are searching by geographic location, then you can isolate the search, or, if you are looking for national magazines, you can choose category and editor beat. The search parameters are separate for each category. I did a sample search in "ceramics," and 338 choices became available by using the "arts and entertainment" category and the "Editor" beat parameters. If you get over one thousand sources, then the search is too large and has to be modified. Further narrowing your search, you should end up with a manageable list of magazines titles. The blue text of the each magazine name will take you to a page called "Media Detail." The magazine's media info appears, giving you the blue text of the home page and e-mail.

The advantages to this type of information collecting are obvious. Its results are immediate, and you do not have to create an e-mail address database. The disadvantage for me is not seeing all the information at once. A small caveat is that, if you click on the magazine's URL link, the browser will take you out of the *MediaSource* and directly to the magazine's home page. When you leave the magazine's site, depending on your computer, you might not be able to return to their database if you use the "back" tab on the Internet browser. If you are interested in the MediaSource, they have a free two-day trial. A Bacon's representative will walk you through basic search and list-building capabilities of the database. The cost is $2,245 per year; see *www.bacons.com.*

Ulrich's Directory

One of the most comprehensive ways to build a list of magazines (database) is to consult *Ulrich's International Periodicals Directory,* which comprises four volumes and a fifth volume for newspapers. *Ulrich's* does a great job of finding and

then cross-referencing subjects; and if you know the title, you can track down the magazine. They have more than 200,000 serials listed throughout the world from 80,000 publishers in two hundred countries. Annuals, continuations, and conference proceedings are included, as well as academic and scholarly publications, trade publications, consumer magazines, newsletters, bulletins, and titles that have ceased publication since 1974. In addition, they also publish updates three times a year. (Contact R. R. Bowker, 121 Chanlon Road, New Providence, NJ 07974; 888-269-5372; fax, 908-665-3528; e-mail, *info@bowker.com*.) The publication entries give the name, address, telephone, fax numbers, e-mail, and Web site, as well as the editor's name and a brief description of the magazine's content.

This directory is extremely important when snail-mailing out slides or e-mailing jpeg images to various magazines.

Gale's Ready Reference Shelf

Providing one-stop keystroke access to a reference treasury, *Gale's Ready Reference Shelf* uses the power of electronic searching to create an integrated resource that incorporates fourteen of Gale's most popular general reference databases. More than 330,000 entries for associations, research centers, publishers, publications (ranging from newspapers and newsletters to periodicals and directories), databases, television, and radio stations are available 24/7. Some of these databases include: Gale Directory of Databases, Gale Directory of Publications and Broadcast Media, and Newsletters in Print.

Call for a free two-week trial subscription. After that, the cost for individuals is $4,300 a year. Or you can use the database in a regional library. (Contact The Gale Group, Inc., 27500 Drake Road, Farmington Hills, MI, 48331; 800-877-4353; *www.galegroup.net*.)

There are a few other directories available, such as *Burelle's Media Directory* and *Power Media Selects*. These are specific to television, radio, magazines, and newspapers; their uses will be discussed throughout this book.

AP, Gannett, Reuter's, and Other Media Syndicates

It is important to know if any AP, Gannett, or Reuter's reporters cover the area of your exhibition site. These reporters are the link to national newspaper, radio, and Internet syndication. They need to be contacted and cultivated since they possess the power to make reputations. For syndicated articles, they will usually interview you and take pictures of you and your work. The member newspapers, radio stations, and Internet sites of the syndicate can decide whether to treat the article as a feature or filler. It is their choice. They pay a yearly fee and can use the material as they see fit. This is one of the best ways to establish a reputation.

Foreign Contacts in the United States

Sometimes, it is better to play the foreign market first and get an article or two in foreign publications, and then go to the local or regional level. This will normally result in more significant coverage since foreign articles always interest the local media.

If you are planning to contact publications outside of the United States, there are many different ways to find out where to send materials. Researching in *Ulrich's Guide to International Publications* or Ulrichsweb will give you the publisher, address, phone, e-mail, Web site, and fax number. E-mail them to find out if they have a U.S. correspondent or "stringer." Visiting a magazine stand and discreetly copying down the information is another method. Sometimes magazines list information about foreign correspondents in their mastheads—names, addresses, and phone numbers. Since these correspondents are located in the United States, this is the most efficient way to contact these publications. If they are interested in your work, they will forward your material to the magazine's main office. Dealing with correspondents, you can be assured your materials will be returned to you when they are finished with them.

Another way to get information about foreign correspondents is to write to a particular country's consulate in New York, Los Angeles, Chicago, or Washington, D.C. Tell them you want to submit an article to many magazines, and they should be able to e-mail you a list. This, again, is just a list and not a description.

Consulates usually have a library with their country's publications. You might have to make an appointment to use the library, but it is a good way to see what types of magazines are published in that country. Consulate libraries are an excellent place to prepare if you are planning to travel abroad with your work. Some public and university libraries carry foreign publications and can be another important resource.

Beware of Media Saturation

If you exhibit in the same area repeatedly and send releases, be careful. Unless your work undergoes a distinctive stylistic change, cultural reporters and reviewers unofficially restrict the amount of press any one person will receive. Regional saturation endangers your ability to receive publicity. Do not do a major snail-mailing often. Once every six months is sufficient. At a local level, you may be successful with snail-mailings every three months, but this depends on how successful the original press snail-mailing was. If it did not result in anything, then three months later in the same area would be appropriate. However, e-mails can always be sent to update your career; just be careful about bugging someone.

Often, when you have saturated one region, you have a better chance of becoming a news or cultural item outside of your region. For this reason, you should try to show your work outside of your home area. It is hard to coordinate

transporting the work and finding accommodations, but without this effort your reputation will be based on luck rather than hard work.

Creative people understand this dilemma and do their best to find you lodging in homes, or if they have to, in the gallery, when you are exhibiting out of town. It is not uncommon to find yourself sleeping on the gallery floor in a sleeping bag. Whatever the situation, stay with friends, or camp; but do what has to be done to advance your reputation outside of your home area.

Working with Magazines and Newspapers

In my experience, making personal contact with magazines and newspapers is the most effective way to achieve success with these publications. Consequently, it is an obstacle if publications institute a drop-off policy or rely solely on e-mail and snail-mail solicitation.

Sometimes, cold calling for an appointment with an art director or photography editor will merely activate voice mail. It is uncertain whether you will receive a return call. Therefore, it is best to call repeatedly until you reach a live voice. If you get through, you will most likely have an initial meeting with the editor's assistants. If you bring in your portfolio, slides, and CD and "pass the test," then the assistant refers you to her superior. This might sometimes be a fashion or beauty editor; it all depends on the magazine and type of art that you create. Look at the mastheads of the magazine to determine who to contact. Make sure the issue is current, as people in this field have a high turnover rate. It is a good idea to call the magazine and ask the receptionist if the person listed on the masthead is still the photo editor.

Visit the local newspapers or magazines first, as they will be the most accessible, since you are the "local talent." Introduce yourself, show your work, and begin a dialogue through which you can find out what they need and tell them what you'd like their publication to do for you. This can take the form of a feature article, review, preview, or photo with a text caption in conjunction with an event or exhibition. If your artwork lends itself to illustrations, mention that you are available for assignments. Try to network contacts from the editors (art scouts) for names of other editors at their magazine, galleries, other artists, and editors from other magazines. If, during the course of your visit, the editor says "You can use my name when you contact this person," it is a lead not to miss.

There might be as much as six months' lag time between an assignment or acceptance of an image and its publication date. This is especially true for monthly magazines, because they work three to five months in advance of the publication date. If you are lucky enough to have something appear immediately after visiting a magazine, thank the image god. And if you ever feel discouraged, remember that often publications are hurting for interesting material, and if you can provide them with a newsworthy item, then you have a feature article.

If a newspaper or magazine is interested in an article or review about you or your work, make sure a photographer is sent along with the reporter. (Sometimes the reporter will be sent out first, and, after the article is written, the photographer will be assigned.) Art is a visual medium, and it is very annoying to have an article run without a picture. If you are uncertain that a photographer has been assigned to the story, you should give the reporter a CD or color slides of you and your work.

Visiting Magazine and Newspaper Offices While on the Road

Magazine offices have phones, fax, computers, and photocopy machines—all things you will be without while traveling. After the appointment is over, it is okay to ask to make a few local calls to confirm appointments or let people know you might be delayed. Trying to obtain another appointment is a standard practice. You might also ask to fax or to make photocopies. But do not be too greedy. While visiting many offices during the day, you will be able to conduct a significant amount of business using the magazine offices' equipment. Do not ask to use the phone and try to call out of the local calling area without the office's permission. Do not make excessive amounts of photocopies (more than ten copies of the same article).

If an article is accepted, always ask what the pay rate or photograph usage fee is, based on the page rate. Always ask how the covers are chosen, since a cover article is a significant coup. If illustration work becomes available, ask about using the publisher's facilities to create the work, since a hotel room might not be adequate. Ask about the commission fee: Does it include a materials budget, film services, kill fee (when a magazine agrees to a story but then decides to not to use it, and pays a percentage of the agreed amount), and the like? Do not forget to ask how payment will be handled, if invoices must be sent or forms filled out in order for payment to be processed. Finally, be sure to get a business card from whomever you are visiting.

Get the most detailed city map you can find with each street, subway stop, and bus route. This is essential when making appointments. When calling a magazine or gallery, you should already know the address. Be sure to ask for information such as which subway or bus stop is the closest or how to spell it (either correctly or phonetically).

Networking through Magazines and Newspapers

Since magazines and newspapers are always receiving information about people, shows, and lifestyles, they are the best source for networking. Getting an appointment with an editor can result in the most current information. They know the who, what, where, why, and how of the goings on. These editors sometimes

have interests and connections in their field and other related fields, which can help advance your career (sometimes even giving you a gallery recommendation). If they decide to publish your work, you have their respect and this can often translate into their support in other pursuits.

In 1978, I arranged an appointment with the New York editor at *Petersen's Photographic* magazine. After viewing my slides, she became interested in my work for publication. As I began submitting my articles, a long friendship developed and, as she was one of the curators of the Arles, France, photography festival, my photography was placed in this festival.

Art critics and cultural journalists are especially important in major cities like New York. Often curators will ask these people to recommend artists when they are putting together an exhibit. The critic acts as an art scout not only for the newspaper or magazine but also for people who need current information about artists. Curators rely on them for their knowledge. Try not to make enemies of critics, as over time they may become very helpful. In fact, when you meet them, either through work or socially, explain your goals. If the opportunity arises for them to aid you (like writing a recommendation), they may be willing to do so.

Reviews

One of the objects of sending out releases and press kits is to receive at least a listing in the cultural or art section of local newspapers and possibly to obtain a feature article or review. You should realize, however, that outside of the larger cities, which have paid art critics on staff, most regional newspapers hire freelancers to write reviews. These critics usually choose what they want to review (unless they are specifically assigned), based on the release, announcement card, and other supporting materials. The compensation freelance art critics receive for reviews can range from $25–$50 (and up). They are paid by the column inch (the amount of printed words that fit into an inch space). Due to this low payment, it is often younger writers or matronly ladies that end up being critics, and there is an erratic quality of the writing.

A good review should always be kept and used as supporting material for future shows. In fact, if a review appears at the beginning of an exhibit, it should be snail-mailed, e-mailed, or faxed to local and national art publications. This might prompt them to send their critics (freelancers) to your show.

Feature Articles

Submitting feature articles to magazines can be part of a publicity campaign associated with an exhibition or can be, as discussed in the previous chapter, pursued independently as part of a long-term strategy for gaining a reputation.

The number of images of your work necessary for this type of article varies from eight to forty, depending on the type and scope of the article. It is necessary

to include an image of yourself working on your art. This not only shows who the artist is, but is a snapshot of the studio and your lifestyle. One or two pictures of this type should be sufficient—nothing formally posed. A wide angle of the studio showing many works with you in it and a close-up of you working would be fine. Captions for these artist-studio pictures should be included, giving the location, type of work, anything particularly interesting about the piece being created, type of tools used, and the like.

The images of the work should be produced in the manner described in the digital appendix. Images of the whole work and details may be included. The captions accompanying slides of the artwork should include the title, size, medium, date, and any particularly interesting things you have to say about the piece. Type the captions on a separate piece of paper from the text and number each image to correspond to the numbers on the typed page, so there is no misunderstanding. This is especially important when submitting materials to foreign magazines. If they find something confusing and still decide to use it, the results might not be satisfactory.

It is necessary to create a digital contact sheet with text information to help support your CD. This information can be placed in the image itself through Adobe® Photoshop® by right-clicking on the image. When the drop-down window appears, you will be able to supply the necessary file information: title, caption, copyright status, etc.

If you are sending an article written previously about yourself and your work, photocopy it and whiteout the byline of the author and type in its place "For Information Only" (this is a method utilized by some of the press photography agencies, since they receive payment for the use of the photography and not the text). This indicates that the article is not to be used verbatim, and that the material has to be rewritten. The ideas and concepts are what are important to you, not the writing style. Rewriting the article does not violate the copyright of the original author.

Sometimes, when I gave material to SIPA or Liaison Photo Agencies, they take the English text, translate, and rewrite it in French. When it is rewritten, it goes out in French and then is translated to Dutch, Italian, German, or the appropriate language. I have the published pieces translated back to English to find out what they say. Often, when the text has been translated from a second to a third language, the results can be surprising, to say the least.

For English publications this is obviously not a factor. However, whenever you send out previously published materials, I would supplement them with your own written ideas. Primary source material is always of interest to editors. Sometimes, they create quotes to make it appear that you were asked a direct question, even when this is not the case. These editors want their readers to feel an intimate connection with the artist. Read the magazines and get an idea of their writing style before sending materials to them.

It is much easier to receive publicity when the press knows who you are.

D:\BADiamond\NewDigiCD

Eyewitness.JPG	JESUS.JPG	Scream.JPG	FireDeptMem.JPG	ActionReaction.JPG
FireandIce.jpg	AftermathNewmath...	SovernignMotif.jpg	JiggingETC.jpg	MyChildsEyescopy.j...
MyBigBrothers	STOP.jpg	9.jpg	MoneyTown.jpg	LadyLibertyBell.jpg
ArabIsolation1.jpg	USAToday.jpg	ArabIsolation2.psd	POOF.jpg	MyMarketplace.jpg
BareBones.jpg	ArabMyOasis1.jpg	Peace.jpg	MyTaxes1.jpg	WTCwFlagBridge.jpg
ArabflorescentArab...	LadyLiberty.jpg	ROOAAAR.jpg	MissAmiss.jpg	CaveDweller.jpg

Page 1

Example of a digital contact sheet.

Once you have received publicity in connection with exhibits, grants, or other events, you can begin to generate your own stories to fit the needs of magazines and to bolster your career. Women's magazines, in particular, are often interested in the "slice of life" story.

I received a call from a German woman's magazine called *Petra* because they were interested in a profile story about an artist at home. The article would primarily consist of photographs and would emphasize the environment of the home and how it relates to creativity. They wanted to focus on the artistic touches that an artist would create in a home or apartment, such as unique giftware items or hand-painted furniture. If you take the utilitarian and create something magical—a hand-tiled kitchen mural, designs around a window, or a unique outdoor paint job—it might get you attention.

What you create should be related to your artistic style or concepts. The environment an artist creates and how he or she lives is the emphasis for which numerous magazines are searching. The text could be about how the space was transformed (before and after shots), the concept behind what was created, and any anecdotes about the process. In this type of article, it is important to have photos of the artist in action. If you did something in the kitchen, have an action photo-

graph taken during the installation. Do not forget about your studio if it is part of this environment. Take another photograph with you in it.

The slice of life story will not be the first article about the artist, unless the house is unique and the story emphasizes the space rather than the artist and his or her work. Usually, these types of stories run a year or two after articles about an artist begin to appear. If you plan to create something artistic in your home or apartment, keep the idea for this type of article in the back of your mind. Don't forget the before and after comparison pictures. These stories might also be sold to interior design magazines, home magazines, and the like.

Possible Magazines for Feature Articles

In addition to the search methods described earlier in this chapter, you will want to try the routes listed in this section. Try to look at these magazines before submitting articles. Whether you should submit or not depends on the type of work you create and the type of features they publish.

Mainstream Publications

For feature articles in monthlies, send materials four to six months before your exhibition; for feature articles in weeklies, send materials two months before your exhibition:

- **U.S. General-Audience Monthlies:** *Artforum, Art-in-America, ARTnews, American Artist, Ceramics Monthly, American Crafts, Earth Journal, Sculpture, Fiberarts, New Art Examiner, Smithsonian, Women Artist's News, Vanity Fair, Harpers, New Age, Interview, Utne Reader, Vogue, Mademoiselle*
- **U.S General-Audience Weeklies:** *USA Today Weekly, Parade, People, US, Time, Newsweek, U.S. News & World Report,* weekly newspapers magazine sections (not syndicated), weekly entertainment papers like *The Village Voice*
- **U.S. Photography Monthlies:** *Popular Photography, Petersen's Photographic, Studio Photography, Shutterbug*
- **Foreign General-Audience Monthlies:** *City Magazine* (France), *Vanidadas* (Mexico), *Du* (Germany), *L'Arca* and *Domus* (Italy)
- **Foreign General-Audience Weeklies:** *Der Speigel* and *Stern* (Germany), *Elle* (France), *Grazia, Panorama,* and *Epoca* (Italy)
- **Foreign Photography Monthlies:** *British Journal of Photography* and *Camera Canada* (UK), *Foto Practica* (Italy)

Tabloids

Most people completely disregard the supermarket tabloid publications such as the *National Enquirer, Star, Globe, National Examiner, Weekly World News,*

and the *Sun* as a publishing venue. I am not one of these people. My point of view is not to debate taste or whether the publication is high- or low-brow. Many people have written about the debasement of art through publicity of this sort. I'm not drawn to this argument. I want to create income from reproductions of my artwork that will support my career as an artist.

If you are picked up by a photo agency, the first place they will try to sell your work will be to these publications. The reason is that they publish in color, are weekly, have a high circulation, and are currently all owned by American Media, Inc.

If you follow these publications at all—if you happen to be a closet tabloid reader—you will notice that they try to use art and photography stories in every issue. They particularly like bizarre collections or any art with an edge or sense of humor. They run articles on odd jewelry and fashion. In fact, they tend to use the same stories repeatedly. I've seen Salvador Dali's surrealistic gold jewelry published many times. It might not be used in the same publication, but it makes the rounds of these five magazines. The tabloids try their best to come up with new material every week, but with six similar and somewhat competitive publications, they need images, so they have to recycle and are eager for new material.

Titles are very important when selling to these publications. In fact, the titles are sometimes the only thing that is important. If your work has this type of edge, whether it is bizarre or funny, and the title describes your art, you are welcomed. An example: an artist created hand-painted necklaces from seashells. The title of the article became "Art from the Sea." When one of my creative tie articles was published, its title was "You'll Tie Laughing."

These publications pay $100 or more for an image in color and slightly less for black-and-white, and they sometimes use more than one photograph. Note that the foreign magazine editors read these publications. If you have an article in them, it is likely that other magazines will contact you for the same material. Foreign tabloids have similar readerships to the U.S. publications, but some of the magazines are a combination of *TV Guide, Time, People*, and the *National Enquirer*. They have people, humor, general interest, fashion, and special last page sections, besides the feature material.

In 1999, the *Sun* used two photos of my brick fashions (hat, tie, jacket, and shoes, for a story called "Wall I'll Be . . . !", which they considered off-the-wall fashions). In 1999, the *Sun* again used my digital photography in a story called "God and Angel Seen in Sky." The computer-generated photograph of the model seen as the face of God was then sold to the *2000 Photographer's Market* as an example of what images can be sold to the tabloids.

The *National Enquirer* has the largest circulation of the tabloids and pays the highest photo fee. The address for all these tabloids is: 5401 N.W. Broken Sound Boulevard, Boca Raton, FL 33487; 800-749-7733; e-mail, *letters@ nationalenquirer.com; www.nationalenquirer.com*. Talk to the photography editors to bounce stories off them.

Specialty Trade Publications

There are some specialty publications, such as airline in-flight and hotel in-room magazines that publish short features on interesting cultural events in the areas they serve. They can be national or regional and are general-interest publications for business and leisure travelers.

Airline In-Flight Magazines

If you exhibit in a city that has an airport, you might want to contact these in-flight magazines about the possibility of an article, photograph, or listing.

- *Alaska Air, Horizon Air,* and *Midwest Express.* 2701 1st Avenue, Suite 250, Seattle, WA, 98121; 206-441-5871; e-mail, *sales@paradigmcg.com.*
- *Aloha's Spirit of Aloha.* 36 Merchant Street, Honolulu, HI 96813; 800-272-5245; e-mail, *nflight@aloha.net; www.honolulupublishing.com.*
- American Airlines' *American Way Magazine* and *Celebrated Living.* 4333 Amon Carter Boulevard, MD 5598, Fort Worth, TX 76155; 817-967-1804; e-mail, *editor@americanwaymag.com; www.americanair.com/away.*
- American West's *American West Airlines Magazine.* 4635 East Elwood Street, Suite 5, Phoenix, AZ 85040; 602-997-7200.
- *Continental,* Tower Air's *Flight,* and TWA's *Ambassador.* Pohly & Partners, 27 Melcher Street, 2nd Floor, Boston, MA 02210; e-mail, *info@pohlypartners.com; www.pohlypartners.com.*
- Delta's *Sky Magazine.* Pace Communications, 1301 Carolina Street, Greensboro, NC 27401; 336-378-6065; e-mail, *editorial@delta-sky.com; www.pacecommunications.com.*
- Northwest's *World Traveler.* Skies American Publishing Company, 9655 S.W. Sunshine, Suite 500, Beaverton, OR 97005; 503-520-1955; e-mail, *heidim@skies.com.*
- Southwest Airlines' *Spirit.* 14470 Trinity Boulevard, MD 1625, Fort Worth, TX 76155; 817-967-1804; *www.spiritmag.com.*
- Spirit Airlines' *Skylights.* 2800 Executive Way, Miramar, FL 33025; 954-447-7965.
- United's *Hemispheres.* Pace Communications, 1301 Carolina Street, Greensboro, NC 27401; 336-378-6065; e-mail, *hemiedit@aol.com; www.pacecommunications.com.*
- US Air's *Attaché.* Pace Communications, 1301 Carolina Street, Greensboro, NC 27401; 336-378-6065; e-mail, *AttacheAir@aol.com; www.pacecommunications.com.*

Hotel In-Room Magazines

Hotel in-room magazines will give you some of the same opportunities as airline in-flight magazines by featuring articles, photographs, or a listing of your work or exhibitions.

- *Where* covers twenty-five U.S. cities, eleven Canadian cities, and eight other foreign cities. Each magazine is edited locally. For domestic coverage, contact *Where's* national headquarters at 810 Seventh Avenue, 4th Floor, New York, NY 10019; 212-636-2700; *www.wheremags.com.* For international coverage, contact *Where International* at 11100 Santa Monica Boulevard, Suite 600, Los Angeles, CA 90025; 310-893-5400; e-mail, *info@millerpubgroup.com; www.wheremagazine.com.*
- *Travelhost* covers 102 regional editions. Contact their corporate offices at 10701 North Stemmons, Dallas, TX 75220; 214-691-1163; e-mail, *thost@travelhost.com; www.travelhost.com.*
- *Guest Informant* covers thirty-five major U.S. markets, reaching over 40 million business and leisure travelers each year. Corporate offices can be contacted at 21200 Erwin Street, Woodland Hills, CA 91367; 800-275-5885; each city has its own editorial e-mail, which you can find on *www.cityspin.com.*
- *Arrive,* a regional magazine covering Arlington, Virginia, can be reached at Z Communications, 1925 North Lynn Street, Suite 502, Arlington, VA, 22209; 703-358-0012; *www.zpr.com;*
- *Pittsburgh Point,* another regional hotel publication, can be contacted at Scott Publishing, 573 Catskill Drive, Pittsburgh, PA 15239; 412-327-2242.

For more information on these alternative publications, look in *Ulrich's Guide* (available at the library) under Travel and Tourism—Airline In-flight and Hotel In-room.

Being Paid

Do not expect to be paid for publicity review photographs, although sometimes short features and notices with accompanying photographs will receive compensation; but you should ask to be paid for feature articles written about you and your artwork. A "first-time-published" article might warrant not being paid, but do not let this become a habit. You should be paid a photographer's fee (to be negotiated) for a feature article written about you and your artwork (providing that they run a photo of your work). If the publication refuses to pay, then determine if it is worth it to be published. You should always be paid for assignments. The receipt of money, in addition to free publicity and tear sheets, makes article placement extremely rewarding.

Magazines sometimes devote a whole issue to a single theme or concept. In order for this to be successful, the editorial content has to be thought out well in advance. Many magazines rely on freelancers for up to 90 percent of the material they publish. When you submit an article, keep in mind that other material can be built around it; or it can be used to support other articles in a theme issue. In the

best scenario, you will have a feature article appearing the same month as an exhibition and be paid both a photographer and writer's fee for the article.

Once you begin to understand how magazine publishing works, money is often made off the media to help defer the exhibition costs. If you received funding for a special project through a nonprofit organization, the media is more likely to write a feature article or review the event, since public funds were awarded. It should be stressed in the release that public monies were received.

Obtaining Tear Sheets

I would recommend requesting as many free copies as possible (or "tear sheets," if your work has appeared in color) of a published review or article. Ten is a minimum, and you will easily find use for fifty or more. Articles in black-and-white photocopy well, but color is more desirable albeit more costly to photocopy (about $1 a copy). If something is published in color, you should request several dozen tear sheets, even if you have to pay for some of them. Ask for them before the magazine appears; tear sheets are used by both the advertising and editorial departments, and their availability is a matter of first-come, first-serve. The reason you want so many tear sheets is obvious: they can be sent out to galleries and other magazines; they can be included with grant and other applications; and they can be used in many other ways.

Sometimes publications will give contributors a certain number of free tear sheets and then offer a reduced price for additional copies. You can then weigh the cost of a single photocopy versus the reduced cost from a magazine. Color photocopies will probably cost at least $0.80 apiece. Or, you can scan the tear sheet and print it from the computer, at a cost lower than a copy shop.

A different method of obtaining tear sheets is to buy the publication in quantity from a magazine distributor in your area. (Look in the yellow pages under "magazine distributors.") You would have to know the issue number and the date of that particular magazine, and then wait for unsold copies of the magazine to be returned to the distributor. When buying in quantity, the price should be close to wholesale, but you should check the specifics with each distributor.

Advertising for Specific Exhibits

Do not expect galleries, whether commercial or nonprofit, to pay for advertising. Remember, the gallery has a full calendar of exhibitions and might want to save funds and effort for a particular show, knowing that newspapers will not cover them every month unless there is nothing else to cover. Ask the gallery if they will cover the full expenses of advertising or whether you will have to contribute.

If you are thinking of creative publicity strategies, and ads are being considered, then either you or the commercial gallery have to know the best market in

which to place these ads. You can receive free sample issues of most art magazines, along with rates for display advertising, just by calling the particular magazine and talking to their marketing and advertising people. After viewing many of them, you can determine whether they are regional or national and you can best decide if your budget can handle the cost of the ad.

If you decide that advertising in art magazines is the best way to proceed, you should be aware of some factors. The cost of a one-time ad in a prestigious art magazine is a small fortune. But taking out an ad could improve your chances of getting a review in that magazine. Although it is not guaranteed, these magazines do tend to publish feature articles and reviews on people who take out ads. This happens, although it might not be in the same issue your ad appears, and it could be months or years down the line.

Certain reference books available in public and college libraries—*Art Index*, *The Reader's Guide to Periodic Literature*, and *Who's Who in American Art*— are commonly used by people who might want to contact you for a college thesis, book project, magazine article, or group exhibition.

Art Index is an index of certain national and international publications that deal with art, crafts, photography, film, video, design, architecture, and other related fields. They index all art articles, art reviews—both solo and group—especially if a photo is used, and they index certain art ads. If you know which magazines are indexed in the current *Art Index* (about 430 international magazines are indexed in the 2003 edition—including French, Italian, German, Spanish and Dutch publications), and which ads are indexed, you can plan to pay for an ad that will be cited in the index. You can always add the citation to your résumé. For more information call the editors of *Art Index* at H.W. Wilson Company (800-367-6770). *Art Index* has an online database, which thousands of libraries subscribe to (unfortunately, they do not offer individual subscriptions). *Art Index* online offers the index itself, art abstracts, and full article text, and it includes high-quality indexing of 428 current publications dating as far back as 1984, full text of articles from 111 journals as far back as 1997, indexing of art reproductions, and links to Web sites cited by articles to help users find related information and images. Check out the Web site at *www.hwwilson.com*.

The "Hairy Chest Tie": A Case Study

Back in 1982, I created the "Hairy Chest Tie," which originally was commissioned by the *Village Voice* for their V fashion section. The *Voice* published two tie-related articles and one fashion photography spread. The "Hairy Chest Tie" is not a real tie at all. It is a photograph of my chest cut into the shape of a tie and then rephotographed on a model's body (it was held on by tape). Subsequently, I made a silk-screened version, which is three photographic generations less in quality from the original photograph, but the humorous and subversive quality of the original still holds up. What started out as a surrealistic fashion joke turned into some-

The Hairy Chest Tie is an illusion of a tie by Julius Vitali.

thing profitable. I wrote an article about the tie that was syndicated by a photography agency and then later on by myself. The total sales worldwide from this one article have grossed more than $8,000 since 1982.

Publicity from the articles led to the ties being exhibited in numerous galleries, including a traveling exhibition, *Fashion and Surrealism,* at the Fashion Institute of Technology in New York City and the Victoria and Albert Museum in London.

In addition, I have had interest in the ties from many clothing stores and individuals over the years. Unfortunately, hair is very hard to reproduce on fabric; losing its photographic crispness, the hair appeared to be clumped together on the samples that were manufactured. So, because my insistence on achieving a photographic realism is thwarted by the complexities of manufacturing and distribution, the tie has never been mass-produced. Nonetheless, the "Hairy Chest Tie" is a good example of how a single idea can provide both income and publicity.

Chapter 3.

Broadcast Television, Cable, and Radio

Artists sometimes forget about broadcast television, cable, and radio, but these media reach a wide audience and should be included in any publicity campaign. How do you get access to television and radio coverage? It is unlikely that you will get an appointment to see radio or television news editors, as they are always under deadlines. It is best to try to reach them by snail-mail, e-mail, or fax, sending along videos or CDs if possible. Since this is a video era, television seems to respond to VHS videotapes and DVDs with streaming video better than written releases.

Generally, a publicity video should be no longer than ten minutes. The editors do not have the time to watch anything lengthy, so ten minutes is the maximum, but it is better if you can make your point in three minutes. Remember, television news clips are usually two minutes or less. Using sophisticated editing techniques, both television and radio can convey a lot of information in two minutes and a significant amount of information in as little as ten to fifteen seconds. Video and audio releases will be discussed in more detail later in this chapter.

Releases for Newspapers, Television, and Radio

Three to four weeks before the opening of an exhibition or other significant art event, send releases and feature articles and ideas to newspaper columnists and local radio and television talk shows. In all these media, the news works on a tight deadline. You are not *news* three weeks before the event.

I would visit your local newspaper and see the art or entertainment editor to see if a feature article can be written about you. Do not be shy! If you are mentioned in a feature article or in a captioned photograph (especially in a color photograph about the opening), you are more likely to be perceived as a news item by radio and television, especially if a few publications have picked up on your work.

One week before the event, send e-mail and snail-mail releases, with photos, to the radio and newspaper news desks, and send a video release (either VHS or DVD) to the television (cable and broadcast) news desks. If you are successful in planning a feature article, and it appears in conjunction with the exhibition, it can be used as a snail-mailing piece for television, radio, and other newspapers. Gallery listings that include your event should be sent to the television news shows that have a one-minute weekly cultural roundup. Watch the news shows or e-mail and ask about the specific features for each particular show, so you can tailor your materials to fit their formats.

As mentioned in the previous chapters, art openings are an excellent opportunity for television to cover the exhibition or event. On the evening before, or morning of, the event, e-mail and fax releases to the television, radio, and newspaper news desks. Get the e-mail and fax numbers a few days before, so you do not waste time trying to gather them on the day of the event. Because the news is concerned with the moment, your opening is news the day it occurs. Every day, television needs filler (unfortunately, art is put into this category) for the last piece on the local news, so do not neglect this opportunity. By the way, it is always beneficial to have many people at the opening. If television coverage happens, then numerous guests will prove that there is an interest in your work. Invite your friends!

Talk to the television news desk for your area about coverage. They can tell you what kind of staffing they have on weekends and can advise you about what the best times are to schedule your opening or other event in order to receive coverage. Anything out of the ordinary done at the opening will always be a plus in terms of media coverage.

Taking TV into Account When Scheduling an Opening

In dealing with television news desks, the best time to schedule an event is between 10:00 A.M. and 2:30 P.M. This allows it to be aired on the 5:00–6:00 P.M. news as well as the 10:00–11:00 P.M. news. It is possible that events held as late as 9:00–11:30 P.M. can still be aired as a live feed. If only a cameraperson arrives at your event, then your previously recorded voice and image are used in conjunction with the live newscast.

If you have the time, it is advisable to offer a press preview. Since the public is not invited, the media can concentrate on you and your art. The preview is usually held in the morning a day or two before the show (or other event) takes place.

On weekends, the news departments have skeleton staffs, but they still cover events. It is important to make sure that your event is listed in the "day book" (an electronic calendar), which is often a computer database that lists events the news director considers important. Calling a day or two before the event and asking if the event is in the daybook is one way of finding out or getting it listed. Remember to say that your event is very visual; if you are doing something special or even a bit bizarre, tell them that, because the combination of the two makes for great television news stories.

CNN does not cover stories on weekends, except for major events. The FOX network news runs for an hour from 10:00 to 11:00 P.M., while the ABC, NBC, and CBS stations and affiliates have only a half-hour of news from 11:00 to 11:30 P.M. Therefore, the FOX networks are more inclined to cover soft news like art openings, because the hour-long news format is more flexible. In the major television markets, like New York City and Philadelphia, ABC sometimes runs the hard news from 6:00 to 6:30 P.M. and the soft news from 5:00 to 6:00 P.M. An opening held between 5:00 and 6:00 P.M. could be run as a live feed. If an event takes place over time, they can cut back and forth from the studio and the site to report on the progress throughout the duration of the news program. When sending out the release, let them know the coverage could be done live. The more information that is offered, the easier it will be for the news director and assignment editor to create a narrative segment.

Remember, it is possible to have the media arrive, shoot the event, and then decide not to use it. Stories get killed all the time because of tape or camera failure, lack of airtime, and many other reasons.

Why go through this process for a few seconds of coverage? Because step-by-step, this is how a reputation is made. The more your work appears in a public forum, the more opportunities are open to you. The local television affiliates can make the tape available to a national audience through a "feed." This means that any affiliate that is part of the syndication might want to use a local market's news to supplement their news or to show on Sunday when they do a roundup of the events for the week. Exposure is the key; it opens opportunities that lead to bigger things. This method is especially important for artists exhibiting in nonprofit galleries where sales often are nonexistent. If you prove your ability to garner publicity, you will be more attractive to commercial galleries.

Media Reference Books and Databases

If you don't know how to get in touch with your local media, go to the library and find the *Gale Directory* or *Burelle's Media Directory* for your city's media. These directories give a current and complete listing from which to begin your carefully planned media assault.

If you have a good local college library, it probably subscribes to the Internet media databases. Lehigh University in Bethlehem, Pennsylvania, has six

kiosks where local patrons can use Gale and Ulrich's databases (Gale.net and Ulrichsweb) and print the requests for no charge. This is where I do most of my research.

The media also looks for stories and guests on their own schedule and timetable. If they need to use an artist as a guest or spokesperson, they often look for information in a book called *The Yearbook of Experts, Authorities, and Spokespersons*, published by Broadcast Interview Source, Inc., in Washington, D.C., at 800-YEARBOOK, *www.yearbook.com*. If you feel you fit into these categories and want to be included in the book, the standard reference listing with all membership benefits begins at $795, and full platinum membership is $1,895, which includes a profile in their book and Web site. The deadline is usually in May. The *Yearbook* is a primary reference in newsrooms and other centers of broadcast and print media throughout the nation. It is the book to which reporters, news directors, producers, and others turn when they must swiftly find expert and articulate guests in response to breaking news, issue-oriented events, trends (read: "art trends"), and a host of features on every imaginable topic.

Broadcast Interview Source also publishes two other annual directories: *Power Media Selects*, a directory of more than three thousand top media contacts ($166.50); and *Talk Show Selects*, a directory of more than seven hundred top radio and television talk shows ($185).

Two other invaluable resources are *New York Publicity Outlets* and *Metro California Media*, both published by Bacons. The cost of each book is $149.50, which includes two yearly updates in June and December. Subscribers can call to check or request updated information. The information is as current as it can be, since they send out questionnaires and do their own research. The table of contents of the *New York Publicity Outlets* (which covers a fifty-mile radius from Columbus Circle, New York City) has twenty listing sections and four special index sections, such as African-American Newspapers, Ethnic Newspapers, Freelance Journalists, Major New Services and Syndicates, Magazines and Newsletters, Major Distributed Newspapers, and Radio Stations by Format. These books are expensive for one person to buy, but if you think that your work is appropriate for the television medium, it might be a worthwhile investment. If an art group has the funds, these directories are invaluable for finding phone numbers and contacts.

Another possibility requires a charge of $29 a year. It is The National Talk Show Guest Registry, a database and clearinghouse for potential cable and broadcast guests on talk shows. You can e-mail a "written story" (your hundred-word rap) about yourself and your art and, if selected, the written entry will be included in the Registry. The Registry is looking for twists, angles, or hooks that can be highlighted in a story summary with special keywords for quick computer retrieval. Submit story ideas to The National Talk Show Guest Registry, Dept. W., P.O. Box 4355, Blue Jay, CA 92317; *www.talkshowregistry.com*.

Working with Television Stations

If the opportunity arises to appear on a television talk or entertainment show (cable or broadcast), you should be aware of several things. Television in the United States is notorious for trying to get something for nothing. When talent coordinators or producers call, their rap is to offer you free publicity in lieu of payment for services. You must weigh the value of the offer: Calculate the costs for transportation, accommodations, and any necessary meals. You should ask to be paid at least enough to cover expenses, and it is not out of line to ask to be paid for your time. Some shows do have smaller budgets than others, but if they do not have stimulating content (such as interesting artists as guests), it will be reflected in their ratings. Work with the talent coordinator to arrive at an acceptable arrangement. Once you have an agreement, ask for it in writing. The written agreement can act as a legal contract should any dispute arise.

If travel is part of the arrangement, it should be from door to door. If a limo or taxi is necessary to get to the airport or television studio, make sure it is part of the agreement. If the job requires a few days' stay, find out if a rental car will be available for your use. The food allowance might be over $50 a day per person. The hotel should also be part of the package, and it should be a good hotel. Negotiate the artist fee for your time; and remember, this fee is in addition to travel, food, hotel, and material expenses. Sometimes the fee is figured according to a film and video union scale and can be a few hundred dollars.

If the show is commissioning a work, find out if the station keeps the work or if it reverts to you. This will affect the fee, but $500–$1,000 a day is not uncommon. The entertainment field pays consultants a day rate, and the day may be very long, often more than eight hours. You work until the taping or live event is over. It is not a bad idea to agree to work a certain amount of time for one fee and, beyond that, to receive overtime. Use an analogy. Ask them how professional models are paid—by the hour, day, or overtime rates? Be careful about signing away copyrights to your slides or other work. A fee should be paid for any artwork used on television. (For more information, see the American Society of Media Photographers section in chapter 4.)

Remember that television news programs and CNN do not have a budget to pay an honorarium (but they might pay expenses), as they are not entertainment shows. Therefore, coordinate these events with an exhibition, since you will be there and could be interviewed either before or after the opening.

Getting Copies of Television Coverage

You will want to have copies of any television news clips or interviews, which can be used to create a video release. Usually, you should record the program "off-air" when it is first broadcast, since it is most likely the only time it will be shown. CNN will broadcast your piece a few times over a twenty-four hour period

before it is released to its sister cable station *CNN Headline News,* where it will run many times the next day.

If you believe that the television news will appear at your opening, it might be advisable to bring one or two blank tapes to the gallery along with a pre-paid snail-mail envelope. This can be given to the cameraperson or interviewer, who can make you a copy of the broadcast news spot. If they agree to tape it for you, you save money and trouble, and the quality is usually better than that of clips taped off the air.

If you cannot get the program taped, contact the station the next day and find out the procedure for receiving a copy. You will most likely have to send them a tape and pay a fee. Ask about policy procedures for obtaining a copy. Bacon's TV/Cable Directory make is easy to find this out.

If you are on the road, you might bring your own VCR. Connect the input from the hotel cable into your VCR and the output of the VCR into the television. This way, you can tape a show if necessary. If you are not in when it airs, a timer can be set.

There are also press clipping and electronic media monitoring services, such as Burelle and Gale's, that tape an enormous amount of material every day: approximately 450 local stations in 170 cities, besides the news and public affairs programs on ABC, CBS, NBC, FOX, PBS, and major cable networks. It is expensive to get video clips through these services, but written transcripts are reasonably priced.

Do your best to contact the station or have somebody tape the broadcast spot. It saves time and money. These news clips become precious items for your portfolio, so pay attention to them.

Creating Your Own Publicity Video

Should you use VHS, CD, or DVD? Currently, any of these systems are acceptable; however, VHS is in the process of being phased out. Therefore, I would recommend that the fine artist use CDs or DVDs to send out their footage.

How do you create a video? One way is to find out if there are any public access television stations in your area. Public access television must give you access if you request it. You may have to wait your turn, but you will be able to appear on television and get a videotape of the appearance.

The quality of the video you produce will depend, in part, on the facilities available at the station. Do some research. For example, the studio may be able to transfer slides to video or digital files to video. You can assemble different broadcast or cable clips if you have someone interview you, or you can adapt an article or release by showing images of your artwork and reading the text. If this is your first attempt, get a book from the library about making a video. Talk to the people who run your cable company about what they offer for public access taping. Watch the news and other public access shows to get a feel for different format and styles.

Since the price of a DVD player has dropped to as low as $50, and since the cost of a DVD-R disk is the same price as a videotape, it's advisable nowadays to send out a DVD-R disc when you are seeking an appearance on television. Most new computers have a DVD player included as standard equipment, and the DVD is of superb quality over a videotape.

If you can get access to a digital recorder, you can create a mini-documentary about your art. Have a professional shoot you working in your studio and at gallery installations. The DVD can be edited later. Remember, with the current equipment available one can create a DVD that is broadcast quality, especially if one can has access to computer editing software. It is now very simple to download your DVD raw footage, digitally edit it, and then output the material to a CD or DVD. Digital editing software like Final Cut Pro, Abode Premiere, and Avid Xpress DV 4.0. are expensive, and they have a learning curve, so this may be an opportunity to "cash in" on a favor from a digital video–savvy friend.

Phillips, the electronics manufacturer, introduced the DVDR 985 Progressive-Scan Recorder and Player. You can take your VCR and connect it to this machine, press "play," and the DVD 985 can record on DVD-RW or DVD-R discs. Videotapes (analog), will deteriorate over time, and repeated use eventually worsens their quality. DVD discs (digital) have a longer shelf life, and it is easy to make copies; however, the price of the DVD discs is more expensive, especially if you are sending them out as part of a press package. The Phillips machine gives you some more flexibility, allowing a variety of audio and video inputs and functions. Price varies, but at the time of this writing, it listed for $750. Single DVD-RW discs sell between $5 and $15 (depending on rebates), and DVD-R discs between $3 and $5 (depending on rebates).

Radio

More people listen to the radio than ever before, especially Internet radio. All radio stations are on the Internet; however, this does not mean that the opportunities it presents for artists have increased. What is popular today is a variety of music—classical, rock, country, blues, folk, religious offerings, and call-in talk shows. In New York City proper there are thirty-six different AM and FM radio stations, and this does not count the other four boroughs. Compare this to the eight different television stations and five daily newspapers. Most of these radio stations, however, feature standard programming.

The best opportunities for fine artists are on the radio stations on the FM bandwidth at the bottom of the dial. These are the eclectic, nonprofit, or college radio stations. Local college or nonprofit stations offer a better opportunity to be a guest or be interviewed than do the national shows. In certain cities, announcements on college or local radio stations can reach a significant number of people. It is definitely worthwhile to send releases to these stations whenever you are having an exhibition or event.

Make sure you contact your local public radio stations. In New York City, for example, WNYC-FM (202-513-2000) carries several National Public Radio programs, which sometimes feature artists on such shows as *All Things Considered* (*www.atc@npr.org*). WNYC also carries WHYY, Inc.'s *Fresh Air* (*www.freshair@whyy.org*), as well as other music, interview, news, and talk shows.

Currently, commercial talk radio and contemporary music seem to have proliferated on the AM bandwidth. However, this depends entirely on where you live. Most AM talk radio consists of syndicated shows that are bought by local affiliates or independents. However, FCC regulations require radio stations to offer community affairs programs. These are usually on Sunday mornings or late at night.

Radio, like television, culls its topics from AP, Internet news services, and print media. I have been on the radio as a result of my work appearing in either newspapers or magazines. However, if you are on one radio show, it is unlikely that that will lead to another radio show.

There are at least two issues with which artists have to be concerned: (1) radio is obviously not visually based; and (2) documentation of radio appearances has to be done on CDs. Today, radio stations use audio CDs exclusively, as they allow one to selectively screen the different selections for review.

Radio interviews are done both in person and via telephone. In terms of sound quality, it is always best to be at the radio station conducting an interview, because the microphone equipment is much superior to the telephone microphone receiver. If you must conduct the interview over the phone, it is better quality on a landline phone than a cell phone. In terms of convenience, it is obviously much easier to conduct a telephone interview.

In order to find out about the radio stations in a particular city, consult Internet databases or get the hardcopy *Gale Directory, Burelle's Media Directory,* or *Bacon's Radio Directory,* or the local phone book. If you are trying to get on the radio in the New York City region or in California, then consult *New York Publicity Outlets* or *Metro California Media.* They list the radio stations as well as the individual radio programs. Radio offers an immediate, live experience to listeners, through a car speaker or in the office or home. For this reason, radio is best suited to publicize something, that will immediately happen after the broadcast is heard. One has to schedule events to allow time for broadcasts occurring on the same day. Most likely, the fine artist will be interviewed on a nonprofit PBS-affiliate afternoon arts program for an event happening that evening.

Radio, unfortunately, is a nonpaying market.

Chapter 4.

The Artist as a Small-Business Entrepreneur: Setting Up a Home Office and Negotiating Sales

Repeatedly, I hear the complaint, "It's not that there isn't a market for my work; it's just that I don't have the time to find the market." Take the time to find your market.

Artists are small business entrepreneurs. Just like in business, the more successful you are, the more you will be known. In the United States, success equals money, which is unfortunate but true. In our society, it is becoming increasingly apparent that the fine artist and the small business owner need to adhere to a common set of principles if they are to be successful. This can be difficult for artists who savor the image of the artist-as-bohemian that was dominant from the turn of the last century through the 1960s. Today, a more appropriate model would be the painters of the Italian Renaissance (Michelangelo and Botticelli, for example) who ran their studios as entrepreneurs.

If artists are going to operate as a small business, they need to be familiar with the tools of marketing and publicity. They need to own or have access to certain equipment in order to start and continue the business. It is not so important that you go out and buy all the equipment tomorrow, but if you are seriously planning on making a career as an artist, you have to know what is necessary to operate a business.

I have already mentioned the importance of having written material, good-quality digital images, and slides, but that is just the first step in being a small business entrepreneur. In this chapter, we will discuss tips and techniques for running

your art business efficiently, as well as ways of increasing profit by working with, or functioning as, a press agency.

For most artists, the key to running a smooth business is knowing how to disseminate a "product" efficiently in order to increase sales and create opportunities. If you have older equipment and want to upgrade, the cost can be approximately $6,000 for a fully loaded computer, specific software, all-in-one printer/copier/scanner, digital camera, slide scanner, and so forth.

Fine artists now need to be able to make CDs of their own photographic images and have the ability to transfer analog or digital video to CDs. Right now, we are in a transitional period between digital and conventional means of reproduction. Both methods are currently acceptable; however, that will soon change as the media slowly acquires the standard use of digital files. Therefore, both digital and conventional means of reproduction will be discussed; but in a few short years, traditional photography and analog video will be obsolete.

Computers and Digital Accessories

It is now essential for artists to own a PC or Mac computer. It is fifty-fifty as to which computer to buy, as prices are very competitive. Until recently, Mac computers were unsurpassed in terms of graphic design, but the PC has leveled the graphic playing field. It is still much easier to buy hardware and software for a PC than for a Mac. And concerning Mac repairs, there is more downtime and expense; you either have to return it to Mac or contact the company's nationwide on-site home and office network at 877-865-6813 or *www.macsolutionexperts.com.*

When I first wrote this book, the price of a computer with 32 MB RAM and a 1 GB hard drive was $3,000. Now that amount of money buys maximum RAM at 1 GB, the latest Pentium Processor, 120 GB hard drive (or more), 128 MB video card, a CD burner, and a DVD player, plus software, a flatbed scanner, a monitor, a keyboard, and a mouse. I would also recommend an all-in-one home office machine such as the Lexmark X83 for $169 (Staples), which can be used as a flatbed scanner, a color and black-and-white photocopier, and computer printer. Plus you can create special copy jobs with the operator panel menus of the printer without using a computer. These machines can enlarge and reduce by individual increments; they include a photo mode (with a good halftone configuration) and can accept two-sided copies.

A battery backup is a glorified surge protector. An APC BK 350 for $90 (at Staples) protects equipment and data from brownouts, spikes, surges, and lightning. It allows you to work through brief power outages and allows you to save work before shutting down the system in the event of an extended power outage. Moreover, it has up to a $100,000 lifetime equipment protection policy.

I used to photocopy images of my work onto 6" × 9" snail-mail envelopes. Now I use a computer to print images directly onto the envelope. Almost any size envelope will go through the computer printer. This is a very impressive way to

introduce people to your work. It gets attention; people notice your snail-mail, which is important when sending out material cold.

As mentioned before, if you are fortunate enough to be on television news or entertainment shows, you will need to tape these shows and later make CDs or videotape copies. To be able to transfer videotape to a digital file, you will need additional hardware and software. The hardware requires a sufficient amount of memory—120 MB is more than adequate.

Digital Cameras

Currently, the cost of a professional digital camera with enough memory storage and interchangeable lenses begins at $2,000 and can reach $7,000. What I have found out to be best is to have access to a digital camera that has at least two-megapixels; the cost is approximately $200. This digital camera is for reproduction, a Web site, and e-mailing only, since you want to be able to send a jpeg file quickly, usually at 300 dpi. The other file formats like tiff are much larger and take forever to download and upload.

Scanners

For print reproduction of images, the best option is to buy a slide scanner. I own a Polaroid Sprint Scan 4000. It has the capability to scan at 4,000 dpi; the retail cost is $1,200 (I was able to buy it on sale for $750). It has software that allows the artist to digitally color correct (vary the color temperature as from blue to orange), vary the contrast, and adjust the hue and saturation.

The minimum hardware requirements for a slide scanner are 128 MB RAM, 40 MB available hard disk space, and a video card of at least 16-bit. Your operating system must be Windows 95, 98, or better, or Macintosh OS 7.5 or better. Since it costs $5 to transfer an image to a CD (plus $10 for the CD) at a commercial photo lab, you would do well to purchase a scanner if you have more than 240 images.

Digital Imaging Software

Once you've captured your image digitally, save it as a digital file, where other software programs such as Paint Shop Pro, Adobe Photoshop 7.0, or Corel PhotoPaint 11 can further manipulate them. Remember that it is always better to have the highest dpi in the original scan, reducing it only in copied form. If the dpi is not there, no amount of computer manipulation can substitute for better quality.

There are a variety of ways to increase digital storage space, whether it is a Zip disk, additional hard drives, or digital wallets; you have to figure out what options are best for your system. If you still need to make videotape copies you need to have access to two VHS video machines. The duplicates are for publicity

material, some grant applications, or other uses where a video makes more sense than sending out digital images or slides.

Telephones

Since telecommunications is one of the ways you will be interacting with potential clients (remember the one-hundred-word rap), it is necessary to have a landline phone and a cell phone.

Cell phone companies offer such billing options as Internet service plans, e-mail, voice-mail, call waiting, caller ID, three-way calling, paging, and so forth. Therefore, it is impossible to give a price comparison; however, having a cell phone is convenient, and the cost is comparable to the landline phone services. I personally use Verizon Wireless. The $75 "America's Choice" national calling plan has no roaming charges and allows for nine hundred daytime and four thousand nighttime minutes after 9:00 P.M. and on weekends.

Verizon (*www.verizonwireless.com*) offers a Mobile Office service option, which is useful when you are in a Verizon Wireless digital service area. This allows you to connect the cell phone to a digital network, offering a secure method of transmitting either voice or data. A connectivity kit, which costs between $70 and $80, includes software for a laptop, CPU (Central Processing Unit), or personal digital assistant (PDA) such as a palm pilot, and the connecting cord. On the top left-hand side of your cell phone display, you must have the hourglass symbol displaying at least three bars for the best signal strength. This allows you to continue to do business (although possibly more slowly) while on the road.

Postal Services

Snail mail is vital for artistic success. There are several ways to correspond: the U.S. Postal Service, UPS, FedEx, Airborne Express, plus others, which provide a variety of services. Everybody uses the U.S. Post Office on a daily basis. In most cases, this massive operation is the least expensive of all the providers. Although they do lose or damage a small percentage of what is snail-mailed, they are the best choice for most of your printed communication.

Since artists usually send out CDs, slides, printed matter, DVDs, and catalogs, (and sometimes original work), the cost can become enormous over time. It helps to know postal regulations in order to save money. Insurance and delivery confirmation are also an essential consideration. The post office has four classes of snail-mail and a variety of rates, which vary depending on distance. This is especially true for Media Mail or Library Mail. Let's consider the following example: You see a listing in an art journal, to which you respond by sending out a CD or slides, résumé, and a statement with an SASE (self-addressed stamped envelope). What are your choices? If the deadline is two weeks away, you can safely assume that if you send the package Media Mail or Library Mail, it will be delivered on

time. If you are running close to the deadline, then first class, Priority, or Express Mail are available options. First class is $0.37 for the first ounce and $0.23 for each additional ounce up to twelve ounces. Between thirteen ounces and a pound, the material becomes Priority Mail, at a two-day rate of $3.85.

An 8-oz. package containing a set of twenty slides or a CD in the plastic sleeve with a letter, résumé, statement, reviews, and two snail-mail envelopes (possibly padded) will travel first class at $1.98. The return postage will most likely be $1.75. The total cost is $3.73 minimum. Consider this over time, and it adds up fast. Moreover, this is without insurance or return receipt; you should not need insurance if sending out CDs or duplicate slides.

Media Mail

If you can get your material organized two weeks before the deadline, then you benefit from the cheapest postal rates. If you have videotape, CD, or a catalog of at least eight printed pages as part of your package with slides and printed matter, you can probably send your package at the Media Mail rate. This costs $1.42 up to 1 lb. per piece within the United States. You have to allow a window of time for the package to be received. Media Mail is sent by air, but it's processing is slower; first-class mail is given priority.

I'd add enough photocopies, announcement cards, and other materials to make it weigh more than five ounces. The cost for first-class mail at five ounces is $1.29. Anything over this and up to one-pound that can be considered at the Media Mail rate should go that way, as long as you give yourself enough time for the slower delivery.

Most art spaces that offer grants have deadlines and require entries to be postmarked by a certain date. If you can get it organized, snail-mail it early. Even if it is delayed, the postmark stamp qualifies you for the deadline. I would recommend getting these packages hand stamped rather than stamped by the postal meter, because hand-stamped mail must be sent out that day. I wouldn't recommend sending something fourth class on the deadline date because the art spaces might only accept mail for that listing up to a certain date and, at fourth-class rates, mail going any distance might take two weeks or more.

Library Rate

There is another rate that you should be aware of: the library rate, which is used for material to be returned by a school, college, public library, or museum, but not alternative spaces. The post office regulations allow slides, CDs, audiotapes, videotapes, catalogs, and books at this rate, which is $1.35 for up to 1 lb. You cannot send materials to these organizations at this rate, since you're not considered a library. However, SASEs included with material sent to these institutions would qualify. This is a $0.12 per piece savings (it adds up!) and is the same cost for mate-

rial sent back to you from anywhere in the United States. If you are unsure, call the organization and ask if they use this rate for return of artists' materials.

It is important to note that Media Mail (audio- and videotapes and catalogs) and library rates are subject to postal inspection regardless of how the package is sealed. If the postal inspector decides to inspect your package and finds its contents do not meet the rate regulations, then you can be charged at another rate, either third or first class (usually third).

The U.S. Postal Service employees use a Domestic Mail Manual (DMM) to determine rates. If you have any questions, visit the local post office or go to *www.usps.com*; every two weeks, they receive new updates on postal regulations. Things can change.

Insuring Snail Mail

When you have to snail-mail something of value (for example, original slides or artwork), the postal service has three ways to mail these items: insured, registered, or Express Mail. Insured mail provides reimbursement for up to $600 and is available for Media Mail, as well as for first class and Priority. You need to prove value by receipt, invoice, bill, or some other evidence of value. In the case of original artwork, an insurance floater by a gallery or museum should be used. Your own insurance policy covering artwork might work, but a third party that has exhibited and insured your work is the best documentation. Regarding lost or damaged slides, normally, the cost of replacement film and processing will be allowed and not the value of the slides. Just because you pay for insurance does not mean the post office will pay the insurance value. Proof is everything.

Registered mail is the most secure means of delivering valuables; up to $25,000 postal insurance is available, and, for an additional fee of $1.75, a return receipt may be obtained.

The basic price for Express Mail varies from $13.65 to $17.85. This allows for overnight delivery with insurance coverage from $500 through $50,000.

General Delivery

General Delivery is intended primarily for use at post offices without carrier delivery service and at noncity post offices that service transients and customers not permanently located. The Postal Service will hold the snail mail no more than thirty days unless otherwise requested or determined by the local postmaster, who may make exceptions. You must present an I.D. to receive the mail.

If you were to have an exhibit in, for example, Tampa, Florida, and would not return for over a month, and were expecting checks or other important snail mail, then the snail mail could be sent to a specific Tampa post office as long as the post office address, your name, and the words "general delivery" are marked clearly on the envelope. Picking up the mail is easy, and it can even be forwarded if you fill

out the right form. This is especially good for people who are on the road doing festivals, craft shows, workshops, lectures, or a book circuit. As long as you know the dates and places ahead of time, your snail mail can follow you at no additional fee.

If you have snail mail delivered to your home or apartment and plan to be away, the post office will hold it for only thirty days. After that, you have to make arrangements to have the mail collected. Another option is to obtain a post office box for six months or one year and either have your snail mail forwarded to the box or change your address. By paying for the box for six months (this is the minimum), the mail will be held for those six months. Explain your situation to the local postmaster, who can suggest the best solution to accommodate your "temporary" lifestyle.

Be aware that getting a post office box just to have snail mail forwarded is not possible, as a number and street address are necessary. The post office cannot give out a street address for forwarding without a court order.

A note about nonprofit third-class rates (bulk mail): Congress subsidizes this service. They have to pass a measure every year to fund this rate. If you ever exhibit at a nonprofit gallery, library, or museum, the institution can mail out your postcard or other material via bulk rates at the $0.12 basic rate. This is a bargain. However, there are a multitude of restrictions. The mailing cannot be a co-op mailing by the organization and a person. Only the nonprofit organization's own material is allowed, and it must be sent to over two hundred addresses for the organization to use the bulk rate.

Allow six weeks for delivery of out-of-state bulk mailings. This snail mail has the lowest priority, and nonforwarded or expired addresses can cause it to be discarded. Third-class mail sent within state should only take up to two weeks. However, talk to the local postmaster to find out how long the bulk mail is held before delivery.

Foreign Mailings

The time will come when it will be necessary for you to mail out packages to foreign addresses. There are two basic options, either air or surface (by boat), and various rates apply. Airmail takes about one week, and surface delivery takes six weeks to three months. I'd recommend sending via air. I've sent things back from Europe by surface many times, and they have to be securely packaged, or they can get damaged. Surface mail is not considered a priority, and trying to track down lost or damaged material from a foreign country is a lost cause.

If you send out slides or CDs to foreign magazines, it is best to send them via letter-post. Rates for airmail are $0.80 for one-ounce and $0.80 for each additional ounce. The cost of a set of slides or CD and photocopies (four ounces), ranges from $3.20 to $3.40, depending on the county.

Another method is Global Priority Mail, which has two fee tiers. Both use

a flat rate envelope, the usual fee is $5 for the 6" × 10" size and the weight limit is 4 lbs. The large envelope is 9½" × 12", with the same weight limit, and it costs $9 and takes three to four days to deliver.

When sending international mail, a customs declaration is necessary for anything over 16 oz. This is a customs green label (form 2976), which is attached to the package and indicates the contents. For duplicate slides and most of the other materials you will be sending, simply write "no commercial value," or mark it "sample merchandise" with no value. This way, if customs officials open the package, the recipient will not be charged a customs duty. The package can be delayed up to three weeks if customs decides to open it. (When you are mailing slides or CDs to foreign magazines on speculation, the post office does not need to be told that you might be receiving a photographer's fee. The magazine can still reject the material.)

Return postage for international mailings presents a problem. International reply coupons, which cost $1.75, must be purchased at the post office. They have to be included in your package for return postage. One coupon is exchangeable in any other member country for stamps representing the minimum postage of an unregistered letter. Each country sets their own rates, and it is in 1 oz. increments; therefore, it is impossible to know how many coupons to include with your package. I just send out the slides or CDs without return postage and hope that the magazine will return them. If unsure, snail-mail, e-mail, call, or fax them and ask what their policy is about returning foreign mailings.

Sometimes material can be sent through correspondents for foreign publications who are working in the United States. If they accept the materials, they take on the costs of the postage both ways.

Foreign Checks

Sometimes when foreign checks are received in the United States the bank has to send them out for collection. This can take up to six weeks to process and can result in two bank fees—the primary bank (yours) and the secondary bank, which your bank sends the checks to. This can result in $20–$35 in fees, per transaction, and is an especially annoying process for small sales.

When you are filing income tax, all this money has to be reported. However, the whole trip to Europe can be a business expense if you are self-employed and can prove it. If money is made on your trip, it supports your filing status as a self-employed artist.

Other Services and Concerns

UPS charges less than the post office for sending larger items. This is because they charge by zone; plus, they give $100 free insurance as part of the price. When sending out original artwork, whether it is a painting, drawing, or

MS. INA GUTTER

CURATOR

WHATSA MATTA U

22 CATCH STREET

RANDOM, PA 18050

Business letter with image. Photo by Julius Vitali.

photograph, never send it framed with glass; use Plexiglas. The glass can shatter, and when it does, it is likely to tear or ruin the art. UPS will usually ask you what you are sending when you fill out their forms.

Paintings need cardboard telescoping mirror boxes, found at moving companies. They collapse when fitted over the painting. It is also advisable to cut two pieces of cardboard to the exact dimensions of the painting and to tape these two pieces together around the painting. This helps prevent anything sharp from piercing through it. If you pack it securely in this way and use UPS, put "Fragile" stickers on the package and have UPS date the stickers. I have seen artwork delivered to galleries being thrown onto the ground, even with fragile stickers on them. A UPS worker told me he doesn't know if the stickers actually refer to the contents of the boxes or if they refer to an earlier delivery's contents. If you date the "Fragile" stickers, it might help reduce damage.

Most magazines believe that FedEx is the best way to deliver material with a minimum of risk. FedEx is expensive, but many magazines have FedEx accounts and allow artists, photographers, and writers to send material to them without paying a fee. You will need to have the publication's FedEx account number to send your material. Do not be shy about asking for it; this is the standard for the industry. Even if you solicit them through a phone call to the photo editor, ask them if you can send material via their FedEx account. FedEx will pick-up from, and deliver to, your home or apartment.

A note about damaged material: If artwork is damaged in transit, you will need to submit a museum/gallery insurance floater to prove the value of the art and decide what percentage of the damage can be fixed and at what price. If you fix it, you can charge $10 an hour and up for so many hours of repair. Of course, the insurance value has to be provable for you to receive insurance money. If you insure art through UPS for a large amount, they will want to see what is in the box and how it is packaged. Naturally, they do not want to pay claims, so get the name of the person who approved the amount of insurance and packaging. You need to cre-

ate a paper trail when proving the value of art. Generally, it is necessary to get an insurance floater from a museum or nonprofit organization before you send out the artwork, including transportation insurance from your studio to the museum and back. The art organization is considered reputable and its insurance floater will prove the value of the work. Talk to the museum or gallery to find out the best way to send your artwork. Ask for and keep on file all insurance floaters from the spaces that offer them. They provide the proof that the value of artwork has been appraised by a reputable third party.

Photo Agencies, Press Agencies, and Doing the Job Yourself

The main business of photography agencies is to sell images, features, and short features to magazines. They will also sell images to whoever will buy them, such as book publishers, corporations (for annual reports), ad agencies, and poster and postcard companies. They exclusively use digital files. Having these photo agencies sell your images is not as difficult as it might appear, especially if your artwork is superbly photographed.

I have worked for four photo agencies over the years: Black Star, Images Press, SIPA Press, and Liaison. Although the bulk of their sales are pictures of famous people, magazines also need features, as well as fillers (a photo with a caption). New, "interesting" art is always wanted, especially if it is a new technique, colorful, or has a good composition or other notable feature. This does not mean that landscape painting does not have a market. If you believe your work is exceptional, then that work can be sent out. Photography agencies can transfer your original slides to digital files. Then the digital files are sent directly to the magazines or to a sub-agent. These are photography agents in other countries who make the actual sale and take a percentage.

Usually between twenty and thirty sets of images with text are distributed worldwide by the agency. The countries that receive this material number about twenty-five. They include the United States, England, France, Spain, Italy, Germany, Holland, Austria, Belgium, Denmark, Norway, Sweden, Finland, Turkey, Hungary, Greece, South Africa, Australia, Japan, Canada, Brazil, Chile, Argentina, Portugal, and Mexico. Generally, third-world countries such as India, Pakistan, or Haiti pay so little that the agencies do not consider them.

However, if you are planning to act as your own agency—and that is exactly what I suggest you do—some of these third world countries are perfect for getting yourself published. But remember, pay is small or nonexistent and sometimes the quality of the paper is no better than newsprint.

Since photo agencies take on the cost of transferring images and making duplicate CDs and doing the mailings and billings, their share is 50–66 percent of the sale of your images, a hefty percentage by any standard. It's obviously more profitable if you can sell the material yourself and avoid the agencies. I try to sell

the images first myself, and if I have no luck, then I go through an agency as a last resort. (For a list of photo agencies, see the NYNEX *Business to Business Directory*, which has over seventy entries, or do an Internet search.)

I'll give an example: A photo with a short article is sent to Holland. The photo agency has to give the material to a sub-agent in Holland, who will translate the text and captions from English, French, or German (depending on which language the agency provided to them) to Dutch. If you work with a French agency like SIPA or Gamma, the text gets translated into French, then to Dutch. The Dutch agent then places the material with a magazine and, if a sale is made, gets copies or tear sheets for the main agency and takes 33 percent of the sale for providing this service. The agent then exchanges the currency from Dutch guilders to either French francs or U.S. dollars. The main agency receives the remaining 67 percent and splits it with the photographer. On a $500 sale you'd receive $166.

If the main agency can sell the material directly to either a U.S., French, German, or Italian publication, then you would split the sale fifty-fifty. Some photographers generate a significant number of images, and they are very happy with this arrangement, but if you have a feature article about your artwork, technique, and aesthetic, it might be better to try to sell it yourself and keep the proceeds.

Photo agencies have a standard fee scale or tier system for receiving payments from magazines for various services such as research, holding, and kill fees. When I was working for agencies, a magazine would call looking for information about a particular topic or personality. The agencies would charge a research fee of $50 and up to put together these images, which would then be sent out to whoever called. If the magazines did not use the material and returned it within a week or less, the $50 fee was the only fee to be paid. If they decided to use the material, then the $50 fee was waived because the amount of the scaled fee for the use of the photograph would be much greater. This fee was set up to keep away frivolous requests.

If a magazine decides to hold onto the material for longer than a few days or a week, then its offices could be charged with a holding fee (the material will not be available to others in the same market—there is only one set of slides in each country). The holding fee varies depending on the amount of material being held. The holding fee is waived if the material is used.

If a magazine indicates that they will use the material and then decides not to use it, they have to pay a kill fee. This is usually 50 percent of the price for publication, and, depending on the agreement, the research or holding fee may or may not apply. This depends on the total cost of the image or images that would have been paid if published.

Sometimes, the photographer does not share in these fees, as the images are not sold, only held, which is a touchy, gray area. The policy depends on the agency. If you act as an agent for your work then you can try to share in these fees, especially the kill fees. The presence of fees will encourage the return of materials that might otherwise be lost. Include a schedule of fees with all requested material,

as the agencies do. If receiving publicity is more important than a sale, it will create a better rapport if you do not include the schedule of fees.

By functioning as your own photo agency, you can also avoid some of the typical problems encountered when working with photo agencies, such as finding material published in a magazine, but not listed on the sales report. Often, the agency is unaware of the use! The agencies usually do a poor job of getting you tear sheets of the published pages, leaving you in the position of tracking them down. The sales report tells you the magazine, page, and issue; however, you still have to find the magazines' addresses and then write to them directly for copies.

Advance Information

One benefit of becoming your own photo or press agency is getting on e-mailing or snail-mailing lists of museums and other important institutions. Press information will include listings of upcoming shows (sometimes far in advance) and other information that might be helpful to your career. However, this practice raises an ethical question; are you actually planning to do stories or do you just want the press information? If all artists also become press agencies, the rules will have to be changed, as accountability becomes a factor; but, as it stands right now, this is not the case. The museums give away releases for free publicity; in turn, the writers take it upon themselves to cover the museums. To avoid potential problems, it might be wise to team up with a group of artists and writers to receive the press materials.

The American Society of Media Photographers

In preparation for starting your own photo agency, you should know about The American Society of Media Photographers (ASMP). They are the closest thing to a photographers' union in the United States, and they have many publications that can help you out. These books can be found in the library if you do not want to purchase them. The books offer a schedule of fee guidelines, which explains what photographers are paid for usage, depending on the circulation of the magazine and the image size used.

ASMP books that would be of interest to artist/photographers are *The Sixth Edition of the ASMP Professional Practices in Photography, 6th Edition*, and *Right and Value: In Traditional and Electronic Media*. It is entirely possible that your work could be considered for illustrative purposes and/or commissioned for a magazine illustration. In this case, your fee would be greater than for stock photography. You can ask the photography editor or art director what they pay, and you should always mention ASMP rates, as it shows you are aware of the guidelines. Always ask for something in writing if a magazine is interested in using your work, because if disputes arise around a kill fee or other unforeseen problem, having it in writing provides a legal means for settlement.

Pricing is an art in itself, and everybody needs guidance since negotiation is the norm. Famous photographers can ask for more money based on name recognition and reputation, while others have to display ASMP rates knowledge to have equal footing. ASMP conducts pricing surveys and publishes their results in a guide for members only. This guide serves as an excellent way to check your pricing in relation to industry-accepted prices. Write to ASMP, 150 North Second Street, Philadelphia, PA 19106; 215-451-2767; *www.asmp.org.*

A quick guideline: Covers pay the most, followed by two-page spreads, one-page spreads, and percentages of a page. A feature article with many photographs might require a special deal, or publishers may pay a flat fee per page or image and use whatever they like. Remember to grant only one-time rights, in order to be able to resell the images.

Acting Like a Photo Agency

Setting up your own agency, or at least acting like one, does not require you to do much. If you just use your own name, you do not have to set up a separate business account. Begin by getting a rubber stamp made. It can say, "Photo by [your name]," or your name followed by the copyright symbol, the year, and the words, "photograph not to be reproduced without written permission."

The copyright symbol reminds people that they may not use your images without your permission. In fact, photographic labs will not duplicate slides with a copyright symbol unless a written notice is included that says, "[your name], who is the photographer, gives permission to duplicate his/her copyrighted material."

Stationery, both envelopes and letterhead, are a must. This is a minor expense to have printed or photocopied. I personally favor having an image of my work on both the envelope and stationery; it allows for instant visual identification.

Laurence Gartel

In a 250-page monograph *GARTEL: Arte and Tecnologia,* published in 1998 by Edizioni Gabriele Mazzotta (Italy), the noted art critic Pierre Restany said, "Laurence Gartel is surfing on the wave of electronic communication through the poetic impulse of his multimedia language. Photography, graffiti, digital paint blend on his computer as in the weaving loom of an everlasting tapestry: a texture of fragmented visual elements in continuous progress whose varied serial lines form the consecutive photograms of a mental film in full virtual surfacing."

Although Gartel's achievements could be profiled in numerous chapters, we will concentrate on his various corporate commissions. In 1986, Absolut Vodka began its commissioned-art magazine ads. Gartel then snail-mailed a publicity package to

Laurence Gartel at the Gibson factory with one of his limited-edition digital art images on a Gibson guitar body.

the TBWA ad agency, and their response was, "We do not solicit outside ideas." As was Gartel's practice, he pursued select companies (and galleries and museums as well) for years, sending out new material as it became available, while refining his "pitch" techniques.

As a matter of courtesy, Gartel sends out packages to middle management to begin the quest for the right person, and sometimes this method proves to be successful. If he does not succeed, he will wait a year, and then he writes to the president or vice-president of the company. It is not part of his vocabulary to take no for an answer. As Gartel says, "I go client-direct." Numerous agents, gallery representatives, and publicists whom he has employed over the years do not have his long-term persistence and consequently do not achieve the same success with their efforts as he does when sending out material bearing his individual imprint. Now, after thirty years in the art field, he does most

of the solicitation himself (except for certain longstanding gallery affiliations), and continues to achieve a phenomenal success rate.

His client-direct approach has resulted in numerous triumphs, including his most famous, Absolut Gartel. Gartel's full-page ads, which began in 1990 for Absolut (the first digital art ad) are still being published (see below). Three other client-direct solicitations are his teacup, shot glass, beer stein, tea tin, and vase for Ritzenhoff giftware; two plates and a teacup for Sakura dinnerware; and two original pen designs for Acme Writing Tools. Additionally, he was selected in a highly competitive national competition for a permanent commissioned installation of nineteen photo light boxes at the Miami International Airport, Concourse F. And his latest coup is being approved for six different limited-edition digital art images on a Gibson guitar body. How does he achieve this success? "He gives very good letter."

Success is often time-consuming and laborious, as Acme Pen Company decided on two designs from thirty submitted, and Ritzenhoff giftware chose six designs from over thirty submitted. Other commissions have included some of the Fortune 500 companies and sports and entertainment notables such as Walt Disney, Phillip Morris, Mobil Oil, IBM, Phoenix Suns Basketball Team, St. Louis Rams Football Team, and the Red Hot Chili Peppers.

At the time of publication, Mr. Gartel was commissioned by the National Basketball Association (NBA) to create official artwork for the 2003 Eastern and Western Conference and championship finals. These were high-quality photographic prints done in his raconteur digital collage technique. A single image is akin to witnessing an action-packed full-length movie. These posters are available through *www.nba.com*, as well as from the Gartel studio.

As part of an overall strategy, the media division of Gartel Enterprises now sprung into action. In July 2003, Mr. Gartel flew to San Antonio, TX, and at the press conference presented the mayor, the NBA commissioner, and the owner of the San Antonio Spurs with the championship artwork. Then, Clear Channel Radio interviewed him several times during that week and allotted two hundred airtime minutes. In addition, display ads announcing the availability of the artwork ran in the San Antonio newspaper and were co-sponsored by the NBA. Another co-plan is to specifically target certain businesses within the San Antonio area for display and sale of the NBA posters.

Often, he spends 90 percent of his time completely

devoted to the business of art; "It is a necessary process to remain a successful artist," he says. Depending on the circumstances, some weeks are more devoted to the making of art, while other weeks concentrate on marketing and publicity. If he receives a call from the media or a company, usually he drops everything to cater to them. If he does not do so, due to their time constraints, they will find another artist for that project. Although this might throw off a daily schedule, his thirty years in the field have taught him not to ignore the phrase, "I'll call you."

A pioneer of digital art for over twenty-five years, Gartel has had more than fifty solo and more than one hundred group shows in such venues as the Museum of Modern Art, Princeton Art Museum, Norton Museum of Art, Joan Whitney Payson Museum of Art, Long Beach Museum of Art, Musée Francais de Photographie (France), and CUANDO (Cultural Understanding Neighborhood Development Organization) (New York City); his work is also included in such collections as the Bibliotheque Nationale (France), Museum of Modern Art, Lending Collection, Absolut Museum, and Smithsonian Institution Museum.

The Absolut Gartel ad commissioned for Absolut Vodka has adorned the back covers of such prestigious publications as *Art-in-America, Artforum, Art and Auction, Sotheby's Preview, Scientific American, WIRED, Technology Review, ArtByte,* and *New York Magazine.* Additional articles and reviews in more than five hundred publications include the *New York Times, School Arts, Popular Photography, Studio Photography, Zoom Magazine* (American and French Editions), *British Journal of Photography* (UK), *Actuel* (Spain), *Domus* (Italy), *Scope* (South Africa), and *City Magazine* (France). In 1989, Gibbs Smith (Layton, Utah), published a full-length monograph (sixty-four pages), *Laurence Gartel: A Cybernetic Romance.*

In-kind grants include donations of software and hardware products. In return, Gartel endorses these products through published articles, seminars, and lecture/workshops. These companies are: IBM, Canon USA, Adobe Systems, Iomega, Roland, La Cie, Epson America, Metacreations, ArcSoft, Hasselblad, and Olympus America.

Gartel has had a consistent following in Italy (numerous solo exhibits, reviews, and articles) for many years and he was honored in 2001 in *La Storia dell'Arte (The Story of Art),* Editions Giunti (Italy), to be profiled as the only computer artist and photographer besides Man Ray. The authors, Maria Carla Prette and Alfonso De Giorgis, have profiled every major art movement

since Michelangelo and included Gartel's piece *The Critics*, 1997. He receives e-mail correspondences at *gartel@aol.com*; *www.dam.org/gartel*.

Making money off your art gives you free time to have either a part-time job or no other job at all. This freedom allows the fine artist to spend as much time as is needed to not only create, but also successfully market, publicize, and sell that art.

How to Professionally Exhibit
Your Art in a Variety of Venues

It is believed that the first formal exhibitions were held in European taverns during the seventeenth century when art was purely representational and photography had not yet been invented. Since those times, an evolutionary process has taken place, creating a multitude of exhibition opportunities for both the sale and display of artwork. The usual progression of a fine artist's career is to initially show in a local restaurant, cafe, open studio, library, community center, or bank, then to organize group or solo shows in unoccupied commercial space, free or very low-rent co-ops, alternative spaces, or commercial galleries. Next, the works appear in colleges and regional museums, and, finally, they are exhibited in significant commercial galleries and major museums.

What factors fuel this linear progression? Media hype, reviews, and a place in important collections all contribute to the signature value of art. The number of artists recognized by blind luck is extremely small, but recognition does happen through word of mouth. If this is your modus operandi, start conversing with as many people as possible (see chapter 3, for example, for information on getting on a talk show), since oral communication will be your method of achieving a reputation. There is no single formula for moving your work through these steps; the various routes to getting your work exhibited will be described in this chapter, along with examples of artists who have successfully used them.

Fashion Moda

Fashion Moda was a local alternative art gallery, located at Third Avenue and 149th Street in a South Bronx, New York, storefront. In 1979, Fashion Moda began presenting exhibitions involving artists and other professional people, community residents, and children. Due to a lack of funding, Fashion Moda closed in 1993. Defining itself as a Museum of Science, Art Invention, Technology, and Fantasy, Fashion Moda helped to redefine the function of art. In addition, it was a major force in graffiti art and the outsider art movement and deeply influenced the post-eighties contemporary art world. The artists included Keith Haring, David Wojnarowicz, Jenny Holzer, Mark Kostabi, Kenny Scharf, Crash, Futura 2000, Richard Hambleton, Koor, Daze, Spank, Lady Pink, John Fekner, Stefan Eins, Marianne Edwards, Candace Hill-Montgomery, John Ahearn, Joe Lewis, William Scott, Jane Dickson, and myself, among others.

The South Bronx, with its abandoned buildings and outdoor graffiti art, was not known for its cultural offerings, but it was a perfect forum for this independent artist-run gallery. Stefan Eins, Fashion Moda's director/founder (and an artist himself), was successful in publicizing graffiti and outsider art. Attracting the attention of the New York art scene as well as domestic and international magazines and newspapers, he brought the Fashion Moda artists to the attention of the curators of the New Museum of Contemporary Art. The New Museum invited three New York–based independent artist organizations—Fashion Moda, Taller Boricua, and Collaborative Projects—to select, organize, and install a series of installations and exhibitions at the New Museum. Fashion Moda presented the first show, *Events* in 1981. Because the exhibit was in a museum in a New York City location, it received noteworthy publicity (a Sunday *New York Times* feature article). After the exhibition, many of these artists began to exhibit in commercial galleries in New York's East Village and Soho. This culminated with two exhibitions: *Post-Graffiti Artists* at the Janis Gallery located on West 57th Street, in 1983; and *Committed to Print*, a 1988 exhibition at the Museum of Modern Art, in New York, featuring Keith Haring, John Fekner, Jane Dickson, Robert Longo, and others from the group. In 1982, Fashion Moda was represented at *Documenta 7*, Germany, where Keith Haring created his first tee-shirt design for that show.

Like other art movements (notably pop art), its history followed a familiar course, a major innovator—Keith Haring—died,

and the movement splintered off into different directions. Lucy Lippard, an art critic for *Seven Days*, a New York City weekly publication, said in April 1980, "The liveliest events in the art world always happen when artists take things into their own hands."

Since Fashion Moda was such a creative center where famous artists first displayed their works, New York University's Fales Library Special Collection purchased the Fashion Moda archive from Stefan Eins in 1999. This collection preserves the scope of the various postmodern art movements originating through the gallery (visit *www.nyu.edu/library/bobst/research/ fales/coll_mss/fashionmoda.html*).

Many artists, after exhibiting in their chosen venues, make the financial leap to commercial success through galleries or other museums. For most visual artists, a museum such as the New Museum of Contemporary Art (583 Broadway, New York, NY 10012; 212-219-1222, *www.newmuseum.org*), or the Museum of New Art (249 Washington Blvd., Detroit, MI 48226; 313-961-2845; e-mail, *detroitmona@aol.com*; *www.detroitmona.com*) offers the best opportunity to graduate from emerging to established artist. Call or write for review guidelines.

However, before inundating the New Museum of Contemporary Art or MONA with images, you should have significant accomplishments under your belt. Try to curate artist-organized shows (this will be discussed at length later in this chapter). Start with a show in your studio or coordinate a day of open artists' studios in your area. When a regional museum has an open competition, enter it. These museums, like the Allentown Art Museum in Allentown, Pennsylvania, often have a community gallery. They usually give regional artists the opportunity to exhibit in solo and four-person shows during the summer months. Sometimes, they print a catalog or brochure for these artists and will purchase a work for their own collection. The recognition from a regional museum will generate publicity and possible local collectors (usually met at the opening reception).

Start with the National Association of Artists' Organizations

The National Association of Artists' Organizations (NAAO), which began in 1982, has relocated and restructured to Space One Eleven, 2409 Second Avenue North, Birmingham, AL 35203 (e-mail, *info@naao.net*; *www.naao.net*). Its mission is an artist-centered, membership-driven organization that fosters communication and interaction among artists and artists' organizations and communities at the local, regional, and national levels. It promotes advocacy for artist-driven organizations nationwide, as well as serving as a valuable network connecting artists and artists' organizations. They produce a directory of all member organizations, which primarily fosters the development of emerging artists. Artists' dues are $35 a year,

and this includes free copies of monthly NAAO e-newsletters and NAAO publications, the NAAO Directory and Field Guides, substantial discounts for NAAO conferences and meeting fees, plus invitations to regional conventions. For an organization to be a full voting member, it must: (1) be nonprofit; (2) demonstrate a commitment and responsibility to contemporary artists, ideas, forms, and equal representation; (3) its artists must maintain a central policy and decision-making role in the organization; (4) organizations must guarantee artists' control of the presentation of their work and art; and (5) be committed to paying equitable artist fees—i.e., honorariums. These member organizations should be the first alternative galleries and spaces any artist contacts.

The spaces tend to be experimental in what they show, and they favor installations, new genres, interdisciplinary works, social-political themes, and performance art. Another reason to contact these spaces is that many of the directors and curators sit on federal or state organizational and individual grant panels. Governmental grant panels usually do not have commercial gallery owners as panelists unless they are experts in a particular field or know nonprofit organizational procedures. These individual and organizational grant panels are primarily made up of professional artists (previous federal or state grant recipients), contemporary museum curators, and NAAO member curators and directors.

Receiving an individual or organizational grant from these panelists might mean not only being financially compensated, but also being asked to show in another NAAO space. The panelists take notes and may subsequently contact you. After the grants are awarded and the notification letters are snail-mailed out, it is important to request the grant panelist list. If you receive a government grant, it is because the panelists thought highly of your work, and querying them about exhibitions and residencies is advisable.

NAAO usually has a conference in a different city every eighteen months. This is the place to network as performances, workshops, and seminars are offered. The art spaces that make up NAAO are at the forefront of avant-garde art, and an emerging artist's career can be advanced by regularly showing in these spaces.

Beth Ann Diamond

Originally an exotic ceramicist, this thirty-two-year-old emerging photographer and digital artist exploded on to the art scene as a direct result of the destructive events of 9/11. As Beth Ann Diamond watched the WTC and Pentagon attacks, and the harsh aftermath, the angst and sorrow immediately caused an internal eruption. This eruption was an experience, which then inspired her to create a series of exceptionally powerful images that invoke both the presence and absence of the Twin Towers.

After responding to two e-mail requests for submissions to the significant CUANDO and *From the Ashes* and Exit Art

The Scream, digital photography, Beth Ann Diamond, 2001.

Reactions exhibitions, Beth created digital art from a wide variety of images. In fact, in a few of her works, she has used some of my digital photographs (in which she posed as a model) as primary source material. The original CUANDO show traveled to Open Space Gallery (OSG) in Pennsylvania, and although the show was only open for one day, due to board politics, it received significant coverage. Then, under the new name *Ground Zero,* it traveled to the Museum of New Art (MONA) in Detroit, Michigan, and to Freyberger Gallery in Reading, Pennsylvania. Meanwhile, the *Reactions* exhibition, which only accepted 8½" × 11" images, selected 2,500 artists and traveled to the Art Center College of Design in Pasadena, California, before the whole show was donated to the Library of Congress.

After participating in the seminal *Ground Zero* show, she received permission from artists Amy Shapiro, John Montalvo, Jr., and Doug Fishbone to incorporate their documentary photographic images into her art. Some of these images are digital monoprints (one-of-a-kind), adding vibrant watercolors on Ilford's Galerie Inkjet Fine Art Paper (matte and acid free).

Beth received another e-mail request from *Wired* magazine, forwarded through one of the curators, Frank Shifreen; after she responded by submitting work via e-mail, *Wired* selected a collaborative piece (hers and my image) for use in the calendar sec-

tion. She then made numerous color copies and submitted it to a regional Pennsylvania newspaper, the *Saucon News*. Its new editor was particularly impressed, and, in two separate issues (including the anniversary of 9/11 in which she received the entire back page), they published front- and back-page color reproductions. Since it is a free publication, she obtained one hundred copies. This is an important inclusion in any press package; the large format of the color weekly newspaper makes a terrific impression. Additionally, at the initial editorial meeting she was invited to submit "freelance" photographs and articles, as well as begin a weekly "Asked & Answered" column for the *Saucon News*. After a number of columns appear, she will send clips to other publications to request other freelance writing assignments.

Recently, she has done a promotional snail-mailing of all her articles to fifty domestic and international photography, digital, and women's magazines. This should result in additional publishing and publicity, and, when they become available, she will photocopy them and then submit them to regional newspapers and magazines. Being published in international and domestic magazines drives the regional publications to run feature articles, since you are no longer a regional fish in a local pond.

Additionally, she is seeking further group and solo exhibitions, to coincide with those prospective published articles. In this way, the next exhibitions will not only feature her work, but also drive the future publications to run feature articles before the exhibitions open, increasing gallery attendance.

Exhibitions include: *Ground Zero*, MONA, Detroit, Michigan; *Ground Zero*, Freyberger Gallery, Penn State Berks Campus, Reading, Pennsylvania; *From the Ashes*, OSG, Allentown, Pennsylvania; *From the Ashes* and *Witness*, CUANDO, New York City; *Reactions*, Exit Art, New York City; and *Reactions*, Art Center College of Design, Pasadena, California; *Art Against War*, Macy Gallery, Teachers College, Columbia University, NY Arts Space, New York, and Presbyterian College, Clinton, South Carolina. Her work is in the collection of the Library of Congress and in numerous private collections. Her publishing credits include: *WIRED, Detroit News, Real Detroit Weekly, Reading Eagle*, and *Saucon News*.

Cooperative Galleries

Artist cooperatives in New York City first started in the thirties. During the Depression many galleries were forced to close and artists had to finance exhibi-

tions on their own. These artists' co-ops collectively shared costs, made exhibition decisions, and handled all the functions of running a gallery. They followed the Mexican and Soviet artist collective model, which integrated the division of labor, where the artist members had to share responsibility such as expenses, decision-making, and operations of running a co-op gallery.

Today co-op galleries have taken on a hybrid form, remaining artist run, but surviving on a combination of fees and grants. They are not successful enough to rely solely on grants and must make up the difference through yearly dues.

Co-ops can be a perfect place for emerging artists to begin exhibiting their work. From 1984 to 1985, I was president of the Hempstead Harbor Artists Association and the Discovery Art Gallery, originally located in Glen Cove, New York, now closed down. It was one of the best forums for emerging artists to exhibit on Long Island, due to its three gallery spaces and its fourteen-year history. The critics expected interesting art to be exhibited. Over the years, the gallery has received reviews from *ARTnews*, *Newsday*, and the Long Island section of the *Times*, as well as the local papers.

From 1996 to 2002, I was Executive Director of Open Space Gallery, Allentown, PA. This three-thousand-square-foot space presented many seminal exhibitions that traveled across the United States. If a commercial gallery route is your chosen goal, then associations, co-op galleries, and art bars (bars where artists are known to meet) are beneficial places to meet people and network. For artists at the beginning of their careers, I would recommend becoming a member of a co-op gallery and paying the fees for a theme-related group or solo show. Find out what kind of response the public has to your work. If negative responses occur, or if responses are lukewarm, you need to re-evaluate your career options as an emerging artist. This might mean postponing your first exhibit indefinitely, which can be emotionally devastating. After creating work for a few years, hopes can be dashed by a poor review. (In haste, some people then decide to become art teachers or leave the field altogether.) A positive review boosts morale. Of course, if what you have created is radical, political, or is socially or environmentally conscious work, and the critic just did not get it, then negative or cool reviews can be dismissed.

Co-op galleries, either nonprofit or for profit, allow artists who are at the same career level to interact socially as well as artistically. It is good for your career to interact with other emerging artists. Artistic identification can produce collaborations, contacts, networking, and friends. Nevertheless, do not let the big-fish-in-the-small-pond syndrome become your reality. Co-op galleries should be a stepping-stone in your career, not the culmination of your career. It is very comforting to know that you will be in three group shows in the coming year and have a two-person show in eighteen months. The co-op is an excellent *temporary* forum; too many artists regard this situation as the pinnacle of their résumé, and become satisfied with a good review or an occasional sale.

A regional career and résumé establishes you as a local talent, but you need to establish a reputation that is not localized. An unfortunate side effect of the co-

op gallery is that the artist learns to expect to pay for exhibiting. Vanity co-op galleries exist all over the United States; some of them are located in major cities like New York. The artist sometimes pays a hefty fee to exhibit. Try not to be pigeonholed into a gallery that does not guarantee anything. You can easily end up paying additional fees for announcement cards, opening costs, and ads. It is possible that sales will occur through the announcement mailing or through someone walking in off the street, but if you want to develop "patrons," only established, commercial galleries offer a ray of hope. Critics avoid vanity galleries in major cities like the black plague.

Know the Market

You will want to look into commercial and NAAO galleries, both locally and in other cities. It is essential that artists visit galleries, libraries, and community colleges to see what is being shown; to know the spaces and their requirements; to talk and/or show work to owners or curators. Obviously, the major cities like New York, Chicago, Miami, Los Angeles, or San Francisco are a magnet for contemporary artists. The competition can be fierce, and research and persistence is necessary. A plan has to be created, implemented, and then put forward.

Remember, art galleries specialize in certain types of work. Sometimes, it takes the form of an ism, trend, gender, or politics. A realistic portrait painter should not try to exhibit at a minimalist gallery, but at a figurative gallery. Finding out as much as possible about the art market by researching Web sites, newspaper or magazine listings and reviews, and networking, will save time and money. Find out which galleries in different cities exhibit similar work to yours and concentrate on strategies for building your career so that you can interest those similar galleries.

Artist-Organized Shows

One of the more remarkable phenomena is the artist-organized show. This is different than a co-op gallery. Usually, it is held in a temporary site or space either donated or rented for the specific occasion. The artist-organized show allows you to create a forum for showing your work and receiving publicity. These shows are often an important intermediary step between showing at co-op galleries and participating in exhibits at commercial or other well-established galleries.

Planning is extremely important, because all costs, which include rent, utilities, repairs, release, photos, mailings (via snail mail and e-mail), curating, opening reception, and creating the work, have to be covered by you, the artist. If you are able to pull off an event like this, the satisfaction dividend carries through to everybody involved. I have been involved with many of these types of shows over the years, usually concerning humanitarian topics, such as the recent *Ground Zero* exhibitions.

Often, the media eats it up, especially if the show relates to a topic of local concern. If any of the artists have a local reputation, they should try to obtain "free

space" from local government, businesspersons, or utility companies. Promote the fact that this will be good for community relations and it will bring more traffic, due to the publicity generated.

When I first moved to Pennsylvania, I found out that the pristine countryside near my home was going to be the site of one of the East Coast's largest landfills. For many months, the newspapers discussed this issue. A core group of five people (four artists) called the group and its exhibition *Friends Urging Environmental Liberation (FUEL)*. One of the artists' studios (Lisa Fedon's) in Pen Argyl—the same town as the landfill—was the exhibition site. The Saturday opening had political speakers from both sides of the issues and an art performance, and the exhibit lasted three weeks. This enabled the local newspapers to report on the events in its Sunday edition. Donations from the opening (about $200) paid for all our expenses, plus fifteen artists contributed $15 each.

Eight weeks before the opening, a call for entries was snail-mailed out to the local newspaper, which ran a few small articles with a photo. Many artists contacted the group, and from them the work was selected for exhibition. The show created another way to visually describe the vital news item, from a positive artistic point of view rather than the written point of view. The same journalists who had been writing about the issue covered the show. Unfortunately, the local art critics were contacted many times, but they responded with, "Since it ran as a news item, it was already covered." It is probable that the art critics would not have covered the event in any case. Sometimes local critics stay clear of political work. Why? Because they see art as only "pretty pictures" and feel unqualified to comment on anything else.

Artists often appreciate artist-organized shows because the artwork created comes from the heart, as installations and unusual pieces are encouraged. Sales are usually nonexistent because of the topical nature of the shows but that is not the prime reason to create this type of work—sometimes, you just have to make a creative statement.

Frank Shifreen

Frank Shifreen has had such a colorful art career that a whole chapter could be written about his achievements. He is an artist-writer working in painting, sculpture, digital photography, scenic and graphic design, a curator, and a genius of artist-organized events. The way in which he operates provides a textbook case for understanding how to realize the myriad possibilities of sponsoring artist-organized projects. He uses a unique combination of guerrilla tactics and sound business practices.

Over the years, he has had thirty-seven solo shows, some of them in such prestigious New York City galleries as Scott Pfaffman, Enigma, New Math, and Theatre for a New City.

The Second Plane, digital print, Frank Shifreen, 2002.

International exhibitions of his work have been in Gallerie Ostien, Germany; African Cultural Center, Senegal; and Gallerie di Collosseo, Italy. Additionally, he has exhibited in more than two hundred group shows and has work in the collections of museums and corporations including the Brooklyn Museum, Museum of Modern Art, San Francisco City Museum, Dallas Museum of Fine Arts, Vassar College, Chase Manhattan Bank, and Citibank. Reproductions of his work have appeared in: *New York Magazine, Unsound Magazine, East Village Eye,* and the *New York Times,* and he has been internationally published in *L'Occhio* (Italy), *Neu Malerei,* and *Taz* (Germany).

Shifreen found that the best way to begin an artist-organized show was to create low-cost, black-and-white posters that could be plastered all over the city. Shifreen first started doing this in 1976 for his own solo exhibitions. In 1979, he began to have open-studio party shows at his Gowanus, Brooklyn studio. Here many artists started to network.

Since his building was 9,500 square feet, Shifreen asked his landlord if he could occasionally use the space as long as it was not being rented. He and artist Michael Keene decided to have a "monumental art" show, which a group of artists then assembled. Six months before the show, Shifreen put up a call-for-entry posters and sent out releases. Grant applications were also written, and after receiving a $1,500 grant from the Brooklyn Council on the Arts, Shifreen assembled more than 150 artists to create the *Gowanus Memorial Artyard.* Artists had to send in pro-

posals, and the organizers received over a thousand proposals and selected 150 artists. Each artist was given a 20' × 20' space to create monumental art. Monumental art can be paintings, sculptures, mixed media, or anything that is one-and-a-half times life-size. Usually, it is oversized in overall thickness and depth, which renders it impressive. The participants included well-established artists such as Carl Andre and Keith Haring. The show opened May 16, 1981, and more than four thousand people came out from Manhattan on Saturday and Sunday. Sculptors, painters, video, and dance performances increased attendance.

Unfortunately, Frank Shifreen had a misunderstanding with his landlord, and as a result of the art show, he lost his living space and was arrested for stealing his landlord's electricity. Because of this controversy and the success of the show, he made the cover of the *New York Daily News* on June 15, 1981.

In addition, *New York Magazine* did an article called "Gowanus Guerrillas" on June 8, 1981. They called this exhibition "the event of the season." Because Shifreen was an organizer, they used a color photo of his art to illustrate the story. Although there is no written rule, reviewers will usually use the artist-organizer's work to illustrate an article since they do all the legwork and receive little credit. This is a creative payback. After this show, Shifreen was asked to participate in many exhibitions.

With this success under his belt, in 1982, Shifreen and Scott Siken organized *The Monument Redefined*, an exhibition held at three sites. The outdoor site covered twelve acres, and the artwork was visible from the window as one rode the F subway train. The space for two indoor sites was donated by the Downtown Brooklyn Cultural Center. Some of the sponsors were the Department of Parks and Recreation, the City of New York, Con Edison, F. W. Woolworth Co., and the Organization of Independent Artists. Shifreen made some interesting associations preparing for this exhibit. He discovered a direct link between art and real estate interests: Since art has to be hung on walls and exhibited, management and realty companies will sometimes lend space for various reasons. It is a good idea to make friends with real estate people, since the space can be among the most expensive aspects of an artist-organized show.

The concept of *The Monument Redefined* was to create true monuments—public statements rising out of a collective need and based on a personal understanding. Size was not a prerequisite; the challenge was to communicate social responsibility. The call-for-entries consisted of a poster and donated free ads

from *Artforum*, *Arts*, and *ARTnews*. Some of the jurors were Marcia Tucker, the director of the New Museum; Henry Geldzahler, the New York City Cultural Commissioner; and Mary Boone, the gallery owner. Three panel discussions were held at Cooper Union, and artists as well as art critics took part. Thousands of artists submitted entries and the curators selected four hundred proposals. (The selected artists had to pay a $25 fee for the catalog.)

Again, the show attracted well-known artists, including Carl Andre, Christo, Vito Acconci, Nancy Holt, Chris Burden, Dennis Oppenheim, Nancy Spero, and Leon Golub. The *Times* and many art magazines reviewed this important exhibition.

Just as Frank Shifreen was about to organize the *Brooklyn Terminal Show*, he fell ill and did not have a major hand in its organization, although he did exhibit in it. This September 1983 *Terminal New York* at the Brooklyn Navy Yard, Brooklyn, New York, was one of the biggest artist-organized shows ever attempted. Over 550 artists assembled in what, at one time, was the largest building in the world.

Through his contacts with artists, critics, and museum curators, Frank Shifreen was asked to organize legitimate shows, as well as to exhibit in commercial galleries. But this did not stop him from continuing to develop artist-organized shows. The Pan Arts group in Manhattan made Frank the editor of its magazine, which served as a catalog for their *Art and Ego* show in 1984. In 6,000 square feet of space, approximately three hundred artists exhibited in various media, such as sculpture, painting, performance art, film, and video art. A landlord excited by the ideas and energy of these artists donated the space.

Frank believes the East Village art movement of the 1980s came into existence as a result of the artist-organized and not-for-profit shows of those years. The shows created an opportunity for galleries and dealers to take on emerging artists, along with art that had a political or social consciousness. From 1985 to 1986, Frank Shifreen had five one-person shows as a result of the publicity and connections cultivated through his artist-organized events. He became a successful grant writer, writing grants for the performance artist Karen Finley, and a $100,000 grant for a blind artist for the New York Commission for the Blind. (He wrote himself into the grant as an art teacher.)

The *Brooklyn Bridge Centennial Show* was organized with Pratt Institute and Creative Time, a nonprofit public outdoor sculpture organization. Shifreen was one of the organizers that

helped coordinate grants, artists, and sites. The 22 Wooster Gallery gave him the paid position of Program Director for the Artists Talk on Art series from 1984 to 1986. He organized seven to ten panels a year for four seasons on such diverse topics as *Art & Anarchism*, and these were always well attended and provided lively discussions.

As a diverse movement numbering between ten and fourteen people, Group Scud lasted from 1983 to 1989. Group Scud grew out of the ashes of the *Monument Redefined* exhibition. They bought and reconstructed a 12' trailer and used it as portable gallery space, which allowed anywhere from three to eight pieces at a time to be displayed depending on the artwork size of the works. The group parked the trailer in front of New York City museums and Soho galleries. Because a member of Scud remained behind the wheel at all times, the group was able to average three to four hours of rent-free exhibition space in prime locations such as the Metropolitan Museum of Art, Whitney Museum, Museum of Modern Art, and Leo Castelli Gallery at 420 West Broadway. These art actions happened approximately twenty times during this six-year period and every time they "parked," sales were made.

Because Frank Shifreen organized and wrote many grants for them, the Organization of Independent Artists helped coordinate *Art Against Apartheid*. This benefit exhibition raised consciousness about South Africa and was held at twenty-six sites in New York City.

From 1986 to 1989, he was involved with the international artists' organization called Plexus, which created multi-cultural art environments. Some of these exhibitions traveled to Rome, as well as other parts of Europe. In 1990, after a decade of significant achievements, Frank Shifreen finally took time out to travel, write, and go back to college. However, in 1993 he again joined with younger artists such as Amy Shapiro to exhibit in Cat's Head events in Brooklyn's Williamsburg and Greenpoint area.

Upset over the 2000 presidential election, Shifreen put out an e-call through fifty Web sites such as *www.rhizone.org*, *www.nyfa.org*, and *www.artdeadline.com* to develop an exhibit. In addition, through e-mails and phone relay, each interested artist contacted five other artists who did the same. Therefore, the response to George Bush's tainted presidential victory resulted in an exhibit called *Counting Coup*. Although a difficult show to market since the public was not apparently in the mood for this type of artistic response, the first show opened at the Scott

Pfaffman Gallery, New York City on January 21, 2001, the day after Bush was inaugurated.

The Museum of New Art (MONA) in Detroit, Michigan, was interested in presenting *Counting Coup*. At that time, MONA had a beginning fundraiser, and Frank donated some paintings. The director Jef Bourdeau was appreciative and supportive, and *Counting Coup* was tentatively scheduled for exhibition. However, the show continued to travel to the Theater for a New City, in New York City, and the Center for Social Change, Northampton, Massachusetts; the show would have continued to travel except for the tragic events of 9/11. Because of that act, President Bush legitimized his presidency and *Counting Coup* ended as an exhibition.

On September 11, 2001, Frank went to the World Trade Center site to volunteer but was not allowed to help, due to union rules regarding insurance liability. After the initial tragic shock, Frank talked to Patricia Nicholson, a local activist and dancer, about the CUANDO building on 9 Second Ave, New York City. It had been unoccupied for years, yet its nonprofit status was still active. There were plans already underway to do a show in October 2001 called *Witness*; this all changed and a new show titled *From the Ashes* opened October 13 through November 4, 2001.

The show produced a poster promising "Artist reflections on the recent tragedies. . . . In the midst of destruction and chaos, art stands witness to the creative soul." The Herculean effort to put a show together about the WTC tragedy in such a short time—which included 150 visual artists, two hundred performing groups, media artists, site-specific installations, and performances on five floors—is a test of sheer human willpower. On September 25, 2001, after the *Witness* show was transformed into *From the Ashes,* Frank asked the noted Willoughby Sharp to assist as a curator (five curators eventually became involved). Frank wrote an essay, catalog, and release, and he asked Carla Cupid, an outsider artist and actress, to help with the publicity.

As a result of e-mailed and faxed releases, the show received significant press in the *Los Angeles Times, Village Voice, Villager,* and other eminent publications. It was also successful in terms of sales: $5,000–6,000 of art sales plus donations resulted in $7,000 being donated to the Fireman's Fund and five firehouses. However, the show was not without turmoil, as New York City's building inspectors tried unsuccessfully to close the building. While CUANDO had a lease for the building, New York City

tried to condemn the building before the opening, but lawyers for CUANDO received an injunction to keep it open.

As a mid-career artist and doctoral candidate at Teachers College in the Arts and Education Department, which is part of Columbia College, New York City, Frank views colleges as under-utilized resources. Art is a research enterprise and process; it is not necessarily a collectible for an elite buyer. When research is carried out through art rather than through its sale, an educational institution seems to be the most appropriate setting. Besides, it has resources unlike other nonprofit institutions. Most educational institutions have gallery spaces, which can be used as a teaching device, an educational outreach tool, and the opportunity to develop seminal traveling exhibitions. The subject of Shifreen's doctoral thesis is the development of modern art and artist-organized shows. These educational galleries become alternatives to the gallery system, the unpredictability of nonprofit galleries, and the snail's pace of museum shows, since these latter institutions often book exhibitions three to four years ahead. He says, "You must create your own cultural opportunities, as the art world only serves a certain group of bankable artists."

The *Art Against War* show, which ran from June to August 2003, started because many thought that the war in Iraq was a grave mistake. Frank says, "I began to see signs, usually homemade, that protestors created and that had a lot of energy and beauty to them, opposing the war. There was a lot of energy in the street." As usual, Frank sent out a prospectus to about twenty-five spaces, proposing an anti-war art show. Dr. Graeme Sullivan, his doctoral advisor at Teachers College (this show is one of the topics in his dissertation) was very excited about it, as was Abraham Lubelski, who has two galleries in New York City and a gallery in Berlin.

It was then decided to do a simultaneous poster exhibition at the Macy Gallery, Teachers College, Columbia University, and at the NY Arts Space. Since the Internet is changing how artists connect with each other as well as art institutions, three Web sites agreed to be part of the exhibition by creating a version of the show on their sites. The sites are *www.drinkink.com, www.thedigitalmuseum.org,* and *http.retiform.ath.cx.*

He put out a call on the Internet and received a worldwide response. Now that there is the technology to send high-resolution files via the Internet, he received files from artists from fourteen countries. Frank decided to keep the poster format uniform at 24" × 36", a size that creates a public work and can be

printed on a digital inkjet printer. He also offered artists the option of creating a work on paper using traditional materials in the same size form. Artists paid $55 for a poster, which was his cost, plus shipping for each print.

In the exhibition were works by video artists projecting raw footage of pro- and anti-war demonstrations on the walls of the galleries. The juxtaposition of the large videos and lines of posters created a powerful theatrical space, and the Web sites allow for greater interactivity and also serve as documentation for the exhibition. This traveling show will next tour at Presbyterian College, in Clinton, South Carolina.

In addition to his other work, Frank acts as Franz Klein in the DVD feature *Pollock Squared,* directed by the artist William Rabinovitch (profiled later, in chapter 6), and he will be exhibiting at the 2003 Florence Biennial.

Frank Shifreen understands the value of devoting time to organizing, curating, writing, and overseeing publicity. He follows up his releases with e-mails, faxes, and phone calls to the reporter or critic. Human contact is critical to long-term success, and Frank Shifreen knows that art critics will follow your career if they believe in your work; this strategy has helped his illustrious career. E-mail him at *fshifreen@mindspring.com*) or visit his Web site at *www.shifreen.com.*

Selling Artwork on the Internet

If you plan on selling you artwork on the Internet then you should be aware that there is a variety of software to help artists. Try visiting the *www.tucows.com* Web site to find out about freeware and shareware. It offers 30,000 software titles and a network of more than 1,000 partner sites globally, providing users with fast, local downloads.

SYAO (Selling Your Art Online) is a newsletter that covers topics that artists need to know about selling work on the Internet. It is a very comprehensive Web site created by Chris Maher. Visit *http://1x.com/advisor* for information about designing your Web site with search engines in mind and making art sales online.

If you are interested in selling your artwork via eBay (*www.ebay.com*), the realistic selling price is in the $250–$300 range for an unknown artist.

For artists to maintain a high Web profile, they need numerous links to search engines and Web sites. As of this writing, on the Web site *www .digitalconsciousness.com* there were thirty-three sites (some of them free) in the Artists Listing category of the Internet Directory. Some of these include *www.absolutearts.com, www.passion4art.com, www.askart.com,* and *www .americanartists.org.* It would be advisable to visit them and register as an artist.

University and Museum Galleries

University and museum gallery exhibitions mark the pinnacles of artistic achievement, although many artists approach them for solo shows before they are ready to exhibit on this level.

In chapter 4, creating your own press agency was discussed as a way to be placed on the university and museum information and publicity press mailing lists. If you do this, create two different names for your agency, one to sell photographs and the other to receive press information. Names like Xtreme Press Service or Long Island Press Service (LIP Service) are good choices. It is better to make up a name for your business and to allow your own name to be solely identified with your creative work.

Press mailings (via both e-mail and snail mail) will indicate not only the current shows but also upcoming ones. These future group shows hold the most promise, as the curators could be in the planning stages. There is a long period of organization, during which the museums or galleries have to apply for catalog, travel, or insurance grants and decide which works will be included in a show. The lag time before the show, while the exhibition is in the works, is the best time for artists to contact the museum. Many university and museum press mailings and e-mails will indicate the date for the show, which could be two to four years away. In fact, some of these press announcements do not even have a date; they indicate that the exhibition is in the planning stages and just give a working title and brief description.

At least you are aware of these upcoming shows and have a chance to be considered if you believe that your work fits the exhibition's concept. Contact the curators via snail mail, e-mail, fax, or phone calls, and indicate you heard about the show through the "art grapevine." Ask if they are still reviewing work. It is a great opportunity to be in one of these shows, since most universities or museums print catalogs or books of important exhibitions.

Be aware that when you ask to be placed on a press mailing list, the organization assumes you are a legitimate agency, journalist, or photographer. They may ask for verification by mail or fax. If so, I would indicate you are a new agency that works with local, national, and international newspapers and magazines and that you are interested in significant museum or university shows. If you have articles about your work, post those on a Web site, snail-mail them, and indicate that you were the one who placed the article. You could also try to place articles about artist friends, split the sale of the article, and have more diversified tear sheets as proof of your press agency legitimacy. Again, if you are not actually functioning as a press agency, placing art-related articles and photographs in periodicals, you are placing yourself in an ethically tenuous position by requesting this information. However, if you are working as your own agent, receiving such information is one of the benefits. This same approach can be applied to nonprofit or commercial galleries, as it is important to know what is happening in your region.

Jef Bourgeau at the Museum of New Art, Detroit, Michigan.

Universities, especially Ivy League schools with private galleries, offer many opportunities, including exhibitions, workshops, master classes, demonstrations, artist-in-residencies, lectures, performances, and visiting artist residencies sponsored by the art department.

College galleries are curated with or without ties to the art department. Occasionally, the art department curates the gallery and then offers supporting activities that are coordinated with that particular exhibit. The same is true for university museums. It all depends on how the gallery operates, either independently or in conjunction with the courses being offered that semester. It can be great arrangements if an artist can tie in with classes and an exhibition, potentially receiving an honorarium, lecture fees, or artist-in-residency fee, plus travel, accommodation, and shipping expenses.

Jef Bourgeau

A redefinition of what constitutes a museum and the role it should perform in the community requires a profile on Jef Bourgeau. Most museums are encyclopedic, as they wait until the artwork is "deemed" art before cataloging it. Jef Bourgeau warns of the Disney-fixation of large art museums. "It's mostly economics," he says. "To survive, museums must draw as many people as possible and attract a broader and broader audience. That's not a winning hand if you try to play to everyone, you simplify the art, and it dummies it down. Part of the problem with the museums now is that they are not sure what is art. You have always had an aesthetic gauge against art. Anything goes in art now, there is no

precise gauge, and the museums are going crazy. That is one of the reasons why many more traditional institutions tend to avoid current work, because they are not sure-footed. They do not want to be caught with their pants down, saying this is art, and five years later it turns out, that it was not art at all."

Jef Bourgeau is a writer, who sold his first novel at the age of twenty-one, then he became an illustrator, painter, and a filmmaker, which led him in 1991, at forty-one, to become an installation artist and curator.

The O.K. Harris satellite gallery in Birmingham, Michigan, in 1991, allowed him to use one of their spaces every month for two years and during that time he amassed numerous pieces while producing sales. Some of these installations were about art history and he has a "secret theory" of twentieth-century art, exhibiting in Japan, Netherlands, Hawaii, New York, Boston, Houston, Chicago, Seattle, San Diego, and Cleveland. In 1997, he started an Artist's Project, known as the Museum of Contemporary Art, which was literally a walk-in closet nestled inside the Galerie Blu in Pontiac, Michigan. He raised legitimate questions about the nature of museums and what qualifies as art today. This continual questioning, along with allowing a forum for contemporary art, is a central inquiry between the audience and artist. Jef Bourgeau is committed to art on the cutting edge and thus the immediacy of contemporary art. From 1997 to 1999, Jef Bourgeau worked on *Art Until Now* at the request of the DIA (Detroit Institute of Art) contemporary curator and the Institute's first installment *Van Gogh's Ear*, which included pieces that referred to recent art scandals.

This show was supposed to be a series of twelve one-week installations that explore the course of twentieth-century art; however, it was padlocked and canceled because the DIA said that "it might cause offense to important parts of our community."

As a result of canceling his exhibit *Art Until Now*, DIA compensated Jef $12,500, and he used this money to create an authentic museum from his small artist's project, which he entitled the Museum of New Art (MONA), Detroit, Michigan.

MONA first opened in fall 2000 in Pontiac, Michigan, with Jef Bourgeau as executive director and by May 2001, MONA had a 10,000-square-foot space at the Book Building in downtown Detroit and held an auction that raised $40,000. Two-thirds of the work came from artists from outside of the area (including Frank Shifreen). When Jef heard about the *From the Ashes* show, and due to the immediacy of that terrorist act and the

numerous artistic responses, he felt it would be a perfect forum for MONA. The show was retitled and expanded to *Ground Zero*, which included other similarly horrific events, and artists' responses that would be considered a "ground zero site," such as the World War II Hiroshima bombing. However, some artists chose a wide interpretation of *Ground Zero* and felt any site that a community deemed as ground zero should be included. Contact Bourgeau via e-mail at *detroitart@aol.com.*

Education Departments of Museums

Another way to find out a museum's schedule is by contacting the museum's education department. These departments coordinate educational activities for all museum functions including exhibitions. Educational functions are sometimes masked fundraisers and/or grant or profit-making opportunities. Try to get an appointment with the education coordinators, as they offer a vital link to the curators. They are aware of future exhibitions, and they can act as "art scouts" to the curators. Education coordinators are always thinking ahead about how to best complement the museum exhibitions and activities. It is much easier to arrange an appointment with them than with a curator. If an artist is hired for a workshop or master class demonstration, he might also be able to exhibit his work. It is a natural complement, since budgets are tight and exhibition links work well for the museum's literature. But not all artists who do museum education work are in exhibitions.

Meeting with Museum Curators

Curators recognize the power that they yield, and it is extremely hard to arrange a curatorial appointment. Usually, they have assistants who filter out queries, letters, and phone calls. Include museums on your publicity e-mailing or snail-mailing list, as they do follow certain artists' careers. A museum group show is a realistic goal. If you receive a solo show at a museum, it is usually after a group show in the same museum, and because you have cultivated collectors and are already successful in commercial or nonprofit galleries.

If you are included in a museum show, coordinate a show at a commercial gallery in the same month and city. This happens to famous artists all the time. A commercial gallery will piggyback on the museum's publicity. The media is more likely to review your work, since museums are usually extensively reviewed, and if you can arrange other exhibitions, sales are more likely. Museums do not sell work. However, some of them have lending libraries or commission artists to create special prints or lithographs for an exhibition; try to capitalize on this. The major galleries and museums do it all the time. Look in the Sunday *Times* Arts and Leisure section, and compare museum listing and gallery ads. An emerging artist might not be ready to show at these institutions, but one should get used to following this procedure.

Children's Museums

These are a relatively new addition to the museum field, and they offer another way for artists to supplement their incomes. Some children's museums have art exhibitions, collections, workshops, demonstrations, and the like. If you create playful, colorful, elementary, or "pure" art that you believe might fit into their schedule of events, visit a few to check out what they offer. Most major cities have children's museums.

Keep in mind that unless high school students are part of the audience, your work or planned activities cannot be too sophisticated due to the age group. Hands-on activities are essential. These museums have curators, directors, educational departments, and an exhibition space. The Children's Museum of Manhattan has digital cameras and a working television studio with computers, enabling digital, video, and computer artists to offer workshops and residencies. Contact them at The Tisch Building, 212 West 83rd Street, New York, NY 10024; 212-721-1234; *www.cmom.org*.

Do not discount these museums; a workshop can result in future art opportunities in that area. If you have any articles in school or children's publications, the articles could be sent to those museums as part of an introductory mailing.

Donating Works

Artists donate work to nonprofit organizations (alternative spaces, colleges, universities, or museums) for a variety of reasons: in connection with exhibits, for their résumés, and for tax purposes (for the artist, only the cost of the allowable materials are deductible; for the collector, the current market value is deductible).

Do not expect the donated artwork to always be accepted. The nonprofit Board of Directors and curators have to approve all donations. You should query first to determine if a nonprofit collection is interested. After talking to many museum curators regarding the acquisition and exhibition of work, some general approaches become evident. Remember that working with a museum is a long-term career goal. Always call or write for an appointment. The actual artwork is preferred over slides. If the artwork would contribute to the collection, the curators will offer suggestions on how to donate the work. It might be wise to have someone else donate the work to receive the tax deduction. This establishes a value, which is backed up by a museum receipt (useful for insurance and tax purposes). Remember, artists can only deduct the cost of materials if they donate directly to a museum. If the curator asks to purchase the work, it is wise to sell the artwork below market value due to the prestige of the museum.

Artists can also make the most of a museum affiliation by donating work to the museum's permanent collection. The purpose of this is simply to exhibit the work in permanent or long-term displays or mount temporary exhibitions.

To take it a step further, you might think about recontextualizing pieces

for the museum's collection. You will need to assume the role of curator. In this way, when the context is of your own devising, your work can be prominently featured in both the show and the catalog, the latter being of great benefit to your publicity. Take the hypothetical example of the Mercer Museum in Doylestown, Pennsylvania, a renowned museum with a historic tile collection. By creating and curating a show titled *Verse-a-tile*, a ceramic artist might engage the museum to accept a donation of work for inclusion in this new "text on tiles" show.

It is unlikely that a museum would accept a donation of an emerging artist's work to present a solo show. So beware of donating work that will not be exhibited but instead will be assimilated into the museum's vaults or even deaquisitioned (discarded, sold, or traded). Do not donate artwork just for the sake of including it on a résumé, for it then becomes a losing proposition.

Selling Work below Market Value

Selling work below market value to museums, libraries, or galleries establishes a documented insurance value. It is possible to sell one work at full value, and then donate other works. An artist might give away four works and sell one. If the market value is $500, in effect the organization paid $100 a piece. If the organization is willing to buy one at full value, insurance credibility is established when dealing with lost or damaged art.

First Night Festivals

Beyond the traditional, established venues for exhibitions, there exist many other opportunities for fine artists. Every year, approximately two hundred cities in the United States and around the world offer a New Year's Eve festival called First Night®. First Night came into existence in Boston in 1976 to bring the neighboring communities of the city together in a joint celebration, while providing the public with an alternative way of ushering in the New Year. The celebrations wish to change the urban environment that night, by making the city come alive in surprising way that only artists envision. They hope that attendees will participate, to blur the line of performer and audience, even in the visual arts. First Night begins during the afternoon on December 31 and continues until midnight.

This celebration, the size of which varies from city to city, can feature two hundred performances staged in over thirty sites. The venues vary from traditional to unusual performance sites like auditoriums, concert halls, theatres, civic plazas, churches, cultural centers, bank lobbies, sidewalks, city streets, and unoccupied storefront windows.

The First Night committees invite proposals for these disciplines: music, dance, theater, mime, poetry, magic, video, film, visual arts, multi-media arts, comedy, storytelling, multicultural programs, and performance art. Sometimes joint grant applications are necessary for the premiere of new works or for commissions.

Lotus fire sculptures, (eight-foot-tall flowers made of wax and
other materials, which floated in Vinoy Basin, St. Petersburg,
Florida, 2000, were set on fire on the countdown to midnight).
Photo by Patricia Mason.

Events are staged for different age groups, from children to senior citizens. In the
visual arts, outdoor installations of visual, sound, or environmental themes are of
interest. This is in addition to ice sculpture or other temporary outdoor site-specific
artwork. Art performances and installations can be in unoccupied storefronts or
windows and can include temporary building transformations.

Priority is given to ideas exclusively related to First Night. A proposal is
necessary (some cities have forms and others do not), with support materials
(besides reviews, videotapes work well). If a performance is presented, two forty-
minute performances are standard, and other support information is needed: the
size of the group, technical and space requirements, résumés, reviews, black-and-
white photographs (for the brochure and press), and audio-video tapes. It is
important to be self-sufficient for these performances. Since so many events are
scheduled, the technicians are limited. Priority is given to groups that bring their
own lights and sound system, and the setup does not have to be elaborate. If you
are chosen to play in an auditorium, technical support can be provided.

The fee can range up to $1,500 for two performances, $1,000 for site-
specific installations, and if one has a regional or national reputation, the fee can be
higher. Some First Night cities have arrangements with airlines to provide free air-

fare. Hotel chains have donated rooms to First Night, plus a per diem, and you can request this in the proposal. Be prepared to negotiate the fee depending on what is offered and the number of people required for the performance or installation. First Night is a very good place to experiment and try out new collaborations. Many of the First Night festivals have an emphasis on myth, ritual, and the passage of time, as part of an overall theme.

The proposal deadlines are in April or May, and the decisions are usually made by July or August. All proposals are reviewed by a committee, which is usually composed of artists representing a cross-section of disciplines. The proposals are rated on artistic merit, age appropriateness (X-rated is out, G-rated is best), and originality. The final decisions take into account availability of locations, funds, and overall theme.

Artists can appear at a First Night Celebration more than one year in a row; it is up to the producing organization. As it is impossible for the attendees to see everything on that particular New Year's Eve, some activities are repeated over a two-year period. After that time, the artist should do something completely different or apply to another city using the same project.

An informative directory is available from First Night International and a good investment ($100 a year for a printed directory, quarterly newsletters, and a reduced rate for the conference). If a First Night city looks for specific types of art, then First Night International offers artists referrals. CEO Naima Kradjian coordinates an annual First Night International conference for the participating cities, which is held in a different city each year. Some artists have booths to solicit work at the conference. About one-third of the membership also coordinates other festivals or events during the year; therefore, an artist can receive other work. The First Night festival in Westport, Connecticut, exhibited artists' clocks on New Year's Eve and then had a post-event auction, in which participating artists received a percentage of the sales.

Additionally, First Night in St. Petersburg, Florida, has a very active Visual Arts committee, which commissions temporary (although they might become permanent) art installations relating to the urban site. Over the years, some of the projects included: Street Furniture (park benches); Lotus fire sculptures (8' tall flowers made of wax and other materials, which floated in Vinoy Basin and were set on fire to the countdown to midnight); and two 13' Mylar (a thin polyester film often with a metallic pigmentation) paintings that filled the archways leading into the Mackey Gallery to the St. Petersburg Museum of Fine Arts, the lower portion of each painting cut into 2"-wide strips allowing each museum patron easy passage as they entered the new millennium through the arts.

The address for First Night International is 84 Court Street, Suite 507, Binghamton, NY 13901; 607-772-3597; fax, 607-772-6305; *www.firstnight.com*. By visiting this Web site, you can link to the two hundred cities and find out specific information on application deadlines and other matters. A First Night Celebration is a licensed event and is a first-rate way to receive exposure and pub-

licity from the First Night publications and newspapers, radio, and TV, which often do features about the artists.

Outdoor Art Festivals

Some professional artists might thumb their noses at the thought of being involved in outdoor art festivals. This is due partly to the consistently uneven quality of the work or the sites. However, research points out first-rate work always wins awards. Many festivals use shopping malls, university grounds, parks, and city streets. If an artist is selective in choosing festivals, they can be profitable and valid places to exhibit for a short period of involvement. Some of the other benefits are meeting other artists, selling work, winning a significant award or prize money, and traveling to a warm climate in winter.

The dearth of quality professional work in a show of three hundred "talented" artists results in spaces being filled up by emerging artists (even if they have been showing for years). Inevitably, superb work shines by comparison—and wins awards.

In general, these festivals require paying fees. These might include a nonrefundable entry fee of $10–$15 or more. Many outdoor festivals require an additional space fee, from a low of $25, which the February Coconut Grove Art Festival charges. Located just south of Miami, Florida, the festival can be contacted at P.O. Box 330757, Coconut Grove, FL 33233-0757; 305-558-0757; *www.coconutgroveartsfest.com*. The Coconut Grove festival has thirty-five awards: $1,000 Best of Show, $1,000 Purchase Award of Excellence. The remaining thirty-three awards are for first, second, and third place in eleven categories of $750, $500, and $250, respectively.

The Gasparilla Festival of the Arts has occurred the first weekend in March for more than thirty-three years in Tampa, Florida. Each year, three hundred artists are juried into the show from some 1,400 applicants. There is a nonrefundable jury fee of $20 and a $175 booth fee (refundable if not accepted). Two nationally respected jurors select the artists. This festival has the largest award purse— $61,500—of any festival in the United States. Thirty-six awards are as follows: $15,000 Raymond James Best of Show; $7,500 Board of Directors' Award; $3,500 Mayor's Award; $2,500 Anniversary Award; $1,500 Friends of the Arts Award; $1,000 Emerging Artist Award; and thirty $1,000 Merit Awards. If selected to exhibit, you have a 12 percent chance of winning a cash award in twelve artists' categories. Other artist amenities include a Friday night artists' party and dinner, artists' hospitality center, refreshments throughout the day, booth-sitting services, and near-site parking. The winners are mentioned in the Tampa newspapers, the television news, and on the Web site. Approximately 275,000 people visit this festival every year. If you decide to enter, the deadline is September 30 for the March show. The address is P.O. Box 10591, Tampa, FL 33679; 813-876-1747; *www.gasparilla-arts.com*.

If you decide to make the circuit of these shows, it is possible to make money from not only selling the actual work, but also from winning best of show or other prize categories. You can also receive publicity (without any effort). Deciding whether this is the right move for your career and art requires at least visiting these shows and then making the commitment to participate. The magazine that is necessary to read if you are seriously interested in this type of outdoor-exhibition lifestyle is *Sunshine Artist,* 3210 Dade Avenue, Orlando, FL 32804; 800-804-4607; fax: 407-228-9862; *www.sunshineartist.com.* Request a sample copy or subscription, which is $29.95 for one year. They publish a guide every year, usually in September, of the two hundred top outdoor art festivals, craft fairs, art and craft shows, and trade-craft shows in the United States.

When writing to the festivals for a prospectus, you will find that the exhibitor has to have a display system for his or her work. This does not usually mean a homemade or meagerly constructed unit. It does mean a fire-retardant, aluminum structure with an awning or roof to protect one from the elements. The bigger festivals require slides to be sent in with the entry fee, not only of the work, but also of the display system. The display panel has to have a clean, professional look, and an electric lighting system should be considered.

The book *Crafts and Craft Shows* by Phillip Kadubec (Allworth Press, 2000) has an informative chapter 7 regarding booth setup and booth display. The artist has to see the booth as a store, workplace, and a twelve-hour environment in which to invite the public. Creativity makes a difference in the design of the booth atmosphere.

Florida during the winter months is the Mecca for these shows. Many artists will travel south to live and work out of an RV or van. Camping is an option instead of paying for motels.

If this is something that interests you, visit some of these festivals to get a taste of what they are like. The festivals are held all over the United States. Talk to the exhibiting artists to get an indication of their lifestyle and success.

Some festivals (among others, the Coconut Grove festival) offer artist-in-education residencies, and some produce a color catalog that might require an additional photography fee. Research such options thoroughly before spending any money.

Reference Materials

There are many exhibition forums and private dealers besides those that have been described above. The first step is to visit the galleries. This will answer questions about space requirements, type of art exhibited, and the like. If you want to do research before traveling, or if you decide to "shotgun" e-mails with attachments or slides (sending out *x* number of sets and hoping the law of averages is on

your side), then there are several reference books that can help you. Although every effort has been made to find the appropriate sources, and these publications have a wealth of information, this is still only a partial listing.

- **American Art Directory, 2001–2002.** Published by National Register Publishing, 121 Chanlon Road, New Providence, NJ 07974; 800-521-8110; *www.americanartdir.com*; a bi-annual reference guide listing over seven thousand art institutions across the United States and Canada. It identifies collections, funding sources, exhibitions, key personnel, and other vital characteristics of approximately 3,500 art museums, libraries, regional organizations, and associations; details for some 1,600 art schools, major museums, and state art councils; art information consists of nine useful address directories, museums and art schools abroad, art magazines, art editors and critics, scholarships and fellowships, open exhibitions, and traveling exhibitions booking agencies. Entries are indexed geographically and by subject, personnel, and organization.

- **The Official Museum Directory, 2002 Edition.** Published by National Register Publishing (see above), it lists thousands of institutions in categories such as art museums, historic houses, nature centers, aquariums, botanical gardens, planetariums, zoos, and others—showing where they are, what they exhibit, and who manages them. It also gives you verified data that reflects the latest professional affiliations, permanent and traveling exhibits, and contact data.

- **International Directory of the Arts & Museums of the World 5th CD-ROM Edition 2002.** Published by K. G. Saur Verlag, P.O. Box 701629, D-81316 Munich, Germany; e-mail, *info@saur.de*; *www.saur.de*. This is a comprehensive guide to art sources and markets in 137 countries. It contains over 150,000 names and addresses of museums and public galleries (approximately 40,000); art publishers (2,600); art journals (1,200); and associations (2,500). Cost is $525.

- **Art Diary.** Published by the editors of *Flash Art*, this is an international listing of more than 30,000 artists, critics, galleries, publishers, and others in the art world. The current $80 fee includes two listings, one in a hardcopy of the directory, and one on their Internet site *www.artdiary.net.com*; a copy of the directory and a one-year subscription to *Flash Art*. To find out more information about this directory contact Giancarlo Politi Distribution S.r.l., Via Carlo Farini, 20159 Milan, Italy; 39-02-688-7341; fax: 39-02-66801290; e-mail, *politi@interbusiness.it*. U.S. info: Distributed Art Publishers, Inc., 155 Avenue of the Americas, 2nd Floor, New York, NY 10013; 212-627-1999.

- **Art in America.** Published at 575 Broadway, New York, NY 10012;

212-941-2800, this is an annual guide to galleries, museums, and artists. It includes U.S. museums, commercial galleries, university galleries, nonprofit exhibition spaces, corporate consultants, private dealers, and print dealers. An alphabetical listing cross-referenced to artists' gallery affiliations and to institutions where they exhibited in 2002. If you are affiliated with a gallery, make sure they contact this guide to have themselves and you listed. This guide appears during the month of August and is part of an annual $29.95 subscription.

- *Who's Who in American Art.* Published at 121 Chanlon Road, New Providence, NJ 07974; 800-473-7020; *www.marquiswhoswho.com.* The book profiles more than 11,000 entries and contains biographical and professional information about those how have made their mark in the visual arts. Visual artists are listed from the United States, Canada, and Mexico, including artists, administrators, educators, collectors, critics, curators, and dealers, "obtained from nominations provided by current artists, art associations, galleries, and museums, or from citations in professional publications." Read the preface to fully understand the how, why, and what for their selections. There is no cost to be listed, and artists can nominate themselves through the Web site to be included in this book. There are other Marquis books such as: *Who's Who in the Midwest, East, South and Southwest,* and *West.* Contact them at the same address to find out if you qualify.

- *Dictionary of International Biography, Who's Who in the 21st Century,* and *2000 Outstanding Intellectuals of the 21st Century.* All published by Melrose Press Ltd., St. Thomas Place, Ely, Cambridgeshire, CB74GG England; 44-1353-646600; fax 44-1353-646601; e-mail, *info@melrosepress.co.uk; www.melrosepress.co.uk.* *Dictionary of International Biography* details the success and achievement of some 175,000 individuals from around the world and includes an Internet form, which gives you the opportunity to recommend friends, family, or colleagues whom you consider eligible for inclusion. The other two directories select the most influential and respected people in the world today, based on a variety of criteria. There is no cost or obligation to be included in these directories.

- *Strathmore's Who's Who.* Publisher can be contacted at 26 Bond Street, Westbury, NY 11590; 516-997-2525; fax: 516-997-8369; e-mail, *admin@strathmore-ltd.com; www.strathmore-ltd.com.* This directory lists thousands of successful individuals in the fields of business, arts and sciences, law, engineering and government. You can self-nominate and they have a members' Web site. There is no cost or obligation to be included in the directory.

The National Network for Artist Placement (NAAP)

NAAP has many useful directories, services, and publications that can help artists shorten the distance between emergence and paid professionalism. Some of their publications include:

- *Art & Reality*, **2000.** Shows you how to present your artwork in a way that will gain access to museums, universities, galleries, and publishers who might otherwise be out of reach. It is a reference guide and business plan for actively developing your career as an artist. The cost is $42.95, and this includes shipping.
- *Art that Pays: The Emerging Artist Guide to Making a Living,* **2003,** by Adele Slaughter. Inside this book are practical suggestions and ideas to help you cope with the artist's life including: finances, the Internet, legal assistance, grants, working overseas, MFA programs, and artists retreats. The cost is $41.95, and this includes shipping.
- *Breaking Through the Clutter—Business Solutions for Women, Artists, and Entrepreneurs, 1999,* by Judith Luther Wilder. This book has a section on alternative financing, which contains over four hundred listings of micro-lenders who make uncollateralized loans of $500–$25,000, and another section on bartering, which trades your artwork or art services for another service or product. Additionally, it has other information about grant resources for individual artists, business centers, technical assistance providers, and the Internet resources to build your business. The cost is $37.95, and this includes shipping.
- *National Directory of Arts Internships 9th Edition, 2003–2004.* Educators and artists cite this directory as a helpful resource to emerging artists seeking a shortcut to jump-starting their careers in any of the visual or performing art disciplines. There is also a very informative appendix with sample intern forms and résumés. The cost is $83, and this includes shipping. NNAP, 935 West Avenue 37, Los Angeles, CA 90065; 323-222-4035; e-mail, *info@artistplacement.com; www.artistplacement.com.*

Visual Artists' Information Hot Line

The Visual Artists' Information Hot Line is a toll-free service of the New York Foundation for the Arts, offering information for individual artists on useful books and a variety of other topics. The number is 800-232-2789, 1:00–5:00 P.M. E.S.T., Monday–Friday. During other hours, artists can request information either by leaving a message on voice mail, by e-mailing *hotline@nyfa.org,* or by directly accessing fact sheets online at *www.nyfa.org/vaih.*

Chapter 6.

Thirteen Artists' Profiles

After many creative years, an artist produces a major body of work, allowing it to mature over time. Even the graffiti artists practiced their art for years on the mean streets before being commercially recognized. Be patient, allow audiences to become acquainted with your work, and build a distinguished résumé. Private collectors and museum collections do not like to take artistic—and especially financial—chances. They prefer to make a long-term commitment to an artist's development and its aesthetic concerns (perhaps). This happens when an artist establishes a "loyal" relationship with a collector or museum on the basis of a full body of work and the appropriate support materials: newspaper and magazine articles, reviews, radio and television spots, teaching positions, grants, artist-in-residencies, and donations and sales to public and private collections.

Emerging artists attempting to establish a body of work should first organize group shows, and then enter open competitions as well. You should also apply for local or state grants. Before venturing out, you will need to have an appropriate number of quality works: at least eight to twenty pieces, which should have a consistent theme or quality. Do not confuse curators or judges in the beginning of a career by submitting an array of styles or techniques unless you will develop each into a separate series (each series being at least eight to twenty works).

Galleries have come up with the number forty as the optimal number of works to be exhibited in a particular show. This means that if curators know you have more work in reserve, they will want to choose from that body. If you were to create one artwork a week, for a year, fifty-two pieces would be created, of which

forty could be chosen. Today, it is realistic for an established artist to hope for a solo show every eighteen months. Therefore, your output does not have to be one work per week. This may be a good goal to set; however, consider your style and the degree of complexity involved in your work. Creating art at this steady pace would enable you to produce a significant body of work, five hundred pieces, in ten years. The work does not all have to be one particular style or in one media, but it will allow you to become adept at your craft, thereby establishing a reputation. If what is created is top-notch (at least in your eyes), then earning money should be your goal, since your talent will have been proven over time.

If you are not ready for a solo show, assemble a smaller number of works for a group show. Twelve artworks need to be created for group shows, of which eight are selected for exhibition. This small amount of works shows a serious continued investigation and a potential for further artistic development.

Your ideas might not have fully matured, but it is necessary to exhibit (you are either appearing or you are disappearing). Critical public feedback about the work via oral or written reviews provides for growth. After doing a select mailing to galleries, competitions, and grantors, and after executing artists-in-residencies or commissions, it is entirely possible to emerge empty-handed, without any major, or even minor, successes. Be persistent; that is the life of an emerging artist.

All the artists profiled have in common a commitment to creativity, and while their techniques vary (in an ebb and flux), rumor has it they have a way of knowing when to exhibit their artistic toys.

Mary and Eric Ross

By carrying out a carefully planned publicity campaign for many years, Eric and Mary Ross of Binghamton, New York, have gradually attained international recognition for their stunning music and visual multimedia performance artworks. Since 1976, Mary has combined photographic stills with image-processed video and computer graphics. She is one of the pioneers of the videography medium, thus she co-curated with Julius Vitali the seminal *Pioneers of Digital Photography* exhibition, held at Open Space Gallery in 1998. Her publishing credits include *Modern Photography, Popular Photography, Videography, Digital Imaging,* and the *British Journal of Photography*. Public collections that include her work are: Herbert Johnson Museum at Cornell University; Lincoln Center Library for Dance; Bibliotheque Nationale in Paris, France; Royal Library in Copenhagen, Denmark; and Kunsthaus in Zurich, Switzerland. They have received grants from the NEA, New York State Council on the Arts, Meet the Composer, and Pennsylvania Council on the Arts.

Meanwhile, Eric is a versatile composer and multi-instru-

A promotional piece for Eric and Mary Ross.

mentalist performing on keyboards, piano, guitar, percussion, and Theremin, the precursor of the synthesizer, invented by the Russian engineer Leon Theremin in 1924. Being a master of this instrument, he is one of the few composers continuing to write for it. Over two hundred performances in seventeen years have occurred in such noteworthy venues as the Kennedy Center, Lincoln Center, Newport Jazz Festival, Montreaux Switzerland Jazz Festival, Copenhagen New Music Festival, and Berlin Jazz Festival. The Eric Ross Ensemble has had such featured jazz giants as John Abercrombie, Larry Coryell, Andrew Cyrille, Oliver Lake, Leroy Jenkins, Clive Smith, and Youseff Yancy. Occasionally, the exceptional dancer Atsuko Yuma contributes choreography.

The Ross's reputation permits them an honorarium of $1,000–$2,000 per performance. This reputation is partly based on the multimedia aspect of their performances. Eric has said, "I started working with multimedia early on. I was always interested in it. I thought of the projected video as another line in the score. It is a visualization of what I am doing musically. Mary's work seems to fit extremely well with what I'm musically doing because it's nonliteral, non-narrative video."

Eric and Mary met in 1970 at the State University of New York at Oneonta and married in 1972. The collaborations

that continue to evolve today began in 1977. In 1980, Eric had his first solo performance in Europe, and, since then, he has become internationally renowned for his frequent performances at jazz festivals. In 1982, he premiered his *Concerto for Orchestra* at Lincoln Center, New York, and released his first solo album, *Songs for Synthesized Soprano*, on Doria Records, with Mary creating the album's colorful cover art. Eric and Mary have been featured and reviewed in the *New York Times, International Herald Tribune, Toronto Star, Washington Post, Electronic Musician*, and *Keyboard*.

Being his own booking agent, he is constantly in quest of new venues, as their art falls under such festival categories as Cutting-Edge Night, New Directions, or New Music. Eric says, "Searching the Internet under domestic or international jazz festivals, new music festivals, contemporary art museums, concert series, or art centers has proved extremely helpful."

Currently, Eric relies on e-mail and his Web site (*www.geocities.com/theremin_eross*) to solicit work. It has taken him five to six years to create their e-mailing address book, which has more than four hundred names. In the past, he used to just snail-mail out seventy proposals a year and receive about seven to ten concerts a year. Now, with e-mail, thirty to forty concerts are proposed, and they are able to solicit twelve to fifteen concerts a year. A marked improvement, as people can link to his Web site to see and hear one to two minutes of streaming video clips of his concerts, audio clips, and all the written information, reviews, résumé, etc. To produce a European tour of six dates in five countries takes one year to accomplish. After two decades of performing, the possibility of recycling back to previous venues emerges. In 1984, the Stedelijk Museum in Amsterdam, Holland, was the site for a live concert and recording for Dutch radio, and in 2002 he triumphantly returned. Similar sites such as the Icebreaker in Amsterdam happened in 1990 and again in 2002. Currently, four CDs of his works are available: *Live at the Berlin Jazz Festival; Mars2Earth*, a quartet including Byard Lancaster, Toshi Makihara, and Vito Ricci; Debrah Thurlow's *I AM;* and *Songs for Synthesized Soprano.*

Additionally, he receives BMI composer and publisher's royalties from his U.S. and European concerts, Internet radio, radio, and television performances. As for his compositions, the *New York Times* calls Eric Ross's music "an unique blend of classical, avant garde, serial, and jazz," and he continues to push the boundaries of composition in an extraordinarily positive way. E-mail him at *mross@pronetisp.net.*

William Rabinovitch

William Rabinovitch was an engineer and pilot in the air force and an engineer-scientist before finally trading in his engineer's Porsche for a VW camper and paintbrushes. Then, in 1963 he began to paint professionally. After studying at the Boston Museum School, he landed in San Francisco and Monterey, California, creating Imaginative Expressionistic paintings. In 1964 he was accepted to the San Francisco Art Institute in the MFA program on the GI Bill. He began to win awards in every contest he entered. First prize in 1966 included a solo exhibition at the Monterey Peninsula Museum of Art.

In 1973, he was accepted into the Whitney Museum of Art Independent Study Program, solely based on his portfolio. This brought him to New York City, and he has been here ever

The Horse, William Rabinovitch, Acrylic on Canvas, 1979.

since. The Rabinovitch Gallery began two studios, which were open from 1974 through 1996. Here he made most of his sales directly to collectors. William has been in numerous exhibitions and has received forty reviews from such publications as *New York Arts, Art-in-America, ARTnews, New York Times, Village Voice*, etc. The prices of his paintings range from a high of $25,000 down to $10,000; his average sale price is $12,000–$10,000 for large works. Currently, the Ross Power Gallery in North Miami, Florida, handles his artwork, as two of his paintings were shown at the Basel/Miami International Art Fair in December 2002.

In 1995, Wendy's at 650 Broadway approached Bill to display work in their Soho restaurant. They had originally seen his work hanging in the nearby Hot and Crusty restaurant. Six paintings are now on permanent display, and they are seen by thousands a day.

A friend of William's, Dave Howard, was producing and showing a half-hour public access show *Artseen* from San Francisco. However, the public access channel in New York City became his main venue. William was at the right place at the right time when the public access channel wanted a New York City producer to have a show about the New York City art scene. Therefore, he served as the *Artseen* producer in 1993–2002. *Artseen* began as a forum for interviews, documenting thousands of openings in New York City and profiles of artists. From 1993 through 1996, he produced original interpretative plays of famous artists such as Picasso, Egon Schiele, and Julian Schnabel; these were shown in different cable markets across the United States. He won three producer's grants and numerous awards, and in 2001 the Museum of Modern Art (MOMA) provided him a solo evening at the Titus Theater.

His cable show allowed him a dialogue with numerous galleries and this led to being included in group shows over the years. The archives from this show are extensive and valuable and he is in the process of converting everything to DVD.

Because of his experience with *Artseen*, William has always wanted to produce and direct a feature film related to major artists of the twentieth century. In 1993, his first impulse was to interpret Jackson Pollock. It was not until 1997 that he began to formalize this cinematic dream, after losing his Mercer Street studio in Soho. He visited the Pollock-Krasner Study Center in the Hamptons on Long Island, New York. The curator Helen Harrison was supportive of his project and allowed him to film. The 1999 MOMA Pollock Retrospective renewed Pollock as

a household name along with the Ed Harris film about Pollock. Currently William's film *Pollack Squared* is available on DVD and it features artist/actors from the New York City art world, like Dennis Oppenheim, Art Historian Professor Arthur Danto, Frank Shifreen, Vito Acconci, David Hatchett, Lily Hatchett, Lisa Reno, Tatiana Vidus, and Barnaby Ruhe. E-mail William at *rabinart@aol.com,* and visit *www.pollocksquared.com.*

Cindy Sherman and Robert Longo

Two artists who started out in the artist-organized, alternative-space gallery scene were Cindy Sherman and Robert Longo, former State University of New York (SUNY) at Buffalo students. In 1974, they were living in Buffalo in a building supported by the Ashford foundation. The alternative space "Hallwalls" was so named because the walls of the hall of the building were used for exhibition purposes. The gallery space was located in the hall between founders Robert Longo and Charles Clough's studios.

At the time, the New York State Council on the Arts awarded Hallwalls an $8,500 grant. This grant was well received in part because it soon became one of the most important alternative spaces in the country. Cindy Sherman was the secretary and used Hallwalls as a forum for her work. In 1975, she was included in the annual survey show that the Albright-Knox Museum (Buffalo) mounted of New York state artists.

Being part of an artist organization in the 1970s (pre-NAAO) put them in contact with other New York state sites, such as New York City's Franklin Furnace, Artists' Space, and the Kitchen. They realized that living in Buffalo, even with a top-notch alternative space, they could only take their careers so far. Therefore, in 1977, when Sherman had received an NEA (National Endowment for the Arts)Conceptual/Performance/New Genre category grant for $3,000, she and Longo (who received a $3,000 NEA Conceptual/Performance/New Genre category grant in 1978) decided to move to New York City. Sherman took a job as a receptionist at Artists' Space, which put her in contact with the alternative and commercial art scene. In 1979 she received another $3,000 NEA Conceptual/Performance/New Genre category grant.

Between 1977 and 1980, she created about seventy-five pieces for the *Untitled Film Stills* series. This culminated in her first solo exhibition at the Kitchen in 1980, and with the success

of that show, she had her second solo show that same year at Metro Pictures, a commercial gallery in Soho. Her reputation from the Metro Pictures show instantly made her globally known—a situation that most artists only dream about—and she still exhibits there on a regular basis. In 1982, Longo received a $25,000 NEA grant in the Conceptual/Performance/New Genre category.

All artists start from ground zero. The creation of a body of work, persistence, timing, and, most importantly, the public forum of exhibitions (especially in New York City) with positive critical reviews all help to make a career. Contact Sherman via Metro Pictures gallery, *www.artnet.com/metropictures.html.*

Lily Hatchett

Lily Hatchett is an artist who casts a wide web, spanning media that range from drawing, painting, and sculpture, to large-scale installation, photography, and videography. She began her illustrious career in 1975 attending Antioch College, graduating cum laude with a BFA.

Applying late for the Hoffberger graduate program at the Maryland Institute College of Art, she telephoned the Abstract Expressionist painter Grace Hartigan who taught there and said, "Your program can't do without me" and received an appointment for a portfolio review. She passed the portfolio review and received the prestigious Hoffberger Fellowship, for which only six students qualified. The review committee, consisting of Sal Scarpitta, Phillip Guston, Elaine De Kooning, and Grace Hartigan, accepted a wide range of art styles (Lily received an MFA in 1977).

In the same year, she participated in a group exhibition at the Baltimore Museum of Art, the *Five Maryland Artists*, which produced a catalog plus favorable regional press. Then, the success of that show caught the eye of the prestigious Corcoran Gallery, Washington, D.C., for an exhibition titled *Graduate Drawings*, which featured fifty graduate students, one per state.

During this time, she unexpectedly met Barnaby Ruhe in a tree, where both were seeking solitude. Although an unusual place for inspiration, they have remained life-long friends.

Lily comments about the creative process, "The tearing of paper is as an act of drawing . . . Gettin' jiggy with it, have some creative fun. Artists create their own reality from an inspirational point of view; it is like the miracle of drawing—creativity

Toaster, Lily Hatchett, acrylic on canvas, 2000. Photo by Lily Hatchett.

all comes out of that practice—if you think you might get no for an answer do not ask for permission."

In the exhibit *Ajita* at the Station in Houston, Texas, in 2002, Tex Kerschen writes about her work, "Lily Hatchett is a versatile, restless artist, constantly involved in the endeavor of making art. The improvisational, from-the-hip attitude of her work relates to the Fluxus tradition in art. Like the modes of the music paper upon which she has mounted these paper heads like hunter's trophies, each of these masks picks up a refrain in a different key. They are delicate and impermanent, ranging from ripped-up portraits in the manner of Phillip Guston to crumpled, Zen-like abstractions."

mModal Orchestra, Lily Hatchett, music paper, 2002. Photo by Lily Hatchett.

Exhibitions of her work have been at Station, Houston, Texas; DeCordoba Museum, Massachusetts; Wake Forest University, North Carolina; Sarah Lawrence College, New York; The Congress Rotunda, Washington, D.C.; Bard College, New York; Open Space Gallery, Pennsylvania; and Equitable Foundation, Eugenia Kukalon, Exit Art, and White Columns, all in New York City. The price range of her work is from $500 to $7,000.

Some of her production designs are for theatre, film, and television. Two examples are: *Faust Invitro* at the LaMama Theatre, New York, incorporated diffusion screens, rear and video projections; and a television pilot, *The Wheels on a Bus* written and produced by Peter Rosenthal, in which she transformed a yellow school bus into an animalistic cartoon character with moving eyes. This massive project took one month to complete.

Her wide range of innovative occupations (photography and digital video) have put her on the road with bands like Ringo Starr, George Clinton/Parliament, Funkadelic, Fishbone, Live, NOFX, Youssou N'Dour, and Hothouse Flowers.

In the DVD feature *Pollock Squared*, she acted, provided stock footage, and was a cameraperson and creative consultant. Presently, she is a staff senior photographer for the *Film Festival Today*, and this position allows her to travel to festivals like Sundance for assignments.

In 2001, she created a photography and text research book for a landmark eminent domain case in New Orleans, involving a sculptor's studio. Artist Steven H. Lesser has a 40,000 square-foot building with a foundry, glass melting, art gallery, printmaking facility, and an art library. Using Adobe Photoshop, she photographed, wrote, assembled, and designed all the documents (a one-hundred-page limited edition) for this legal case. The case is now pending and the building is still in use.

Currently, she has two Web sites, *www.liltv.com* and *www.onthebus.com*, which serve as offshoots of a work-in-progress documentary about a rock tour bus driver. It will be an independent feature. E-mail her at *Liltv1@aol.com*.

David Hatchett

David Hatchett is the son of Duayne Hatchett, the famous abstract painter and sculptor whose works are in the collections of such major museums as Albright-Knox, and the Whitney Museum of American Art. He taught art at the University of Buffalo, New York, from the late sixties until the

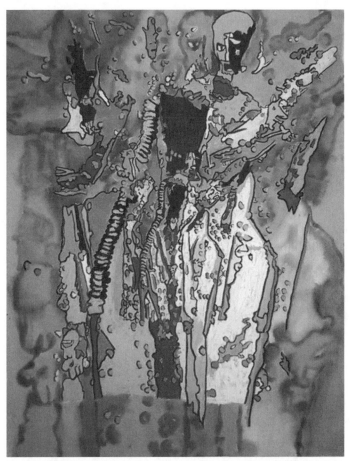

Dramas, David Hatchett, oil and acrylic on canvas, 2002. Photo by Lily Hatchett.

late nineties. David originally attended the University of South Dakota and then transferred to the University of Buffalo, at a time when the color-field painters Frank Stella and Ken Noland influenced his painting style.

A commission to design a 20' × 100' outdoor mural for the "Deco Restaurant" in Buffalo produced extraordinary results. While painting long ribbons with a roller, as part of a peripheral illusionist after-image vision work, the industrialist Seymour Knox of Marine Midland Bank watched him from his office across the parking lot. It just so happened that David was exhibiting his work at the University of Buffalo gallery and Mr. Knox sent his staff to see the solo show. In 1971, at twenty-one, he became the first Buffalo artist to exhibit at the Albright Knox Museum, Buffalo, New York. (His work was then purchased by their collection and again for his sculpture in 1984). Then, in

1970–1971 he received the prestigious Whitney Independent Study Grant from the University of Buffalo to work in New York City. David attended Rutgers University from 1974–1976 graduating with a MFA (and during that time had a teaching assistantship).

The year 1974 was pivotal for him as an artist. During his New York City residency, he studied and practiced kung fu; this involved a rigorous five-year physical training and meditation program, which then became the basis for what he describes as an intuitive creative process that has guided an inner vision.

Often, it is very difficult to explain the creative process; in Hatchett's case, it might be helpful to think of a stream-of-consciousness artistic technique, whereby the ego seemingly has no influence over how the images are formed.

This complex revelatory process is animated by a "moment of vision" that erupts in a flash. For instance, Hatchett has devised an idiosyncratic formula that allows him to convert a commonplace image, like a woman walking down the street, into the foundation for a work of art.

In 1986 he was commissioned by the avant garde visionary Robert Wilson to produce thirty-six costume designs for *Parzival*. This was originally based on Wagner's *Parsifal* legend. A mutual friend introduced him to Wilson, who then utilized his sculptural talents. David worked on the project for four months. The Thalia Theatre premiered this work in Hamburg, Germany, and it continued for nine months.

His new paintings, which date from 1996, are based on his "kid" drawings (ages four through twelve). These works present a "primary image" or inner vision, in relation to a secondary image by means of techniques that are similar to those used to produce video special effects (keying, matting, or superimpositions).

In a second group of paintings that began after 9/11, an extreme close-up of a pile of his metal sculptures is photographed in black-and-white. He translates this photograph to a drawing using Neo-Color, which is a glorified crayon. Then, the drawing is used as a study for his large oil pastel and acrylic paintings. In addition, since 1996–1997 the use of Adobe Photoshop has become a pivotal, though hidden, part of his artistic process. The question of how to get the computer image onto canvas is the major aesthetic problem his recent work addresses. To solve it, he inputs an image in Adobe Photoshop, and then after manipulating it, displays it as an enlarged image. Frank Shifreen has called his work "Neo-Art, Brut Style."

Since 1971, David Hatchett has been professionally exhibiting in such venues in New York City as the Alternative Museum, Exit Art, Side Show Gallery, Souyun Gallery, Diane Brown Gallery, and Charles Cowles gallery.

In the 2002 group exhibit *Ajita* at the Station, Houston, Texas, Tex Kerschen writes in the color catalog about his work: "Hatchett paints these images from drawings he made in his youth. He preserves the original drawings, and with them the assiduous candor of pure imagination, even as he begins to intervene. By repeating solitary images, arranging them in squads, and ghosting them in washes of paint, he garbles their original meaning. His role in the art is as a bad editor or an unreliable narrator. The grotto where Christ on the Cross is eternally tormented by a sliver of a man and what looks like an animated Eiffel Tower, is closer in spirit to the irreducible humor and shambolic narratives of Mark Twain than to the airless sentimentality and systemic nostalgia of the faux-naif painters."

Currently, David writes for *Arts4All* newsletter (penning two recent articles about 9/11); he has also acted in the DVD feature *Pollock Squared* playing the artist David Smith.

In 1984, David began writing music and lyrics—sung by Lily Hatchett—for the performance art band "BandMental" (later renamed "Linoleum Blownapart" and then simply "Blownapart") whose live shows included video and slide projection. They have released two CDs, *Substitute for Bliss* and *Live at the Mercury Lounge* (*www.LilTV.com*), and performed in New York City at Underworld, Spiral, Mercury Lounge, King Tut's Wawa Hut, the Anchorage, Alternative Museum, Hallwalls in Buffalo, New York, and the Patsy Whitman Gallery, Greenwich, Connecticut. Like much of his artwork, Hatchett's music has an improvisational quality to it, although it bears a certain structure (i.e., a synthesis of experimental sound and pop music).

His success as an artist and musician adds to the mythification of an art career that has been defined by a unique creative process and a penchant for commercial ingenuity. His impressive career began at the exceptionally young age of twenty-one in 1971 and continues to develop, as his works are frequently exhibited at prestigious New York City galleries (selling as high as $10,000). Contact him via e-mail at *davidhatch22@aol.com.*

Cynthia Rodriguez

At thirty-two, Cynthia Rodriguez is making a regional reputation for creating various types of cutting edge and "outsider" artwork, including painting, photography, sculpture, objects d'art, and performance art. It all began in 1986 when she was selected through an academic test and portfolio review for the prestigious High School of Art and Design, New York City. In 1990, she moved to Allentown, Pennsylvania, and continued to refine her style, and by 1995 she became affiliated with the Open Space Gallery (OSG), where she first volunteered and exhibited. In 2000, she became a paid OSG assistant director for two years.

Devoted to working in the arts, a variety of opportunities arose through becoming a member of local theatre and performing groups. This culminated in making large-scale puppets for *Mar Y Sol*, a Hispanic group that needed help from local artists for the Allentown's Mayfair festivities and the *Bread and Puppet Theatre*. As a result of working with other professional artists she observed the long-term commitment and dedication which flourished in her found objects d'art. These are titled "Psyko-Deko," which include found furniture and accessories, "Recycled Roses and Other Unique Flora," and "Industrial Ware," (flower sculptures and jewelry made out of found objects). These are found amidst curbside garbage and then fixed, painted, and sold for up to $350. Cynthia also produced "Alternative Lifestyles" magnets, which are similar to the old paper dolls that were designed, in part, so that one could change their clothes. In this case, they are exhibited on refrigerator doors and the different outfits reflect "alternative lifestyles." Prices range from $5–$25. Additionally, every Halloween she is a set designer and mural painter for Terrorhill in the Terryhill Water Park, Allentown, Pennsylvania.

OSG has had numerous seminal national exhibitions in which Cynthia Rodriguez contributed such eye-catching works as: 1998 *Artist Plate Project*, 1999 *Awkwardology*, 1999 *Near-Blighted*, 2000 *Missing Children*, 2001 *Abstracta*, 2001 *Portrait*, 2001 *Crayon*, and 2001 *Doll* shows. Often, photographs of her work appeared in such newspapers as: the *Morning Call*, *Express-Times*, *Allentown Times*, *Easton Irregular*, and *Nickel*, a monthly that featured her on the cover. Additionally, her work appeared on the local television channel WFMZ-TV 69, Blue Mountain Cable, and the New Arts Program cable show *New Arts Alive*. In 2001, a solo show titled *Sexation* was held at Venue Gallery, Kutztown,

Blightcycle Wheel, mixed-media, Cynthia Rodriguez and Julius Vitali, 2000. Photo by Julius Vitali.

Pennsylvania, which brought much media attention due to its sexual-based alternative lifestyle themes. Another important exhibition *From the Ashes* and *Witness,* both post-9/11 shows, from October to December 2001, were held at CUANDO, New York City, New York, and Open Space Gallery in February 2002.

After OSG's upheaval in February 2002, she opened The Underworld Art Studio, in downtown Allentown. This was previously based on her OSG resident artist studio where workshops and studio openings occurred. The new space was modeled after Warhol's factory where the studio and workspace were turned into a gallery and performance space. It is not uncommon for fifty people to attend an art opening and twenty people to attend the live events such as poetry readings, music, performance art, lec-

tures and "outlets for alternative lifestyles." She continues to exhibit in the New Art Programs *2002 Small Works Show*, Kutztown, Pennsylvania, and a solo show titled *Pulp Religion* is scheduled for 2003 at the Theatre Outlet Gallery, Allentown, Pennsylvania.

Cynthia's *The Ror crotch test* (a series spoofing the Rorschach psychological test of ambigious figures) is tempera paint on models crotches, and when the models close their legs, the "crotch image" is adhered to paper. This series will be exhibited widely in the Lehigh Valley in 2003. Additionally in 2003, she will be collaborating with Arthur Eisenbuch, Ph.D. (who also exhibited in the *Ground Zero* show at MONA) in an art exhibit titled *The Great American Novel*, based on the Beat Poets (Kerouac, Ginsberg, etc.) and she will be exhibiting with her artist father, Victor Rodriguez, Sr., in a show titled *Like Father, Like Daughter* consisting of New York and Pennsylvania landscapes.

As a result of opening her underground studio, and the subsequent publicity in the *Allentown Times*, she was offered a weekly political comic strip as a forum for written commentary about local news and culture.

In the Lehigh Valley, Pennsylvania, area, she hosts a few times a month in different locations "Rhythm Street," "The New Beat," and "The Urban Tribe," which consists of people using this forum to try out music, spoken word, drumming, and/or performance art. An outgrowth of this is her three-piece band the "Trash Can Orchestra" (TCO), which falls under the category Experimental Industrial Urban Primitive Noize. Their philosophy is the manipulation of organic sounds using found objects.

Plans are in the works for showing experimental video and film in the "Underworld Art Studio." In 2004, she will open her own art gallery titled "The Alien Beatnik." Contact her at 888-776-1651 or via e-mail at *picasso691@hotmail.com*, and visit her Web site at *www.cynthiarodriguez.com*.

Berrisford Boothe

Let us look at the career of Berrisford Boothe, a professional artist whose recent work in both painting and what he calls virtual lithography can be described as a sampling and recombination of repeated structures and geometric motifs that often include figurative marking and transparent fields of color abstraction. The images have evolved from varied sources but owe much to the 1940s New York School of gestural abstraction.

Berrisford Boothe at his Lehigh University office, Bethlehem, Pennsylvania. Photo by Berrisford Boothe.

Boothe is forty-one years old, and his career is gaining momentum and recognition. Currently, he is a full-time associate professor of art & design at Lehigh University, Bethlehem, Pennsylvania. His most recent résumé includes twenty-seven group shows since 1996 and a 1996 solo show at the June Kelly Gallery, New York City, plus a major 1995 installation at the Fabric Workshop in Philadelphia titled *Material Culture*. From 1999 to 2001, he was included in the African American Museum inaugural Biennial 2000: *At The Crossroads* curated by Helen Shannon. He was an artist-in-residence and printmaker at Curlee Holton's Experimental Print Workshop, Lafayette College, Easton, Pennsylvania. (A limited-edition book of fifteen prints resulted.) A 2001 solo show at the OSG, Allentown, Pennsylvania, titled *Translations. Substance and Form* received significant regional publicity.

Originally from Kingston, Jamaica, Boothe emigrated to the United States at age ten and eventually received his MFA from the Maryland Institute College of Art. While at the Institute, he was chosen to be the sole recipient of the thrifty-but-prestigious Walters Museum of Art Traveling Fellowship. Valued then at $3,000, the fellowship allowed its recipient to travel any-

where to make art. Keenly aware of Britain's class-based racism and, as he put it, the "rapid Americanization of England," Boothe chose to settle within the arts community in Bristol, England. In that community were some of England's rising art photographers including Martin Farr, Peter Fraser, Jamie Woodley, and Sarah Quick. Frequent artistic exchange within this group would have a major impact on Boothe's approach to making art, especially in his digital work.

With the monetary conversion rate eating away at his funds and a shortage of affordable studio space, he joined a fledgling group of artists in an old warehouse space on Redcliffe Street. The Redcliffe artists' group, started by painter Claire Churchouse and sculptor Charles Farina, grounded Boothe in the arts community. During the remaining months of his stay, he was able to create twelve canvases, which he describes as the *Angry Young Black Man in Your Face* series. The works, similar to those that won him the fellowship, were exhibited to favorable reviews when he returned to the United States.

After returning to the States, Boothe taught part-time at his alma mater, Lafayette College, and part-time at Lehigh University. Within a year, the latter asked him to join their Art and Architecture faculty. During the transition period between jobs, Boothe, now feeling confident about the Bristol paintings, spent some time walking the streets of Soho, "looking for a space to show." He remembers visiting galleries and trying to convince the dealers to pick up his work. This approach did not work. He was making a name for himself in regional Pennsylvania exhibits, but nonetheless decided that it was time to "stop painting pictures about things/issues and begin to look at himself as a self-appointed artist outside the trends and flux of the art market."

Encouraged by improvisational jazz musician Gary J. Hassay, he began a series of automatic drawings in a variety of media, all the while "searching for the me in the mess." After hundreds of drawings and several collaborations with other artists, dancers, and musicians, Boothe came to realize his long affinity for expressive, lyrical, gestural compositions.

Performing in interdisciplinary events encouraged Berrisford to begin to investigate the interesection between digital media and traditional notions about the nature of "drawing as a verb." In 1994, Boothe, along with physicist Clem Skorupka and composer Ko Umezaki started The Beclemko Project—the development of an interactive, conceptually flexible environment for real-time drawing as experience. Boothe directed the conceptual

input in developing new software with composer Umezaki. In 1998, this collaboration *The Beclemko Project v1.0* saw its fruition as performance at The Theatre Outlet in Allentown, Pennsylvania. It strengthened into a full cross-media stage concert featuring improvisational Japanese Shukahachi music and virtual drawing on a new interactive system designed by Kojiro Umezaki and Berrisford Boothe. In 1999, *The Beclemko Project v2.0.* premiered at The Art Director's Club, New York City, with Kojiro Umezaki. This multimedia improvisational work features computers, video renderings, and real-time virtual drawing.

As a studio teacher and lecturer on African-American art, Boothe had occasion to visit New York City galleries, including the June Kelly Gallery where he acquainted his students with quality work and introduced himself to the dealer.

Nearly a year later, he approached Kelly regarding a show with a specific body of work he felt would interest her market. With a show date at the tail end of the summer season, Boothe again created a new series of paintings. These were based on drawings, which included multimedia work on Mylar developed in collaboration with the painter Howard Greenberg. The show had a total of thirteen new paintings, ten on wood panels and three on Mylar, and six drawings. Two paintings sold in the $2,500–$5,000 range, and later, six drawings sold in the $400–$700 range. Through the work of the dealer, two pieces on Mylar were chosen to be included in the Albright Knox Museum show *New York Scene Comes to Buffalo.*

The professional relationship Berrisford Boothe has developed with June Kelly has given rise to the free flow of creative and business opportunities. The June Kelly Gallery's prominence in the art world has a wide network; there have been numerous times that authors, writers, or curators have contacted Kelly about their projects. She in turn, will refer the most appropriate artists to them. Berrisford has significantly profited from this association. The African American Museum in Philadelphia, Pennyslvania, mounted their first Biennial 2000: *At The Crossroads,* September 21, 2000–March 25, 2001, and Berrisford Boothe was one of sixteen artists included in this seminal exhibition. In addition, three books have included reference to his work: *African-American Art,* by Halima Thaha (Crown Publishers 1999), *Creative Spirituality: The Way of the Artist,* by Robert Wuthnow (University of California Press, 2001), and *New Material as New Media: The Fabric Workshop and Musuem,* (MIT Press, 2002).

Prior to the June Kelly show, Boothe had been working hard to increase his name recognition in both the New York and Philadelphia markets. He quotes the 1950s jazz maxim "you are either appearing or you're disappearing." He frequented gallery openings and introduced himself as part of a basic overall strategy. This worked for him, and he was able to get his first one-man show in Philadelphia at the Ester Klein Gallery in 1991. With strong and favorable reviews in tow, he was invited to be an artist-in-residence at the renowned Brandywine Print Workshop run by Allan Edmunds in Philadelphia. A friend and noted painter, Michael Kessler, introduced him to founder and artistic director Kippy Stroud at the Fabric Workshop. At the time, inclusion in a workshop roster often came through recognition of an artists' increasing visibility and a recommendation of a current or previous residency artist. After being invited, Boothe submitted a project drawing for the installation *Material Culture*.

The Fabric Workshop insists on the integration of fabric into the process and product. *Material Culture* incorporated the colors of Boothe's native Jamaican flag: black, green, and gold. Boothe explained the work as a way to "purge" the ideas, influences, and concerns that helped shape his life and beliefs as a Jamaican-American artist. The 10' × 30' installation involves seventy-two pieces of hand-dyed silk panels, which allows individuals to walk through membranes of silk, losing defined contours of themselves to the observer as they approach three centrally lit, floating text pillars.

In July 1994, the *Philadelphia Inquirer* magazine did a feature on the Fabric Workshop and prominently featured Boothe and his project. In February 1995, the *Philadelphia Inquirer* reviewed the exhibit favorably. This exposure greatly enhanced his name recognition. Never resting on thin notions of fame or achievement, Boothe continues to enter regional and national exhibits based on who the juror is. "An intelligent juror with a great eye who can put context together with venue will get you far," says Boothe, "especially curators of contemporary art."

Teaching, developing, and facilitating courses at Lehigh University for the past eleven years made it possible for Boothe to receive in 1996 a Curriculum Innovation Award Winner in Integrated Product Design. Continuing on this success in 2000, he became an Endowed Professor of Art & Design (two-year endowment), and in 2002 he was co-author, coordinator, and facilitator of Lehigh's Design Arts Major/Initiative. The Lehigh University Art and Architecture department, like comparable

departments throughout the county, provide internship opportunities for its majors. In early 2002, Boothe assisted in forming, and is faculty advisor for the Lehigh University Design Club (LUDC). This club will offer design services to university entities as well as to local artists and their self-employed businesses, i.e., Web design and new media CV/résumé solutions. Contact the art or computer science departments at your regional college or university to see if they have interns for Web-related graphic work. The amount of hours required for credit will vary from one institution to the next but might involve 120 hours of off-campus work.

The scope of Berrisford's art career also includes graphic design; for example, in 2000, he conceived the entire graphic package for the *Dbops Pollittics* CD (Gary Hassay and Dave Pollitt), which was nominated for a Grammy. In 2004 he is slated to be an artist-in-residence at the London Print Studio in conjunction with the University of Brighton.

Berrisford Boothe's career path illustrates a multidimensional approach to art making: an artist and proactive educator who is simultaneously developing his aesthetic and body of work while networking in prestigious galleries to develop a reputation in a wider art market.

As this book goes to press, Boothe has relinquished a majority of roles as program builder and educator. "The focus now at forty-one is to spend the next five to ten years creating a body of work that moves beyond my northeast regional visibility towards a more sustainable national prominence. Markets like Chicago, Florida, California, New Mexico, and, of course, Europe are where I've set my sights."

As is common practice, the June Kelly gallery has taken ads out in art magazines for Berrisford's exhibitions. The above information about Boothe indicates how such material could be turned into a feature article. Together with reproductions of the work and an image of Boothe in his studio, it could be submitted to magazines for publication. For more information on Umezaki's compositions and updates on performances by Beclemko, visit *www.healthyhboys.com* or e-mail Berrisford at *bwb0@lehigh.edu.* Visit and track Berrisford's exhibitions at *www.lehigh.edul-bwb0.*

Amy Shapiro

The sophisticated evolution of Amy Shapiro's visual and performance art is described by her as: "Increasing the spiritual awareness between humans, in order for them to wake up and respect one another. Religion, ritual, and art were once united and a part of every human's daily experience. Now, I am sidelined. And this gives me a perspective that I would not trade for anything on Earth."

Besides being extremely talented, her success is attributable to her distinctive ability to network. She says, "No matter how talented you are, if you do not have social skills you will not succeed." She does not see other artists as competition but as colleagues. "Surround yourself with people along the same path, spend time with other enlightened beings."

In 1990, she began her journey to a professional art career through a series of Cat's Head group exhibitions held in Brooklyn, New York's, abandoned shipping terminals on the Williamsburg waterfront. Subsequently, some of the original Cat's Head artists curated other shows in the Old Dutch Mustard Factory in Williamsburg. In June 1993, Amy installed and performed fake experiments in a science laboratory for this inaugural performance and art installation. Two-thousand people attended this event, and the warehouse space continued to be used as a venue for almost a year until it accidentally caught fire.

The painting of animals began at this time and continues today. The price of her paintings is between $200 and $1,000. Her group exhibitions include: MONA, Detroit, Michigan; The Brooklyn Museum, Exit Art, New York City; OSG, Allentown, Pennsylvania; Pirate Space, Denver, Colorado. Her solo shows include: Citibank Arts Project, New York City, and Teddy's in Brooklyn. Currently, in New York City she is involved with Gallery 128, China Brilliance Gallery, and The Ridge Street Artists (*www.ridgestreetartists.com*).

One of the common denominators of these gallery associations is the number of artists she meets. People with similar artistic ideas are naturally drawn to each other and so many of her friends are on a similar career path. Some of the people she has exhibited, performed, and appeared on the program with include: Ursala Clark, Lex Grey, Anna Hurwitz, John S. Hall, Deb Margolin, and Shelly Mars.

In 1990, her first performance started in one of her warehouse installations titled *The Graveyard,* in which she built a

9/11, Amy Shapiro, performance art piece, *Ground Zero* exhibit, Museum of New Art, Detroit, Michigan, 2002. Photo by Julius Vitali.

mock graveyard with jokes on the headstones and a crypt made of an old bathtub. She performed as a ghost in this installation.

After that, she began her theatrical training under director Dan McKereghan as a member of *Hit & Run Theater*. The first rule of *Hit & Run* is "never ask permission." *Strike Heaven on the Face* was performed outdoors in the New York City financial district. The show was a combination of *Macbeth* and *Faust*, and the audience would actually follow a character to the next scene, which was enacted at a different location: for instance the final scene of *Strike Heaven on the Face* took place at the World Trade Center Plaza. This type of renegade street theatre was very influential in her development as a performance artist.

In 1993, Amy traveled to Dublin, Ireland, to perform in *Cat's Head 3*. Ten artists went over to perform and she says, "The

Irish people were very supportive" as they needed volunteers to complete this project. Notices went out in pubs and over sixty people offered to help. The Irish authorities originally prevented them from using the exhibition warehouse; instead they hung the art on the exterior of that building and performed in local pubs to enthusiastic audiences.

For seven months, she had a role in the serial play *Manifestations* at the Collective Unconscious, New York City. It was not until 1995 that she began her solo interactive performance works, which now number about thirty different characters. These include: Artemis, Bat, Dragon, and the Housefly. Artemis is the many breasted Greek goddess of the hunt. The artist developed the character Artemis to explore merging her spiritual studies and performance works. The Bat is a storyteller, the Dragon is a reptilian spy, and the Housefly is hostile and feels superior to other human beings. Another character, Spirit of the Grass, is part of Earth Celebrations (*www.earthcelebrations.com*), a nonprofit organization. They perform a spring and winter pageant, which celebrate and support the community gardens of the Lower East Side. In the spring performance, which lasts for eight hours, Amy is the Spirit of the Grass and appears in a wedding dress covered with grass and with grass growing on a large picture hat. Through ten pageants, she has met many wonderful artists and received significant media coverage.

Honing her technique, she has taken influential workshops with Karen Finley and Shelly Mars (*www.shellymars.com*). In the December 2001 workshop with Karen Finley, she indicated that performing in clubs is not the right atmosphere. There are often restrictions such as not being the main attraction and performing amidst too much noise, as the crowd can dictate a visual performance. However, a performance in galleries and museums usually takes place in a suitable atmosphere. Here people pay attention and it is advantageous to be exhibiting in the same space. Amy Shapiro continues to perform in clubs and alternative spaces because it is possible to make important contacts for future shows by performing under less than desirable conditions. She also realizes that when a club or party performance commands the attention of the audience, which can be difficult to accomplish, it can be an extremely powerful experience. An example is through the Rubulad (a temporary club noted for its different New York City locations), which, for the past three years, has given her fabulous opportunities to perform and meet artists who are working in a similar fashion.

Another venue for her acting is an interactive pilot titled *Urban Bedtime Stories*. The starring role of BettyX, created by Beth Carey, tells the story of an artificial intelligence who seeks out lonely people and reads them bedtime stories. Through online chat rooms, she enters their physical space to portray an interactive character. She met Beth through Tom Ritchford's e-mail events calendar and listing called ExtremeNY (*www.extremeny.com*).

For the past three years, she has been participating in "The Ladies Salon" organized by Abby Ehmann (*www.editrixabby.com*). "The Ladies Salon" is a woman's group that meets for dinner once a month to provide mutual support for the participants (with regard to their careers and personal lives). She says, "It is an amazing collection of writers, photographers, painters, performers and promoters. As a networking tool and all around fun time, it cannot be beat."

In 2002, *9/11* was performed at the opening of *Ground Zero*, Museum of New Art, Detroit, Michigan. On that infamous day, Amy was working as a temporary employee at Brown Brothers Harriman, an investment brokerage firm. Her arrival time was 8:30 A.M. At 9:30 A.M., five blocks from the WTC, she witnessed a cloud of smoke billowing towards her third-floor office window. Everything became black smoke, ash was falling everywhere, sirens blaring, and at 11:00 A.M., with wet towels over her face, she frantically returned to her apartment. The text from her *9/11* piece originally began as an e-mail communication to friends to reach out and inform them she was safe. The trauma of 9/11 was fully comprehended through this catharsis. It was necessary to make contact and to tell her story.

As part of the workshop, Finley had the participants talk about *that* day, and it developed into a performance piece. She just so happened to have a copy of the e-mail with her and read it to the group. Then after her illuminating workshop with Shelly Mars in May 2002, the piece finally blossomed. Best performed in an exhibition space, the piece took place at the *Ground Zero* exhibit where she installed a 10' × 10' perimeter of file folders, shoes, and debris. She begins the performance by reading her e-mail, and then a cassette recorder repeats the text as she begins pouring flour (symbolic ashes) on her body. The costume consists of a Korean-era gas mask and an American flag. The hour performance is shockingly accurate in describing the events of that day. The press from this exhibit has been phenomenal for Amy's work, including: *Detroit News*, *Taz* (Germany), and the *New York*

Times (which featured her in the September 11, 2002, anniversary edition section "A Nation Remembers").

Amy spends considerable time promoting her work by using e-mail solicitation. Currently her international e-mail list numbers three hundred, compiled over a three-year period. Amy always has exhibits, performances, and numerous projects in the works; while these still include "club" performances, with her uncanny track record of networking capabilities, it will not be too long before she attracts the attention of the mainstream media. Contact her via e-mail at *amy@amyshapiro.com*; *www.amyshapiro.com.*

Daniel Scheffer

Daniel Scheffer has a unique way of selling his art. His 1975 participation in a seminal four-person exhibition at the Richmond Art Center, near San Francisco, California, was followed by a twenty-five-year hiatus from public view. In 1982, Scheffer met Frank Shifreen through Scheffer's wife, Liza Jane Norman, who exhibited in the noteworthy Gowanus show. Then, in 1995, after seventeen years as a diamond dealer, he re-emerged as an artist, setting up his studio in Coney Island. In September 2000, he began devoting his time to creating his art in paper, light metal sculpture, and sculptural installation. And between May and December of 2001, he participated in twelve shows and installations, including a solo show at boltax.gallery in Shelter Island, New York.

After 9/11 happened, his new work acquired a somber tenor. In both of CUANDO's New York City shows, his *Tin Foil* figures were seen on the first and second floors. Then, for the *From the Ashes* show at Open Space Gallery in Allentown, Pennsylvania (February 2002), he produced a monumental work titled *Witness,* which is a 21" × 45' paper sculpture with over six thousand faces glued to a scroll. Scheffer describes the work as "Having to do with the negative space and vacuum left by the WTC, the dead and anguish meaninglessness in which their lives were taken away from us, and those of use who remain . . . to live on with unanswerable questions, longings and confusion that leaves no resolution. I was trying to understand and feel what losing six thousand people in an instant meant and felt." (Six thousand people were at first believed to have originally perished.)

After the February show, his creative quandary became "What could be continually done to raise money to do my art?"

Kol Nidre Memorial (first prayer introducing Yom Kippur), Daniel Scheffer, aluminum, steel and fabric, 2002. Photo by Daniel Scheffer.

After a few lengthy discussions with other artists, he concluded, Why not design a series of twelve pieces, each selling for $100? The twelve-piece series is in an edition of fifty, each series selling at $1,200. After telephoning friends, former business associates, and collectors who were familiar with his work, in May 2001 he raised $3,600 from three people, who agreed to purchase twelve small works in the next twelve months. All the pieces involve profiles of heads, in paper, copper, or aluminum. The sizes are no larger than one cubic foot. These profiles are nondescript, and all twelve have become part of the *Community Series.*

In February 2002, he tried another marketable approach. He would pre-sell artwork one to three years before it was produced. The prices would be higher, and he would sell to different collectors. For one week, after e-mailing and telephoning potential collectors, his success included raising $10,000 from four "new" collectors. These collectors will visit his studio and "pick out" their artwork, since the value of the artwork being bought through his studio will be at a 70 percent gallery discount.

Due to long associations with numerous galleries, artists, and organizational skills, he became the third curator (the other

two were Frank Shifreen and me) in the seminal exhibit *Ground Zero*, at the Museum of New Art (MONA) in Detroit, Michigan.

As an artist and curator, the opportunities arise for him to flex his "creative muscles." Numerous works such as *Inferno, Shall We Jump . . . ?,* and *YHYH* were exhibited along with the controversial *Trading Card series*. Along with designer Roger Dapiran, twenty "terrorist" cards, in a limited edition, sell for $100 a deck. The cards are the size of a playing deck and consist of the nineteen official 9/11 hijackers and the other accused jailed terrorist. These cards follow the history of the hero/anti-hero card format, from baseball players to serial killers. Since there is very little knowledge regarding these terrorists, available information emerged from various British news Web sites. Obviously, a political consideration as to why there is so little known information contributes to the controversy.

His previous stylistic portraiture work translated into this trading card medium. Scheffer states, "The repetition of seeing numerous hijackers explores the dynamics of the individual versus the group. Twenty people strengthens and supports their interaction, it consummates their intent, as a group they can accomplish the mission."

The computer-printed cards use Epson Photo Glossy paper and are carefully glued together, with the front depicting name, photo, flight numbers, and attack destination. The back describes the date of birth, education, and flag of the country of origin. In another MONA installation, the front of the twenty cards were blown up to 8" × 10." Numerous articles from this exhibit featuring Scheffer appeared in the *Detroit News, Detroit Free Press,* and *Taz.*

In the fall 2002, he received an e-mail exhibition request from the Michigan Institute of the Arts "mobile museum" called *Michigan Now.* Jef Bourgeau, the former director of MONA, contacted numerous vacant building owners in Detroit, as part of an on-going drive to use empty downtown space for this invitational show. In addition, the *Ground Zero* exhibit traveled in February 2003 to the Freyberger Gallery, Berks Penn State Campus, in Reading, Pennsylvania. Contact Scheffer through e-mail: *sadiedora@aol.com.*

Barnaby Ruhe

Let us take a look at the extraordinary career of Barnaby Ruhe, an artist whose recent work can be described as a combina-

Portrait of Steve and Jody, **Barnaby Ruhe, acrylic on masonite, 2000.**

tion of abstract expressionism and realistic figuration. A portrait is not a face; it is an identity. He does not paint from photographs because it does not have enough information; he must have a dialogue with the sitter. Ruhe is currently an adjunct professor at New York University. His most recent exhibitions include Fred Dorfman Projects in Chelsea, New York City. Originally from Emmaus, Pennsylvania, Ruhe received his Interdisciplinary Ph.D. in 1989 on "Shamanism and Contemporary Painting Process" from New York University.

In 1978, Ruhe ran a 26.2 marathon, which was the stimulus for his trademark Portrait Painting Marathon's (PPMs) that he began in 1979. PPMs last for 26.2 hours, and during this time he can paint numerous portraits that are then available for sale. More than two hundred PPMs have taken place in museums, galleries, colleges, prisons, bars, restaurants, and benefits such as the March of Dimes and Gilda Radner's Club (cancer benefit). PPMs have occurred in Germany, France, and Australia, and Ruhe has painted such luminaries as Cindy Adams, Leo Castelli, Connie Collins, Larry Holmes, Keith Jarrett, George Plimpton, Sonny Terry, and Brownie McGee. Moreover, he has exhibited at the Nassau County Museum, Allentown Art Museum, Dorfman Projects, Jack Tilton, and Barbara Braathen Galleries in New York City.

Ruhe has perfected his "fax attack" to gain publicity. This includes certain key words in the release, which television, radio, newspapers, and the Internet "salivate" over. Without this he says, "There is no sense of urgency for the press to respond." Since his PPMs allow the press significant time for coverage, it becomes "reality theater;" will he self-destruct (can he stay awake), and will art come out of it. In New York City, his success includes appearances on the 5:00 P.M. television news on ABC, CBS, and NBC—especially when a celebrity like Cindy Adams is painted and included in the release. He has learned that if the release is not put into the station's daybook (a database scheduler), then it will not be considered. Of course, follow-up phone calls are essential, as sometimes three faxes have to be sent out during the course of the fax attack to the media to achieve positive results. These fax attacks usually take two days once his database is set up.

Some of his publications include the *New York Times, Art-in-America, Village Voice,* and the *New York Post.* He has received grants from the Mid-Atlantic Art Foundation; Pollock-Krasner Foundation; NY State Council on the Arts; Change, Inc.; Artists Fellowship; and the Millay Colony. These prestigious collections own his work: Allentown Art Museum, Reading Public Museum, Lehigh University, Patterson Museum, and Ronald McDonald House.

To add to his reputation, he has become a world boomerang champion thrower. Chuck Harris has primarily been his television agent since 1994. While competing in San Francisco in 1994 he appeared on the Jay Leno show slicing an egg on top of an apple off the top of his head with a boomerang. He says, "Creating a life-threatening situation is newsworthy." In 1997, Ruhe and a fellow artist approached Cuervo Tequila. They understood interactive events and felt that the PPMs in a bar setting would support a dialogue. They were concerned with the point of contact concept, which puts the sitter and viewer on a picture plane and thereby creates a degree of intimacy. Instead of a long marathon, they preferred twenty-minute drawings of the patrons. Cuervo would buy drinks for the sitter and the painter. This was publicized through newspaper ads and Ruhe received a fee for his participation. In 2003, his agent had him commissioned by a television show in Seoul, Korea, to paint a 6' × 6' Ruhesque portrait of Elvis Presley in six minutes.

His PPM paintings sell in the $1,500–$5,000 range, and one of his unique PPMs in 2001 resulted in a huge painting with

fourteen portraits of a law firm in Germany. Moreover, while there he participated in a trade fair for Internet traveling booking agents in Berlin and did the portrait of the president of United Airlines Germany.

In 2001, while in Paris he did PPMs in a salon on the Left Bank as a jazz quartet was playing; after hearing sustained applause, he realized that they were watching his every brush stroke instead of the music. At that particular moment, the model was holding a glass of Pernod, a very bright green liquor, and it became the color key for the painting. The audience was politely waiting for him to finish painting that complementary section before bestowing a round of applause. Ruhe receives a fee for his PPMs and usually sells his portraits; although the sitter is not obliged to buy, they usually do when their uniqueness is captured.

Since 1991, the annual La Braderie de l'Art held in Roubaix, France, hosts one hundred artists. This year, Lorenzo Pace, who is an artist—he contributed and installed the genuine artifacts from the WTC to the *From the Ashes* and *Ground Zero* exhibits—a children's book author, and the director of the Montclair State University Art Gallery, in Montclair, NJ, helped organize the thirteenth annual La Braderie de l'Art. From December 13 through December 14, 2003, ten New York City artists, including Barnaby and Frank Shifreen, will participate for twenty-four hours in former fabric plant sites. In a dedicated space assigned to you, the artists will transform second-hand objects. Barnaby will paint on 6' × 6' Parisian found posters. All the art has to sell between one hundred and two hundred and thirty euros. For more information, visit *www.labraderiedelart.com.*

Another facet of his career, due to his theatrical painting, is acting as Jackson Pollock in the Bill Rabinovitch DVD feature *Pollock Squared.* Considered a natural choice for this leading role, his portrait performances established significant name recognition; Bill did not have to look hard to find this actor. Contact Ruhe via e-mail at *barnabyruhe@aol.com,* and visit his Web site at *www.portraitmarathon.com.*

Douglas Fishbone

Douglas Fishbone is a sculptor and conceptual artist who in 2001 installed almost two tons of bananas (piled six-feet high) for the "Festival International Interactions III." They were placed in the historic town square in Piotrkow Trybunalski, Poland. *The Banana Project*, which constantly changed—and was literally

Autodoner/Gyro Man, Douglas Fishbone (his profile sculpted in an authentic rotisserie out of beef and lamb), 2002. Photo by Douglas Fishbone.

devoured by the audience—offered a participatory commentary on greed, globalization, consumerism, and violence.

With references to the Incas (the myth of Atahualpa), the Nazis (to the piles of looted possessions in the death camps), predatory multinationals like Dole and Del Monte, the installation examines the intersection of personal and institutional desire; questions the creation of meaning and the meaning of "creation" and consumption by complicity through art in a public forum.

Through the metaphor of eating, this project explored the broader question of the collective consumption process. The principal visual reference in the Piotrkow Trybunalski was to the mountains of possessions looted from Jews in the death camps: the piles of shoes, and heaps of eyeglasses that haunt old photographs. At the same time, the arrangement of the fruit in a semi-geometric, golden mound hinted at the image of gold bars stacked up in the vaults of the major Western banks. By linking these images of violence and abundance, the installation asked whether the control of the developing world by the United States and Western Europe—in the particular example of their domi-

10,000 Bananas, Douglas Fishbone, installation at the *Art under the Bridge Festival* for DUMBO, 2002. Photo by Douglas Fishbone.

nance of the banana industry—is at all analogous to the Nazi control of Europe, which was a more extreme system of corporate exploitation and greedy profiteering.

The subtle meaning of this provocative project relies on its location, as different cultures have a different conceptual reading of it, depending on their associative response to the object at hand. He has installed this "organic edible sculpture" numerous times in Costa Rica and Ecuador, the two largest banana-producing countries in the world. These countries depend largely on the export of natural resources like the banana for their survival, and in Latin America the installation could be interpreted as a protest against both the predatory market forces that determine the course of the national experience from afar and the domestic corruption that abets these forces. It also served as a more general commentary on environmental issues.

By contrast, in Poland, before the collapse of the Iron Curtain, the banana was a luxury item, and it still must be imported. Although its current widespread availability is one of the undeniable benefits of globalization, this accessibility comes at a high price (starvation wages) to those who produce the bananas.

As the first town in all of occupied Europe to have a Jewish ghetto, Piotrkow Trybunalski holds a distinct place in history, so the installation's visual reference to the Nazi era was particularly resonant there. In the same square where Jews were rounded up, the crowd's speedy devouring of the bananas evoked

Poland's legacy of brutality to its Jewish population, which was itself devoured and cannibalized.

Finally, the banana is an artistic symbol often used in Europe to denote the presence of an art gallery or similar space. In creating a gigantic, edible installation, Fishbone was making a tongue-in-cheek comment about the experience of viewing art as merely an alternate form of consumption, and about the production of meaning as an interactive process between artist and audience.

Fishbone states, "More than anything, though, the project is visually stunning, a huge mound of green and golden fruit carried away by the audience like a crazed collective sculptor."

In another thought-provoking work titled *Arab Isolation* at the *Ground Zero*, MONA, Detroit, Michigan, exhibition opening 2002, Douglas Fishbone hired Abe Dakhlallah, an Arab who was an American theater student from Wayne State University. Dressed in traditional white attire, Dakhlallah sat silently for two hours, in a 4' × 4' × 2'-high enclosed fence, usually intended to enclose animals. This reference to Arab seclusion suggests numerous interpretations of geo-politics, terrorism, and U.S. foreign policy. Fishbone states, "I wanted to do something that discussed the fear that Arabs inspire in America, but also the unfairness with which their communities are being blamed and mistreated. I went to Home Depot in Detroit for inspiration and when I walked past this fencing, the idea just came to me."

One of his methods for achieving artistic success through the media has been his inventive use of e-mail solicitation. While in Ecuador in 1999, e-mailing to contact family and friends became a cost-effective way to communicate. He began to amass two separate e-mailing lists, one for the media, and one for museum and gallery contacts. This reached promotional fruition while working as a temporary employee during an eighteen-month period from spring 2000 to fall 2001. This unique transitory position allowed for a great deal of free time to use the Internet, to research domestic, international magazines, galleries, and museums.

Currently, his e-press list is thirty-pages (and growing) and has proven invaluable, since it consistently produces rewarding results. In the beginning, his mass spam e-mail proposals resulted in three positive return e-mails out of a thousand sent. Refining marketing techniques over time, by using such Internet addresses as *www.swissart.ch*, a Swiss nationwide listing of art spaces, his database has become more precise, depending on the project that he is proposing.

Most of his recent exhibitions including the *10,000 Bananas* have been a result of e-mail marketing campaigns. The October 2002 show at the *Art under the Bridge Festival* for DUMBO (Down Under the Manhattan Bridge Overpass) received critical reviews in *Newsday, New Yorker,* and again in *Tema Celeste* (Italy). Virtually all of his exhibition press coverage has occurred through actively soliciting media contacts on his comprehensive list. Since 1998, the press has notably embraced each group or solo show he participated in, proving his methods.

Solo exhibitions of his work include the National Gallery, Costa Rica; Galeria Madeleine Hollaender, Alliance Francaise, and Casa de la Cultura, all in Ecuador; and Brainard Gallery, New York City. Group exhibitions include *Ground Zero,* MONA, Detroit, Michigan; and *Counting Coup,* Theater for a New City, and *Undo,* Scott Pfaffman Gallery, both in New York City.

Proper Villains, a group show at Untitled Space in 2002, New Haven, Connecticut, featured a piece titled *Autodoner/Gyro Man.* The work was Doug's profile sculpted in an authentic rotisserie out of beef and lamb. This temporary "soft sculpture" is another critical commentary, through a gastronomical metaphor, to explore the broader questions regarding consumption, temporal conceptual art, and economics.

This sculptor and conceptual artist has been featured in *Art Journal, USA Today, U.S. News & World Report, New Yorker,* the *New York Times, Hopscotch, New York Press, Civilization Magazine, Public Art Review, Juxtapoz, New Internationalist, Taz* and *Kunstforum International* (Germany), *Art Nexus* (Columbia), *Wegway* (Canada), and *A Magazine* and *Tema Celeste* (Italy), to name a few. Plus, the banana installation is profiled in two books, one entitled *The Banana Sculptor, the Purple Lady and the All-Night Swimmer* by Pulitzer Prize–winning author Susan Sheehan, (2002 Simon & Schuster), and the second book titled *Bananen/Bananas,* (2001 Scheufele Kommunikationsagentur Gmbh, Germany).

Some of the public collections include The Museum of Modern Art in Cuenca, Ecuador; Alliance Francaise in Quito, Ecuador; and Miracle House in New York City. His work is also in private collections in the United States, England, Israel, Barbados, and Ecuador. E-mail him at *dfishbone@hotmail.com.*

Chapter 7.

Corporate Support for the Arts

Whatever the future of government funding for the arts, you might also try to receive support from manufacturers—regardless of whether or not their products directly relate to the art field.

Whenever you receive either a grant or corporate support, it provides an impartial endorsement of the project or activity being funded. This can be used as part of a future publicity campaign when the project is finished or the activity is presented. When corporate support is awarded, you will receive a letter announcing the award, written on corporate stationery. This letter should be included in the publicity package along with a release and any other support material. It is a significant achievement for any artist to successfully approach a manufacturer and obtain materials or money. The newspapers and magazines need to know either when support is first given or when the project is finished. A feature article or television news clip could be coordinated to help support an exhibition, lecture, or other event.

I have been successful in approaching digital hardware and software companies in relation to writing this revised edition. Since there is a Digital Resources appendix, evaluations for digital paper, graphics software, printers, and so forth, required a cover letter for my book contract and a detailed letter asking for the donation of specific products. About 75 percent of the companies I contacted responded favorably (the other 25 percent either offered discounted prices for their products or refused the request). In addition, I contacted many reference book companies and received a number of volumes in order to be able to do research for

this project. I began a dialogue with the marketing departments requesting donations. The paper trail (documentation) is critical for realizing continued support. This becomes especially true if you produce and complete projects. The risk factor for the manufacturer decreases if they can see that other manufacturers have supported other successfully completed projects you have undertaken.

The commercial world sponsors events all the time. Did you ever notice how tennis players have corporate logos plastered on their shirts, socks, sneakers, and sweatbands? Anything that they wear becomes fair game. Some people consider them walking advertisements. When photographers take close-ups of the players, the logos stand out in the composition. This is the way corporate sponsorship has evolved. If a player reaches the finals, the amount of free coverage the sponsor receives via the game is worth millions, and that amount is what some of these players receive when they negotiate sponsorship contracts.

Artists too, can think along the lines of sponsorship contracts, but the level of support is minuscule compared to sports figures. Artists have to be aware of the relations among governments, foundations, and corporations. These agencies realize the cultural influence they have and are willing to offer support. Not all artists are willing to play the game, but you should know that the opportunity exits.

One of the offshoots of capitalism is the notion of giving something back to the community and the individual. Photography, music, communications, electronic, and beverage companies, to name a few, are always supporting special projects in the arts. The list is as long as the number of successful and profitable companies. These companies might have a foundation attached to them, as in the case with Kodak, for they support nonprofit groups only.

Corporations realize the moods and trends of the country and recognize when a social or humanitarian issue becomes topical. No company wants to be out-of-step or politically incorrect as there is a chance a product will be boycotted, and profits are always the bottom line.

Some of these topics are 9/11, environmental protection, homelessness, peace initiatives, or any issue concerning the betterment of people and society. Association with these issues puts your project and the company in a humanitarian light, which also garners tons of publicity and therefore thousands of dollars in support. If consciousness can be raised via art projects, then people tend to feel good about the supporting company's products. Ben and Jerry's Ice Cream donates portions of their profits to protect the tropical rain forests. This politically correct policy not only continues to sell their ice cream but associates them with contemporary issues. Thus, a for-profit organization can work hand in hand with nonprofit organizations on contemporary issues.

Applying for Funding

Each company treats its sponsorship differently. If you want to try to receive support or sponsorship, call the company. They will transfer you to the cor-

porate communications department, public relations agency, advertising department, or service representative for your area.

It is very clear that at the beginning of a corporate relationship, most companies will want to see something written. They do not publish any guidelines or brochures (except for teachers) on this subject, and they evaluate each request on a project-by-project basis. Care should be taken in creating a well-written and thought-out project that asks for a realistic amount of support. The most difficult way to approach a company is to ask only for money. It can be done, but the money has to be for a very specific use. The more specific the request, the better your chance that the corporation will positively evaluate the project. For example, if you spend your own money paying for supplies and want to mount an exhibition but can't afford the space, then a company might give you the support money for that specific need. If you used two different companies' products, you might ask each of them for 50 percent of the money.

Companies realize the need for corporate giving, but what they want in return is high visibility and good press. If you ask for free film and photographic paper to document an art installation/exhibition, you must link the manufacturer's name to the project credentials. The artist and manufacturer should both receive publicity due to your marketing success.

Don Mistretta

The Sea Cliff Gallery, located on Long Island, New York, and its owner, Don Mistretta, had an idea for a 1993 Christmas show called *Feed the Hungry*. More than one hundred artists created either ceramic or wooden plates, on which they expressed their feelings about feeding the hungry. There was a $20 fee to enter the show, $8 for the cost of the wooden plates, $5 went to the Interfaith Nutrition Network (INN) on Long Island; and the remaining $7 went to the cost of mounting the exhibition— announcement cards, the opening, snail mail, releases, photos, phone calls, and the like. All the plates were for sale through a silent auction. Fifteen percent of the money received went to the INN. The artists could either keep their share of the sale or donate all or part of it to the INN. The price of the art plates ranged from $75 to $250, depending on how high people were willing to bid. The exhibition came about because many of the Sea Cliff artists had volunteered at the INN. Don Mistretta heard such wonderful things about the nonprofit organization that he decided to help in a formal way through a gallery exhibition.

Since this show is by a for-profit gallery working with a nonprofit agency (INN), both corporate and foundation support are possible. Students in public schools have been involved in

Don Mistretta and architect Danita Otruba-O'Connor in front of the 7' x 9' wall created by artist Judy Amsel of the 343 deceased firefighters relating to the tragedy of the WTC. Embedded in this wall of ceramic tiles located in the Fire Museum, New York City, includes black-and-white photographs and badge numbers of the deceased firefighters, 2002. Photo by Roseann Pellicane.

making the plates as part of an arts/humanities project. Corporate sponsors usually will give money to support this type of project, since it helps the homeless, is art-related, and has a children's education component to it.

Because of its association with an important issue, the exhibit received publicity that it might not have otherwise received, benefiting the cause, The Sea Cliff Gallery, and the artists who participated. I was asked to help as a consultant and photographed all the plates for future articles. For the second annual show, a local monthly magazine, *Creations*, ran one of the plates on the cover, along with a feature article. A television production company volunteered their time and equipment to make an hour-long videotape that was edited into a ten-minute video release. This appeared on various public access television stations throughout the Northeast. As a result of this exposure, Don Mistretta was interviewed for a thirty-minute feature about the plate show. In each new location, local artists will create plates especially to be shown there. A certain percentage of the money obtained during the silent auction is given directly to feed the

hungry in that area. The high visibility the gallery exhibition receives through its touring will undoubtedly interest foundations and corporations.

After working with nonprofit organizations, Don Mistretta decided to create a nonprofit organization called Hunger Relief for the Arts, and it was incorporated in 1996.

In 1997, a major undertaking occurred in the city of Yonkers: Through the community development director, its show *Art on Main Street,* had eighty pieces by local artists, raising $10,000 for the Sharing Committee.

In February 1998, Open Space Gallery hosted the *Artists Plate Project,* in which Allentown students, plus local artists created fifty plates and raised $1,500 for the local ecumenical soup kitchen. Then, in November 2000 at the new location in Locust Valley, the Mistretta Galleries exhibited eighty artists, and they raised $2,500.

Then 9/11 happened. Very quickly, Mistretta assembled a poignant show of photographs by Len Jacobs and a video by former FDNY firefighter Mike Lennon titled *The "Spirit" of the Time . . . Beyond Ground Zero,* October 27–December 2001. Mistretta says, "I wanted to do something to commemorate those who served and who gave their lives in the line of duty, not just shots of the calamity. My father was a New York City fireman and I wanted a fire department angle for the show."

Reportage photography of the WTC by Len Jacobs captures the recollection of the firefighters and their firehouse on that tragic day. Jacobs says, "They are medieval knights with an incredible code of honor and brotherhood. This is homage to the bravest people. It is a privilege to honor them."

Retired firefighter Mike Lennon spent five weeks visiting New York City firehouses after the WTC attack, and his video *Brothers Amidst Holy Ground* was shown as an eleven-minute preview. Because of the publicity created through the exhibit, Mike Lennon was able to raise the necessary funding to complete an hour-long video. He says, "It speaks volumes about the compassion behind every door of every firehouse in New York City."

The timeliness and emotional impact of this two-month show resulted in significant regional media attention, including articles in *Newsday, Glen Cove Record Pilot,* and *Oyster Bay Guardian,* and a feature on the nationally syndicated radio show *Imus;* in addition, Long Island Channel 55 featured Mike Lennon.

In November 2001 one of the board members of the New York City Fire Museum visited the show and mentioned

that the Fire Museum located at 278 Spring Street, New York City, was in the beginning planning stages of accepting proposals for a permanent exhibition to memorialize the firefighters who died during the WTC tragedy. Don, who acted as curator, enlisted the architect Danita Otruba-O'Connor, and together they wrote a twenty-five-page proposal, which was chosen among three entries and awarded a $150,000 budget. "The exhibit is intended to look back at the past year—the terribleness and sacrifices of the firefighters."

The exhibit includes a 7' × 9' wall created by artist Judy Amsel of the 343 deceased firefighters relating to the tragedy of the WTC. Embedded in this wall of ceramic tiles are black-and-white photographs and badge numbers of the deceased firefighters.

Additionally, a 6' × 9' photograph by Joel Meyerowitz of a nighttime scene in which five deceased firefighters were discovered is prominently displayed. Artifacts displayed include a fire engine nozzle, helmet, damaged radio, etc. A timeline of 9/11 and a sixty-photograph display includes the first twenty-four hours after the attack, New York City firehouse memorial photographs, plus others materials in relation to that day and the aftermath.

Marilyn McAleer was chosen by Mistretta to complete the multimedia part of the exhibition. She acquired the necessary materials and got HBO to donate a producer and Lifetime Cable to donate editing facilities; as a result she was able to produce a fifteen-minute loop, which plays on a 42", plasma flat-screen television, invoking the role of the New York City Fire Department in the WTC tragedy. She also prepared two interactive kiosks with a database on all the deceased firefighters, which allows visitors to directly activate biographical information.

Mistretta also chose to include in the exhibit a poem by Roseann Pellicane entitled "If They Could Speak." Although only $600 (itemized as part of his award) was allotted in the budget for the poem, Pellicane took it upon herself to privately raise an additional $4,400 for the fiber-optically lit etched glass poem.

The original show *Beyond Ground Zero* continued to travel, first going to Pace Gallery in Mineola, New York, next onto the Port Washington Library in New York, and then to the Fletcher Free Library in Burlington, Vermont, all in 2002. Visit the Mistretta Gallery at 394 Forest Avenue, Locust Valley, NY 11560; 516-671-6070; 800-372-6386; e-mail, *mistrettagalleries @email.com.*

The Foundation Center

Once you conceive a project and its objectives, it is important to know where to look for support. The Foundation Centers around the country have reference listings of companies, corporations, and foundations that offer support. The main Foundation Center in New York City has a list of publications and member libraries throughout the United States. The Foundation Center offers an online database for individuals that funds students (they are dominated by undergraduate support), artists, researchers, etc. More than five thousand program listings, plus existing sites, are updated quarterly. It costs only $9.95 a month or $99.95 for an annual subscription.

After signing up for a month's subscription, the best way to search for potential sources of funding is to just use the search function for "fields of interest" and "types of support." You click on each of these and on the right side a menu of all the fields appears. You then find the field, click on it, and it appears in your search box. Do the same for the various types of support, and this will bring up all the correct matches.

Their Web site has a link for funding for the arts. June is Funding for the Arts Month at the Foundation Center, and in honor of that occasion, they have put together a collection of annotated links to some of the best arts-related resources on the Web. Moreover, as part of their Philanthropy New Digest area of their Web site, they offer Arts Talk, an online message bulletin board for the sharing of opinions, insights, queries, success stories, and advice among individuals in similar situations to your own relating to the funding environment for the arts. The Foundation Center allows links and pointers to Internet sites that people may list as part of their message text, such as if you ask a specific arts questions, you may list your e-mail in the online message. Visit the Arts Talk at *www.members5.boardhost. com/Artstalk/index.html.*

In addition, the Foundation Center maintains a virtual classroom called the Learning Lab, which has online tutorials. In the Learning Lab they have a section titled "Giving to Individuals." The following is from that section:

> Because most private funding goes to nonprofit organizations, the individual grant seeker should expect to encounter even stiffer competition for grant dollars than the nonprofit organization. It is essential, therefore, that you research potential funding sources within your own discipline or geographic area. Depending on the nature of the project, one might wish to consider affiliating with a tax-exempt organization to broaden your base of potential support. It is important that you begin looking for a fiscal sponsor at the same time that you start researching potential funders. Another option is to consider incorporating as a tax-exempt organization.

They offer periodic training courses relating to their databases, costing $195, from 9:00 A.M. until 4:00 P.M. in New York City, Washington, D.C., Atlanta, San Francisco, and Cleveland. The following courses are useful to the fine

artists: "Finding Projects with the Foundation Directory Online," "Grant Seeking on the Web: Hands-On Introductory Training Courses," and "Keep Current with Online Journals and Interactive Tools."

There are three particular books of interest, which are available from the Foundation Center:

- *Grants for Arts, Culture, and the Humanities, 2002 Edition.* A listing of actual grants of $10,000 or more awarded to organizations. The cost is $75, plus shipping.
- *National Guide to Funding in Arts and Culture, 2002 Edition.* This features essential information on more than 9,200 foundations, corporate-direct giving programs, and public charities with a demonstrated interest in the field. The 19,000-plus descriptions of recently awarded grants give you special insight into foundation funding priorities. This is necessary to know, since the organizations need artists to fulfill the requirements of an approved grant. The cost is $155, plus shipping (or visit a library).
- *Arts Funding, 2003 Edition.* This book explores the state of arts grant making and identifies emerging themes and issues. The report offers an inside perspective on recent changes in arts funding priorities, strategies, and on factors affecting decision making and is based on in-depth interviews conducted in 2002 with thirty-five leading foundations and corporations nationwide. The cost is $14.95, plus shipping.

For more information, contact The Foundation Center directly, at 79 Fifth Avenue, New York, NY 10003; 800-424-9836; 212-620-4230; e-mail, *orders@fdncenter.org, www.fdncenter.org.*

Support for Education

Companies enjoy funding education because of the many students and teachers it reaches. The funding has a direct effect on a local community. If you are a roster artist on an Artist-in-Education program (see chapter 9), this might be a way to help supplement the supply budget. The money saved might be added to your fee.

Some companies will give or loan equipment to teachers for education projects. Here are some corporate programs intended for just that purpose:

- **Polaroid Education Program** supports classroom educators who use visual learning and photography through workshops, imaging products and an online selection of visual learning activities for all grade levels and subject areas. Contact 800-343-5000 or *www.bigchalk.com.*
- **Fuji Photopals** was developed with Scholastic, Inc. It has been bring-

ing teachers, students, and families together for over a decade, providing great opportunities for sharing, teaching and learning experiences. Contact 800-817-2200 or *www.fujifilmphotopals.com.*

- **Ilford's** *Photo Instructor Newsletter* is a good source for funding information. Write to West 70 Century Road, Paramus, NJ 07653; 201-265-6000; e-mail, *us-techsupport@ilford.com;* or view the Web site at *www.ilford.com.*

- **Kodak's Digital Learning Center** is a corporate-sponsored education program. Contact 800-235-6325 or *www.kodak.com.*

- **Agfa** provides education support through a written project description and proposal. Write to 100 Challenger Road, Ridgefield Park, NJ 07660; 201-440-0111; or e-mail *www.agfa.net.*

- **Binney and Smith** (the maker of Crayola products, Liquidex fine art products, and other art supplies) have a corporate contributions program that includes cash and product donations to nonprofit organizations with a focus on the arts, education, civic affairs, and health and welfare needs. They have placed geographic restrictions on their level of corporate support. Their program goals are to support organizations where Binney and Smith manufacturing facilities are located in Easton, Pennsylvania, a part of the Lehigh Valley. If you think you qualify, write to: Binney and Smith, Inc., Attn: Ms. Margaret Heckman, 1100 Church Lane, P.O. Box 431, Easton, PA 18044; or e-mail *www.crayola.com.*

Not all corporate support for education projects goes to schools. If artists have a bona fide education project, it is possible to receive support for it on their own. For example, one could create a project to help recognize vegan entrepreneurship, which could include an article, book, exhibit, or Web site.

Ted Ormai

Some artists request support for a specific product or group of products in order to create a portfolio or series of work. This could take the form of sculpture, oil painting, photography, or mixed media.

Sculptor Ted Ormai of Kutztown, Pennsylvania, has a unique history, and it is important to highlight his achievements. His parents were both mural painters; his father John Ormai worked in fresco, including murals for the Social Security Building, Washington, D.C., where he painted with Ben Shahn in 1941. Ormai cites his parents as his biggest influence—rather than the formal art education he received—because he gained aesthetic knowledge from them. Another influence was working with

Magnetic Sun Hex, Ted Ormai, magnetized oxidized iron and emulsion on paper, 2000.

minimalist Robert Morris in 1986 through a month-long residency at the Atlantic Center for the Arts, near Daytona Beach, Florida. Morris helped Ormai validate what he already knew, that there is a process to drawing. Ormai has been a professional artist since the early 1970s, working in drawing and sculpture. However, his association with Morris led him to seek out new artistic applications and techniques in a variety of materials. One direction led to the use of Dry-vit, a contemporary building material consisting of acrylic modified cement on top of expanded polystyrene foam. Another exploration was magnetic art, in which Ormai uses the natural forces of magnetism as inspiration and material.

In 1986, Ormai began receiving donated materials from Dry-vit's regional distributor, whose owner was interested in exploring innovative uses for the product and supporting arts-in-education. Dry-vit is available in many standard colors or can be tinted with acrylic paint. Ormai creates unique light sculptures out of this material since it is lightweight and durable. Dry-vit has donated the materials to him through nonprofit agencies,

such as schools, or granting organizations, to help sponsor his project. (Any materials left over he uses for future projects.)

Since 1988, he has been an artist-in-residence through the Pennsylvania Council on the Arts' Artist-in-Education program; therefore, a significant amount of Dry-vit wall relief murals are in public schools in Pennsylvania. Usually, he receives a ten-day minimum residency to complete a mural; however, the artwork created at the Blue Mountain School District lasted forty-three days. In 2001, the Nazareth High School in Pennsylvania commissioned a mammoth 3' × 125' public artwork titled *The Elements: Earth, Air, Fire, and Water.* The relief mural is a frieze (a decorative architectural element) located above the trophy cases and doorways to the auditorium in the lobby of the school's main entrance. The centerpiece of the mural is a 45'-wide sun. Special lighting consisting of yellow, red, and blue gel tubes around fluorescent bulbs dramatically illuminates the mural. The other 80' has layers of carved foam coated with Dry-vit and painted to illustrate land and seascapes.

In this case, the Dry-vit distributor sold the product at cost to the school. Other local businesses contributed supplies. In 2002, the Pen Argyl School District in Pennsylvania commissioned an 8' × 25' mural during a ten-day residency. Numerous feature articles appeared in the local papers and this publicity helps Ormai obtain more residencies. This is his tenth artist-in-residency in which he used Dry-vit. Over the years, Dry-vit and Ormai have bartered products for services. In one case, he carved the company's name in Styrofoam for a trade show in exchange for over $500 worth of specialized carving tools. In another case, four-color images of his sculptures illustrated the cover of one of the company's tool catalogs (as creative uses of their product).

Magnets have attracted Ormai since he was a child. In 1987, this attraction became an artistic investigation. He says, "The work evolved out of the use of light, natural elements and elemental forces to produce visual evidence of unseen worlds beyond our senses." Numerous businesses have donated computer, audio, and industrial magnets, on top of what he has found in salvage yards and curbside garbage collection. In the creation of a work such as *Magnetic Sun Hex,* the artist's manipulation of invisible magnetic fields cause ferrous (iron) metals to configure and become fixed in emulsion and paint. Various stages of oxidation vary the color of the metals in both monoprints and sculpture.

Another work titled *Magnetic Marker* is a ziggurat (stepped pyramid) of three progressively smaller stacked steel discs

4" thick, internally loaded with dozens of large-scale (6"–8") magnets, cumulatively creating a room-sized (10' × 10' × 10') magnetic field affecting the thirty-six compasses, arranged in a full circle around the sculptural installation. The compasses all point to the center of the sculpture. In effect, Ormai has created his own magnetic anomaly.

Ormai has exhibited both his Dry-vit pieces and magnetic works. His professional twenty-two year exhibition history includes group shows at the Alternative Museum in New York, Allentown Art Museum in Pennsylvania, and Reading Museum in Pennsylvania; solo shows at the Castellani Art Museum at Niagara University in Niagara Falls, New York (they purchased *Light Seed*, a Dry-vit piece with neon inside of it, and the accompanying drawings for their permanent collection); Open Space Gallery in Allentown, Pennsylvania, and Lafayette College in Easton, Pennsylvania. *The New Art Examiner* has followed his career beginning with a 1985 review from the Allentown Art Center, for the solo exhibit *Good-Bye 1984,* and in 1989 reviewing the Allentown Museum solo award show. Recently, a feature article in *Florida Design Magazine* included his 4' × 8' drawing titled *Heaven Above Earth,* hanging in the collector's apartment. Through commissions, residencies, art sales, lectures, grants, and prizes, Ted Ormai is able to work magically and live cosmologically as a successful artist. E-mail him at *atormai@aol.com.*

I have received support from Adobe, Polaroid, Kodak, Ilford, Fuji, and Casio over the years for photographic and art projects, both for publication and exhibition.

In 1980, I was one of forty-two people around the world who received product and equipment support from Polaroid. Over the years, they have given me about $4,000 worth of film, which includes 4" × 5" and 8" × 10" Polaroid film. Calumet (a large format camera company) lent me an 8" × 10" camera, on the condition that Polaroid take out an insurance policy for the value of the equipment. In addition, work was purchased for their collection, and it has been frequently exhibited.

In 1992, I received product support from Kodak. They have service representatives who will visit photographers in their region. Be prepared for the interview by having on hand your work, any samples of the project, and anything that can benefit your project idea. These reps will not fund anything on the spot, although they might give you some film. Artists will have to send the rep a written proposal. Kodak reps have their own regional budgets and wide latitude in coordinating support for their areas, but for a major project, the proposal has to be channeled through the Kodak headquarters in Rochester, New York.

The Shadow of the Avante-Disregarde, Julius Vitali, Photomontage (*Photographic Windows*), 1997.

The proposal for my particular project stressed the use of slide film, photographic paper, and professional copy film. I received about $700 worth of these products. Companies are often more interested in supporting work that uses their materials in an innovative or high-profile manner. The title of my project was *Photographic Windows*. It involved taking a number of high-contrast color shadow photographs and changing the compositional elements in those prints. I then cut up the 8" × 10" negatives (similar to a jigsaw puzzle) and contact-printed them in the same composition as the original color shadow photographs. Since I was using many different negatives, each with its own particular density, I had to do weeks of testing to have all the negative densities be in the same value in order to avoid significant handwork (dodging and burning of the negatives). It took fifteen minutes to set up all the negatives, and each print is a one-of-a-kind work. I produced a series of twenty (forty prints total), each consisting of one study (the original color shadow image) and the contact printed negatives.

If you have received support for a project, see if the company will publish the work in one of their company projects. Examples include the yearly desk calendar, cover of the catalog, annual report, and company magazine; and, of course, these companies use images for ads. These in-house magazines are popular with many companies since they highlight artist/photographers plus push products in a creative way.

If you have an idea, many of these companies will be happy to discuss your project—do not forget to use their toll-free numbers. Success depends on your imagination and your willingness to follow through on your projects. Serious efforts in publicity and marketing will help convince companies of your commitment to long-term planning and goals. Once you achieve a successful track record,

it will be easier to obtain corporate support. For more information, refer to the photography trade publications listed below:

- **Nikon's** *Nikon World,* 1300 Walt Whitman Road, Melville, NY 11747; 631-547-4200; *www.nikonusa.com.*
- **Polaroid's** *P,* 400 Boston Post Road, Wayland, MA 01778; 800-662-8337; *www.polaroid.com.*
- **Hasselblad's** *Forum,* 10 Madison Road, Fairfield, NJ 07004; 973-227-7320; *www.hasselbladusa.com.*

Grants for Individuals
and Special Projects

Although there is no guarantee of success, receiving a public or private grant can often lead to better publicity and can be a significant marketing tool. Since nearly all grants are awarded by panels (usually established peer artists, critics, or scholars in the field), to be selected for a grant is a significant achievement. Because of the competitive nature of the award and the fact that money is given away, the grant may add an impetus for the media to devise a piece about you or the project. It is also easier for the media to report on a funded project since it usually includes an exhibition, performance, lecture, or workshop held in a public place or sponsored by a public institution.

The public nature of grant projects allows for new publishing opportunities. Locally, it might convince publications to do a feature about you and your work or allow the project to be covered as a news item. Since they are located throughout the United States, an NAAO grant can open up the possibility for the press to feature you outside of your local area. If you have been bombarding the local media with e-releases and have received some coverage, it is often easier to get publicity out of town, where you are virgin material to the media.

Grants are important to developing a reputation both within the art world and with the media. Since grant evaluation is conducted in a rigorous fashion and is, in theory, free of politics, a grant puts an objective and authoritative stamp of approval on your work. It helps the artist achieve name recognition, as the grant givers usually send releases announcing awards. The more grants you are awarded, the more publicity you will receive. It is an inevitable progression.

A Little History

Patrons of the arts have existed for centuries. In the United States, the Guggenheim, Mellon, Rockefeller, Pew, and Macarthur foundations are all descendants of the grant-giving tradition that originated with the Medici family in fifteenth-century Florence, Italy. U.S. government support first started on a large basis with the WPA (Works Projects Administration) in the mid-1930s; and since 1965, the federal government has given limited monetary support to creative individuals. State governments followed the federal example soon after.

There is a distinction between private and public funding for the arts. Private foundations can place restrictions on who can apply for funds (such as only painters or sculptors under thirty years of age), while public funding cannot have such restrictions. Nevertheless, the net result is the same: both provide money. It is important to find grants that offer nonrepayable financial assistance—in other words, money with no strings attached.

Both public and private grant givers request written and artistic support material with their applications. The grant usually lasts for one year, and, if you are granted money, there might be a final report to write, and you must wait a certain amount of time before applying again.

Private Foundations

It must be noted that as of this writing, the stock market's severe decline has affected the amount of money foundations award. As required by law, foundations must give away 5 percent of their assets. For example, if a foundation has assets of $100,000,000, it must give away 5 percent, which amounts to $5,000,000. If their assets decline by 50 percent, they then can only give away $2,500,000. This massive economic drop in grant giving makes for a fiercely competitive climate. Do not be heartbroken if your projects are declined; just keep refining the application until you succeed.

The categories of foundation support can be broken down as follows: national, special interests, corporate, family, and community. All private foundations are required by law to print annual reports. The foundations must conform to IRS regulations and are required to complete Form 990-PF.

The National Center for Charitable Statistics (NCCS) offers access to financial disclosure forms filed by charities with the IRS. These filings—known as 990 forms—provide specific information on a charity's revenues, expenses, executive salaries, board members, programs, and activities. NCCS will be making forms available online in cooperation with the IRS, with support from Philanthropic Research, Inc (PRI-Guidestar). Currently, more than 400,000 of the IRS 990 forms and 990-EZ and more than 200,000 IRS 990-PF forms (filed by private foundations) can be viewed from that Web site (*www.nccs.urban.org*). Adobe Acrobat Reader, version 4.0, is necessary for viewing.

What is of interest to artists is the complete list of every grant made during the year that can be found on the 990-PF or in the annual report. Smaller foundations use the public notice section of a newspaper as a substitute for publishing an annual report (the public notices then have to be included as part of the 990-PF). Identifying who received grants from particular institutions will enable you to spot trends in grant giving and help you make intelligent decisions about where to apply for support.

Annual Register of Grant Support

This directory is organized by eleven major subject areas—with sixty-one specific subcategories. It is the definite resource for researching and uncovering a full range of available grant sources. Not only does it direct you to traditional corporate, private, and public funding, it also shows you the way to little-known, non-traditional grant sources such as educational associations and unions. For each grant program you will find information on eligibility requirements and restrictions, application procedures and deadlines, grant size or range, contact information, and much more. The cost is $229, or visit your library.

The following excerpt from the introduction to the *Annual Register of Grant Support*, 36th Edition (2003), includes excellent advice for artists seeking private funding. For more information, contact Information Today, 143 Old Marlton Pike, Medford, NJ 08055; 800-300-9868; *www.infotoday.com*.

Probably no area of philanthropy is so misunderstood and misused as that of private foundations. According to recent studies, as many as 80 percent of all applications to private foundations are inappropriate or misdirected. While at least part of the blame for this error must be attributed to private foundations themselves, grant seekers often compound the error by tending to lump all private foundations together as if they shared a common purpose.

Not only do private foundations differ greatly from public funding sources; there is a wide diversity among private foundations themselves. What may be an appropriate application to the Ford Foundation may be totally inappropriate to the San Francisco Foundation.

There are more than 375,000 grant making foundations in the United States. The reason that an approximate figure must be used is that the federal government defines private foundations more by exclusion than by anything else. If an organization cannot qualify as a charitable, religious, educational, scientific, or governmental organization, it may be classified as private foundation even if it has never made a grant nor intends to make one. Potential grant seekers should be aware that the mere use of the word "foundation" in the title of an organization is not evidence that the organization will make grants.

In the category of individual artist fellowships or grants (and this includes public and private monies), approximately 4 to 5 percent of the people that apply receive funding. Nevertheless, one can interpret these figures in different ways. If as many as 80 percent of all applicants are dismissed due to inappropriateness or mis-

direction, then there is only 20 percent in competition. To be on equal footing with professional artists (or for that matter, professional grant proposal writers) you must be in the 20 percent of businesslike applications. It is imperative to have adequate knowledge before you fill out any applications. Then snail mail, e-mail, visit the Web site, call, or fax the foundation to have any questions clarified. Do not make yourself ineligible due to carelessness or ignorance; you will be wasting the foundation's and your own time and money.

Artists may be ineligible for a particular grant because of geographic restrictions, too much taxable income, applying in the wrong category (i.e., "travel" instead of "money"), using the wrong form, inappropriate or incomplete project description, enclosing wrong support materials, not typing the application, sending in glass slides, or missing a deadline for the application.

It is worthwhile before writing a grant application to read *Program Planning and Proposal Writing, Introductory Version*. It describes each stage of the proposal writing process, is only twelve pages long, and costs $3. Also read *Program Planning and Proposal Writing, Expanded Version*. It is the most widely used guide to proposal writing in the world. It takes you through each stage of the process and includes specific examples of what can make or break a grant proposal—forty-eight pages and $4.

These are published by the Grantsmanship Center. The Grantsmanship Center is the country's oldest and largest fundraising training institution and has trained more than 50,000 staff members of public and private nonprofit agencies in all aspects of fund development. For further information about the center or to receive a free copy of the center's *Whole Nonprofit Catalog*, contact The Grantsmanship Center (TGCI), 1125 West Sixth Street, Fifth Floor, P.O. Box 17220, Los Angeles, CA 90017; 213-482-9860; 800-842-8484; e-mail, *norton@tgci.com*; *www.tgci.com*.

The Application

The following information is appropriate for both individuals and nonprofit organizations applying for private or public funding. Begin by doing research at one of the Foundation Centers. Ask reference librarians lots of questions, but do not ask them to review your proposal; that is not their job.

A proposal can run anywhere from one hundred to one thousand words. Keep to the point, and be specific and direct. Do not use flowery language or indulge in wordiness. Write the applications as if the reader knows nothing about art. Do not assume anything. Start with your own personal history and include what you are currently doing, and what you plan to do in the future. Clearly defined needs should be backed up with proof: tax returns, reviews, letters of recommendation, and the like. If you are planning to work within a period, provide realistic goals that can be accomplished during this time span. This is sometimes based on previous achievements. Credibility is everything: Who you are, whom you

know, and where you have exhibited or received prior support become the keys to receiving grants. Remember, no concept, idea, or aesthetic dominates in determining who is funded. Pluralism reigns. Therefore, all types of art are equal. However, art that defines trends, is politically correct, or deals with popular topics that are kaleidoscopic in nature (which include themes of multiculturalism and interdisciplinary arts) might have an advantage in funding, since the panelists are human and are a product of their culture.

The reputation of the emerging or mature artist is another concern. Grant-giving organizations want to be part of the infrastructure that contributes to an artists' fame. If a foundation can claim to have helped put emerging artist X on the map, then the foundation will be viewed as visionary. Grant hierarchy is important to those applying for grants. Begin with local foundations. Then apply to regional, national, and, finally, international donors. Do not expect a Guggenheim grant to be your first grant. A majority of people are rejected because they apply for national or international grants too early.

Some grants are almost impossible to receive without the backing of a former grant winner. The alternative to that kind of support is to obtain a letter of recommendation from a museum curator. If this is not possible, then letterhead counts, especially from famous artists, art critics, or private gallery owners for further information (see chapter 10.)

If you do not know important art people, start to cultivate relationships with them. The sooner you do, the sooner your long-term prospects will improve. Where do you meet important art people? Openings are one place. You can get into the press openings (remember how to start your own press agency, discussed in chapter 4?), since you will be receiving their mailings and getting an admission. However, you should realize it is hard to do business at openings. Try talking to critics and curators to feel them out about their attitudes toward new work and unknown artists. Another way to cultivate relationships is to become a member or supporter of a museum. Attend lectures, workshops, and take classes. Without actual contact with these people, it is very unlikely that you will be able to receive a recommendation.

According to the previous NEA individual artist guidelines, the applicant's work should reflect "a serious continued investigation of important or significant aesthetic concerns and a potential for further artistic development during the proposed fellowship period." This applies to other grants as well. The work must be photographed superbly (digital and traditional) and should be in the form of a series documenting your aesthetic "investigation." Having a résumé with regional or national exhibits, reviews, articles, or television appearances can only help you pass this rigorous competition and receive an award.

Grant panelists want to see career development as demonstrated by your résumé and support materials. A coherent and sustained aesthetic is of utmost importance. The written statement is something created over time and can be redefined, changed, and updated, but if it is done without a rigorous examination, it will be rejected as significant professional work and overlooked for funding.

At these times they would do well to consider the major figures in art history, as most of them belonged to a school of thought, an ism. That ism is the aesthetic concern that public and/or private foundations are looking at closely.

Most major figures in art history are not isolated artists. They hung out, exhibited, and collaborated with one another. Think of cubism, and Braque, Gris, Leger, and Picasso come to mind; abstract expressionism, and de Kooning, Klein, Gottlieb, Motherwell, and Pollock come to mind; surrealism, and Dali, Ernst, Magritte, Miró, and Matta come to mind. *Be prepared for a (sur)reality check when applying for these fellowships!*

Fellowships and Awards for Individual Artists

Awards granted in this category are based solely on work that has already been created that represents either a beginner's approach or a life's work. Consequently, it is the most competitive type of grant. Awards are completely dependent on the artistic merit of submitted support materials and only a limited amount of writing. The support materials are usually 8–12 slides.

These are two national organizations to take special note of:

- **Puffin Foundation,** 20 East Oakdene Ave, Teaneck, NJ 07666; *www.puffinfoundation.org.* This organization makes grants that encourage emerging artists in the fields of art, theater, dance, photography, and literature whose works, due to their genre or social philosophy, might have difficulty being aired.
- **Creative Capital,** 65 Bleeker Street, 7th floor, New York, NY 10012; 212-598-9900; fax, 212-598-4934; e-mail, *info@creative-capital.org; www.creative-capital.org.* Creative Capital is a new national organization supporting visual artists who are pursuing innovative approaches to form or content in the visual, performing, and media arts. Creative Capital will work closely with its funded artists to provide audience development, marketing, and other forms of assistance tailored to individual projects. Artists will, in return, share a portion of their proceeds with Creative Capital, enabling the fund to support more artists in the future.

Getting Away to Create New Work: Artists' Communities and Other Great Escapes

Every year, approximately four thousand artists from all disciplines and genres become temporary residents at the eighty-two artists' communities (some international) that provide working space, housing, and sometimes a stipend, in a

community environment that supports more than one artist at a time. In addition, eleven communities are in serious planning stages or almost ready to open their doors.

Here are some general criteria for a nonprofit organization to qualify as an artists' community: a primary purpose of the organization is support for artists in the creation of work; the organization has artists on its board; it has a paid professional staff; and it requires a formal application, plus support materials. The organization brings artists together into a community, removing them from their everyday obligations and providing uninterrupted time to work, in a specific site that is dedicated to that mission. The admissions process, which can include international artists, is rigorous in terms of artistic quality.

This excerpt should help clarify certain modus operandi. It is taken from the *Artists Communities*, Second Edition (Allworth Press, 2002):

> Whether artists communities are located in pastoral settings or in the middle of urban warehouse districts, artists' communities have been founded on the principle that through the arts, culture flourishes and society's dreams are realized.
>
> If their application is successful, they arrange the details of their residency with the community's staff. They may receive a stipend or be required to a pay a fee, depending on the community, and details about equipment and materials needs, accommodations, and reimbursement for expenses vary.
>
> Once at a community, artists are given studios or workspaces, housing (or reimbursement for the cost of housing), and often meals. Their residencies may last anywhere from a few weeks to a year or more, depending on the type of community. During their residency they are free to work 24/7 if they choose, though some communities may require some light duties to be performed.

In recent years, there has been movement regarding "the support system for artists." That is why in 1992 artists' community founders and directors formed the Alliance of Artists' Communities. Together, they are trying to build an organized system to understand the needs of artists and to offer help where it is most critically required. Clearly, time and space to work are still a primary need.

Some artists' communities are now offering production, exhibition, performance, and publication as an outgrowth of their residencies' programs, recognizing that the products of the creative process are also in need of support.

Artists' communities and those who support them are committed to the principle that art stimulates new ways of thinking and new ways of seeing. It should come as no surprise, then, that the voices and visionaries of our time continue to be cultivated at artists' communities. Many famous and emerging artists work at artists' communities; therefore, it is a supportive place to network. If you receive a residency, it is important to contact your local paper to see if an article can be written about receiving the residency. Then, contact magazines and newspapers after the completed residency with the documentation of what was created.

The International Association of Residential Arts Centres and Networks is the global equivalent to the U.S. Alliance of Artists' Communities. The most cur-

rent list is from 1998. Contact Michael Haerdter, Resident Artist President, Kunstlerhaus Bethanien, Marianenplatz 2, 10997 Berlin, Germany; 49-30-6169030; fax, 49-30-61690330; e-mail, *resartis@bethanien.de; www.resartis.org.*

Patricia Goodrich

Patricia Goodrich is a professional poet and interdisciplinary artist (site-specific installations, conceptual art, and sculpture derived from natural and manmade found objects). Since 1989, she has had seven residencies in poetry and visual arts at such colonies as New York's Yaddo, Vermont Studio Center, Florida's Atlantic Center for the Arts, and Lithuania's Europos Parkas (for which she has recently received grants from the Leeway and Puffin Foundation).

Some of her achievements through poetry include a Pennsylvania Council on the Arts Fellowship in Literature, 1991; six chapbooks of her poetry; featured poet on Smithsonian Public Radio's *Dialogues* (1993–1994); New Jersey Arts Council's Writer-in-the-Schools; and Geraldine R. Dodge Foundation's Poet-in-the-Schools, 1987–2003.

Since 1996, her museum exhibitions include Museum of New Art in Michigan, as well as the Woodmere Art Museum, Allentown Art Museum, and Packwood Museum, the three of which are in Pennsylvania. Additionally, Patricia has won eight first prizes and purchase awards in sculpture and is in the collections of the Pennsylvania Academy of Fine Arts, Bryn Mawr Rehabilitation Hospital, Bucks County School District, and in numerous private collections.

One of her noteworthy creative occupations is being a lecturer, offering arts, crafts, and writing aboard Cunard and Celebrity cruise ships from 1990 to the present. Often, these guest instructors receive free room and board and a stipend; it all depends on your résumé and reputation. Fifteen cruises between one and two weeks have taken her to Alaska, Egypt, Bermuda, the Mediterranean, Baltic, Caribbean, and the United Kingdom—for additional information, see end of chapter 9.

Patricia offers some residency-colony tips. She spends between five and six hours a week completing residency, grant applications, and show announcements. The application fee is free or nominal ($20–$30); therefore, do not consider this an obstacle. When the panels have to select between two residents, they will often choose a resident who has never been to the colony; the colonies, therefore, support emerging artists.

Wolf Kahn and Patricia Goodrich at the Vermont Studio Center during a critique in 2002.

Artist Patricia Goodrich stands next to her *Produce Poetry* installation at Publix Supermarket, New Smyrna Beach, Florida, 1999, created through a residency at the Atlantic Center for the Arts.

References are extremely important, especially from someone who had an outstanding residency at the colony. If you cannot find a previous resident, then obtain a reference from a prominent person in your field. Do not contact the colonies early to find out if you were selected. They will inform you in due time. It often takes two to three months to receive a positive answer. Deadlines are usually six months in advance of the resi-

dency date. Most facilities do not house spouses; they have to stay at a nearby hotel. The colonies are as accommodating as possible, but one has to remember that you are a guest.

The selection panels take a significant interest in the work sample. Their expert evaluation reflects professionalism. For example, in the writing and poetry category, the work sample has to be a good, clean copy on high-quality paper. She recommends at least a 25 percent cotton rag paper (Strathmore), and at least a 20 lb. paper.

In the visual arts category slide submissions should vary from eight to twenty in number. The best slides of your artwork should be foremost. They must be first-rate slides (make sure you review your slides through a projector before submission). You do not want to show out-of-focus artwork, a slide that needs color correction, or a background that interferes with the artwork. A nondistracting background is essential for concentrating on the artwork; use either a white, gray, or black background.

The length of the residency can vary from two weeks to several months; for Patricia, three weeks is a minimum. At the Providence Fine Arts Center a residency can be as long as nine months; however, they more often last from a month to six weeks. Most colonies underwrite the cost of the actual residency, such as housing plus meals, but travel (unless otherwise stated) and materials are often the responsibly of the resident. Residents often ship materials via UPS to the residency site. Most colonies have access to the Web, but call in advance with any specific questions.

Generally, colonies want to keep the panelists names secret, even after they have awarded the residency. This ensures an impartial review process. Often, the panels rotate every year; therefore, if you have been rejected, you should apply again. (But the MacDowell Colony advises applicants not to submit slides that have already been submitted, even if the panels rotate.)

Patricia also describes the residency experience. Your studio time is sacred. At some colonies, if the office wants to communicate with you, they will slip a note under the studio door. Once you are in residence, they do not monitor you, and nobody visits you during the day. The evenings can be formal if someone gives a concert, reading, or offers an open studio. You see the other residents, which range in number from five to fifty, during breakfast or dinner. At the Vermont Studio Center, resident artists can sign up for critiques, if they so choose, from a prominent artist-in-residence. Often, they, as well as the other residents, give presentations, readings, and open studios.

The time you congregate with other residents is often intense, as there is a collective energy from being in the company of many creative people. These are focused individuals, and the residency experience can lead to contacts, networking, and collaborations. Very often, if artists decide to collaborate, they will do so at a new residency. The collaborating artists will then apply separately (to the same colony) for a new joint residency, and the colonies support this. Patricia prefers colonies that offer inter or cross-disciplinary approaches, rather than only, say, a writers colony. She says, "Stimulation comes from composers as well as visual artists."

In 1995 she applied to work with a master artist in the field of poetry at the Atlantic Center for the Arts. Lucile Clifton selected her, but she was unable to be in residency, therefore Sonia Sanchez substituted as a resident poet. Patricia had the opportunity to cancel the residency, but decided to continue it anyway. At another residency, she met Glenis Redmond who later did a residency at Patricia Goodrich's Central Bucks School District. In 2002, both were in residency at Vermont Studio Center.

In 1999, the Atlantic Center for the Arts hosted artist Tadashi Kawamata, through a Japanese/American Exchange. He then selected four American and four Japanese artists in the area of public sculpture; Patricia met with him for three hours every day and then worked on her own projects for a three-week period. E-mail Patricia at *pgoodric@cbsd.org*; *www.philasculptors.com/ members/pgoodrich.htm.*

The National Endowment for the Arts

The Visual Arts Program of the NEA funds organizations and they can only submit one application from the following areas: (1) Access; (2) Challenge America Access; (3) Creativity; and (4) Heritage/Presentation. All artists have to be included in the organization's grant application to be eligible for any funding. Contact the National Endowment for the Arts at 1100 Pennsylvania Avenue, N.W., Washington, DC 20506; 202-682-5400; *www.arts.endow.gov.*

Organizational opportunities are:

- **Arts Learning** supports projects that involve children and youth, in school and outside the regular school day, in three areas: Early Childhood, School-Based, and Community-Based. Grants generally range from $5,000 to $150,000 and require a match of at least 1:1.
- **Grants to Organizations** guidelines contain application information for Heritage and Preservation projects and for Challenge America

Access projects that make quality art broadly available, especially for underserved communities, etc. Grants generally range from $5,000 to $150,000 and require a match of at least 1:1.

- **The Arts on Radio and Television** supports arts programs that are intended for national broadcast on television and radio. Grants generally range from $20,000 to $200,000 and require a match of at least 1:1.
- **The Folk and Traditional Arts Infrastructure Initiative** assists projects that strengthen the infrastructure of support for the folk and traditional arts within a local community, state, or region. Grants generally range from $10,000 to $50,000 and require a match of at least 1:1.
- **Partnership Agreements** assist the state and jurisdictional arts agencies and their regional organizations.
- **Resources for Change and Technology** supports model projects that demonstrate technological advances that can benefit the entire arts field. Grants generally range from $50,000 to $200,000 and require a match of at least 1:1.
- **New Public Works** makes a limited number of grants for design competitions to stimulate excellence in design in the public realm. The Arts Endowment expects to award up to ten grants of approximately $75,000 each. All grants require a match of at least 1:1.

Limited Grants for Individuals

National Heritage Fellowships in the Folk and Traditional Arts recognize the recipients' artistic excellence and support their continuing contributions to our nation's traditional arts heritage. Up to thirteen nonmatching fellowships of $10,000 each are awarded based on nominations.

American Jazz Masters Fellowships recognize distinguished jazz artists who have made a significant contribution to the art form. Up to three nonmatching fellowships of $20,000 each are awarded based on nominations.

Literature Fellowships are provided for published creative writers and translators of exceptional talent in the areas of prose and poetry. For Creative Writing Fellowships, nonmatching grants are for $20,000. For Translation Projects, nonmatching grants range from $10,000 to $20,000.

Cultural Funding: Federal Opportunities

The NEA's Web site now includes a page called "Cultural Funding: Federal Opportunities." This is a resource intended to point you to an array of funding opportunities supported by federal dollars at the national, regional, state and local levels. At the core of this resource are specific examples of funded cultural programs. However, it is not a definite comprehensive resource. Categories are:

- **Arts Education,** which includes Pre-Kindergarten, K–12th, Special Education, and Lifelong Learning.
- **Youth Development,** which includes Early Childhood; Prevention and Child Development; Intervention Programs; Job Training, Apprenticeships, and Life Skills.
- **Access to the Arts,** which includes Connecting Technology, Disability and Accessibility, Rural, and Inner City.
- **Cultural and Heritage Preservation,** which includes Cultural and Heritage Tourism, Traditional Folk Arts Events and Learning, Documentation and/or Preservation of Heritage Collections and Sites, Community Cultural and/or Heritage Assessments.
- **Community Arts Partnerships,** which include Transportation Design and Art, Design and Revitalization of Communities, Livable (Sustainable) Communities, and Collaborative Partnerships.

Regional National Endowment for the Arts Funding

The NEA has developed a program of regional awards that covers the fifty states, Washington, D.C., and the Virgin Islands. Call these organizations to find out the current status on whether they fund fine artists. The six regional arts organizations are:

- **Arts Midwest** (Illinois, Indiana, Iowa, Michigan, Minnesota, North Dakota, Ohio, South Dakota, and Wisconsin), 2908 Hennepin Avenue, Suite 200, Minneapolis, MN 55408; 612-341-0755; e-mail, *general@artsmidwest.org; www.artsmidwest.org.*
- **Consortium for Pacific Arts & Cultures** (Hawaii, American Samoa, Guam, and Commonwealth of the Northern Mariana Islands), 735 Bishop Street, Suite 310, Honolulu, Hawaii, 96813; e-mail, *cpac@pixi.com; www.pixi.com/~cpac.*
- **Mid-America Arts Alliance,** (Arkansas, Kansas, Missouri, Nebraska, Oklahoma, and Texas), 912 Baltimore Avenue, Suite 700, Kansas City, MO 64105; 816-421-1388; e-mail, *lisa@maaa.org; www.maaa.org.*
- **Mid-Atlantic Arts Foundation** (Delaware, Washington, D.C., Maryland, New Jersey, New York, Pennsylvania, Virginia, Virgin Islands, and West Virginia), 201 North Charles Street, Suite 700, Baltimore, MD 21202; 410-539-6656; e-mail, *maaf@midatlanticarts.org; www.midatlanticarts.org.*
- **New England Foundation for the Arts** (Connecticut, Maine, Massachusetts, New Hampshire, Rhode Island, and Vermont), 266 Summer Street, Boston, MA 02210; 617-951-0010; e-mail, *info@nefa.org; www.nefa.org.*

- **Southern Arts Federation** (Alabama, Florida, Georgia, Kentucky, Louisiana, Mississippi, North Carolina, South Carolina, and Tennessee), 1401 Peachtree Street N.E., Suite 460, Atlanta, GA 30309; 404-874-7244; e-mail, *saf@southarts.org; www.southarts.org.*
- **Western States Arts Federation** (Alaska, Arizona, California, Colorado, Idaho, Montana, Nevada, New Mexico, Oregon, Utah, Washington, and Wyoming), 1543 Champa Street, Denver, CO 80202; 303-629-1166; e-mail, *staff@westaf.org; www.westaf.org.*

Crunchy Snail Mail

The delivery of first-class mail to the NEA has been delayed since mid-October 2001 (due to biological contamination), and delays are expected to continue for the near future. Until normal snail-mail service resumes, consider using alternative delivery services, particularly if you are sending time-sensitive materials. If you do opt to rely on the U.S. Post Office, be advised that it may be put through an irradiation process to protect against biological contamination. Support materials (e.g., CDs, videos, and slides) put through this process are apt to suffer irrevocable damage—known as "crunchy snail mail."

The Automated Panel Bank System

If an artist wishes to be considered as a panelist, the NEA has a database called the Automated Panel Bank System. This computer program searches for panelists and has about four thousand names on it. Ask for this form from the NEA Office of Panel Operations, Nancy Hanks Center, 1100 Pennsylvania Avenue, N.W. Washington, DC 20506; 202-682-5533.

State Funding

As of this writing, some states, like Arizona and New Jersey, are considering eliminating altogether their arts councils, due to serious budget cutbacks. Fellowship amounts left in the remaining states vary, and the competition is statewide rather than national or regional, making it less rigorous but still fiercely competitive. The state capitals are home to the local arts councils, and you need to e-mail, write, call, or fax them to be placed on an e-mailing list for application guidelines.

Additionally, sometimes arts councils offer an arts newsletter, which lists different grants available and the deadlines. *For Your Information,* for example, is the New York Foundation for the Arts newsletter, at *www.nyfa.org.* When writing to state arts councils, ask for the guide to programs, the individual artist fellowship, and artist-in-education applications. The full scope of what your state arts council has to offer will then become apparent.

Some state applications have two written sections of one hundred words in length: one describes how your work will be advanced by this fellowship; the other is a statement about the work (your art rap) documented by the support materials. There are no project descriptions to fill out. A panel of your peers (artists who have previously received grants, museum curators, directors from nonprofit organizations, and critics) selects the individuals for awards.

State and Local Opportunities in Pennsylvania

Although each state has its own guidelines and categories, most have a visual arts program. I will use the Pennsylvania Visual Arts Program as an example. It is similar in its essentials to other states' programs, with a purpose and background to assist contemporary artists of exceptional talent and encourage activities that further their professional growth. The program supports serious works that foster a professional attitude toward the aesthetics of contemporary art.

The funding categories are Individual Artists Fellowships and Special Opportunity Stipends (SOS). The Individual Artists Fellowships alternate categories each year, with odd years addressing Arts Commentary, Crafts, Folk and Traditional Arts, Literature (fiction and nonfiction), Media Arts (narrative and animation), Music (jazz/blues/world or nonclassical composition), Theatre (new performance forms), and Visual Arts (photography or sculpture/installation). Even years are devoted to Dance, Folk and Traditional Arts (performing); Literature (Poetry); Media (documentary and experimental); Music (classical composition); Theatre (scriptworks); Visual Arts (painting, drawing, artist's books, printmaking, or new technologies). In addition to the fellowship money, the award recipient receives a spot in the PCA Online Fellowship Catalog, which includes an image of the work, a résumé, an artist statement, and the recipient's contact information.

By applying to the Individual Artists Fellowship program, an artist may be transferred to the SOS pool and thus become eligible to apply to the SOS program. The program provides reimbursement for up to $1,000 for the documented costs of a specific, concrete opportunity such as an exhibition, mentorship, performance, publication, residency, conference, or festival that significantly benefits and advances your development as an artist. You can only be named to the SOS pool through the Fellowship process. All new SOS members are eligible the September after their notification letter.

Incidentally, all Visual Arts and Craft artists who apply are also included in both the online and the physical Levy Gallery Artists Registry at the Moore College of the Arts in Philadelphia. Since this is not a juried registry, any artist can submit work. Currently there are 1,700 artists in the registry. Contact the Galleries at Moore, 20th and The Parkway, Philadelphia, PA 19103; 215-965-4027; e-mail, *rshortell@moore.edu*; *www.thegalleriesatmoore.org/gmslide.*

In addition, the Pennsylvania Council on the Arts is currently funding a traveling exhibition program called Picture Pennsylvania (*www.picturepa.org.*), which encourages partnerships among Pennsylvania's nonprofit organizations by promoting the development of curated exhibitions designed to travel within Pennsylvania. The initiative provides resources by maintaining an interactive Web site for participants to register, promote, market, and foster traveling art exhibitions with the purpose of reaching the maximum audience. The goal of Picture Pennsylvania is to enable organizations to exchange information about traveling exhibitions, related programs, and collections. In addition, they plan to fund 50 percent of the approved traveling exhibitions. If an artist independently curates a traveling exhibit, it has to be submitted through a nonprofit organization to receive any Picture Pennsylvania funding. Picture Pennsylvania also offers an annual conference.

The Freedom of Information Act— Finding Out Who's Receiving Money

The primary purpose of the Freedom of Information Act (FOIA) is to make documents available to the public. For example, any successful NEA application for an individual artist fellowship or for an organization would be available under the statute to anyone requesting the opportunity to review it.

When appropriate, a fee may be charged for processing an FOIA request, depending on the status of the requestor and the use of the requested information. The first two hours of search time as well as the first one hundred pages are free.

To find out which individuals and organizations received grants, refer to the NEA Annual Report for any year since 1965. In the report, all grants awarded by the agency in that fiscal year are listed, along with the category, project description, and the amount of the award (only for organizations). These reports are available at no cost every spring or summer and may be requested through the Arts Endowment Public Information officer. However, current listings are also online at *www.arts.endow.gov/learn/FOIA.* Here, you can make the request, and it takes approximately twenty working days to fulfill the request. Contact Joan M. Evans,

FOIA Officer, Office of the General Counsel, Room 518, National Endowment for the Arts, 1100 Pennsylvania Avenue, N.W., Washington, D.C. 20506; 202-682-5400.

A successful individual artist grant application from previous years is a valuable tool that will allow you to understand what written criteria helped the proposal to be funded. It can offer critical insights into how to write your application for regional, state, or private foundation grants.

In addition, the information gathered from Visual Artists Organizations establishes monetary guidelines for residencies, workshops, demonstrations, or honorarium fees. The range is $25–$1,000. These figures represent group shows (lower fees) and solo shows (higher fees) and are based on the reputation of the individual artist and organization, location (major versus minor city), and other factors. Information based on NEA applications obtained through the FOIA can be used as justification when negotiating fees.

A Citizen's Guide on Using the Freedom of Information Act and the Privacy Act of 1974 to Request Government Records is now available free and online at *www.epic.org/open_gov/citizens_guide_97.html.* In addition, the American Civil Liberties Union's Web site has a FOIA online systematic guide at *www.aclu .org/library/foia/html.*

Other Sources of Information

It is advisable to check both the NEA's Web site, which lists NEA-funded organizations, and the publication *AfterImage* (31 Prince Street, Rochester, NY 14607; 716-442-8676; *www.afterimageonline.org*), which publishes a list of who received NEA money in the Visual/Media arts. *AfterImage* also supplies brief descriptions of these funded organizations.

You might also call the Visual Artist Information Hotline, which is available to assist artists in the United States and its territories. It is primarily a referral service that gives details to visual artists on a wide variety of programs and services at organizations they can apply to directly. Direct staff assistance is available Monday through Friday, 1:00–4:00 P.M., at 800-232-2789; e-mail, *hotline@nyfa .org, www.nyfa.org/vah.*

A Note about Panelists— and about Becoming One

The NEA will only review slides for nonprofit organizations and museums. When an artist's slides are viewed by a state panel like the Pennsylvania Council on the Arts or the by NEA's six regional organizations, the slides are viewed simultaneously.

The Pennsylvania Council views four slides simultaneously, three times for ten seconds for their first round. It is very important to present your strongest

work, since eight to ten seconds for four to five slides is not enough time to fully comprehend the work. The panelists do not talk; they view and take notes during this time. At this point 50 percent of the applicants are eliminated. However, they do briefly look at every slide.

The second round lasts twenty seconds for each group of slides, and the panelists both discuss the works and take notes. Maybe 60 percent of this group will be eliminated.

The third round can last up to one minute for each group of slides, and the panelists can ask information regarding size, medium, or technique, and the discussions about the art becomes more directed. Again, around 60 percent of these remaining artists will be eliminated.

The final round is the fourth. At this time, the applications are finally seen by the panel along with the résumés. More discussions take place, and the final numbers are narrowed down to those grants to be awarded.

This process lasts two to three days for the Pennsylvania Council on the Arts. Every year, the panel is different, and its makeup is based on many factors; they try to achieve an even balance of men, women, and different ethnic groups, based on all regions of the country or state.

The NEA has a layperson on each of its organizational panels, but the states do not follow this procedure. The number of people on the Pennsylvania panel for Individual Artists Grants, for example, varies between three and five and usually consists of professional artists.

The process for becoming a panelist differs from state to state. You can write the state art council's grant panel officer for guidelines and applications. If you prove to be a good panelist in one forum, it is often easier to serve on another panel, because the names of good panelists are networked from one state to another. To be considered for the Pennsylvania panel, artists need to contact Brian Rogers at Commonwealth of Pennsylvania, Council on the Arts, Room 216, Finance Building, Harrisburg, PA 17120; 717-787-6883; fax, 717-783-2536; *www.artsnet.org/pca*. Brian looks for practicing artists from out-of-state, but sometimes he uses in-state artists and nonprofit administrators. The panelists are paid $150 a day plus travel. Note that the council prefers to use regional people to save on travel expenses.

The Scotch Tape Test

It is an act of blind faith when artists submit supporting materials with a grant proposal. You assume the panelists will actually view the work; however, a "scotch tape test" is a way to determine whether the slides were indeed viewed. Just fold the slide sheet, and put a piece of tape over it. The seal must be broken to take the slides out of the sheet. If the work is returned still sealed, then you know it was not even opened. The same procedure should be followed for video or audiotapes.

During the early 1980s, I applied for a video grant through a public television station in New York City. I did this test and received the materials back still

sealed. I called up the person in charge of the grants and explained the situation. I was told I was sneaky to do that test. I was not considered for that grant, because by the time the videotape was snail-mailed back to me, the decisions had already been made. I am not saying that organizations do not view the slides or other support materials, but a check system is necessary, just to keep them honest.

Recycling Applications

When you apply for a grant and are either accepted or rejected, the application can be recycled. It is not necessary for every project description to be original for every application. If you applied for a special project on a state level and it was approved, then you know the grant proposal is strong. It might be modified, but it could be used again if another organization accepts the proposal. The best strategy is to do the project in another state through an NAAO group. There is no clearinghouse network for those who receive grants as the state governments do not print up annual reports. In effect, it would be a touring exhibition that does not officially go on tour.

If your grant application was rejected, it is important to find out the reasons for rejection; then the application could be modified and resubmitted at a later date. If a proposal is rejected on the federal level, the same grant might be approved on a regional, state, or local level. Remember to make photocopies of all applications for your files.

Finding an Assistant

If you have been awarded a grant or fellowship but the timing of the award is inconvenient because of prior commitments, you might need to hire an assistant or apprentice. Today, assistants do a variety of jobs ranging from secretarial work (mailings and phone work) to detail activities (commissioned editions or special projects). How do artists find an assistant? One way is to run an ad in a newspaper, magazines, or artists' newsletters. Try contacting a high school or college art department and inquiring about a student interested in working with a professional artist. Sometimes, educational credits can be given to the students in lieu of payment.

The qualifications needed for an assistant are some experience, a personality you are comfortable with, and the willingness to work odd hours. Successful artists sometimes have numerous people working for them. Networking and meeting successful artists to discuss business practices might be a worthwhile learning experience for an emerging artist.

The National Network for Artist Placement, NNAP, now presents the completely revised and updated eighth edition of *The National Directory of Arts Internships* (935 W. Avenue 37, Los Angeles, CA 90065; 213-222-4035; *www. artistplacement.com*). The cost is $75. At the time of this writing, if you purchase

this directory, you also receive *The National Resource Guide for the Placement of Artists*. The eighth edition is one of the most comprehensive guides of its kind; the National Directory of Arts Internships has again expanded its listings of entry/intern/fellowship opportunities for artists seeking experience in every art form produced in the United States. This directory cites over approximately 1,300 host organizations and more than 3,000 internship options.

The following periodicals can also be helpful resources for finding assistants.

- *Afterimage,* Visual Studies Workshop, 31 Prince Street, Rochester, NY 14607; 585-442-867; e-mail, *afterimage@vsw.org; www.vsw.org/afterimage.* The $30 subscription includes six issues a year.
- *Art Calendar,* P.O. Box 2675, Salisbury, MD 21802; 410-749-9626; e-mail, *info@ArtCalendar.com; www.artcalendar.com.* The $33 subscription includes eleven issues a year.
- *Art Papers,* Atlanta Art Papers, Inc., Box 7548, Atlanta, GA 31107; 404-588-1837; e-mail, *info@artpapers.org; www.artpapers.org.* The $35 subscription includes six issues a year.
- *The Crafts Report,* P.O. Box 1992, Wilmington, DE 19899; 800-777-7098; *www.craftsreport.com.* The $29 subscription includes twelve issues a year.
- *FYI,* New York Foundation for the Arts, 155 Avenue of the Americas, New York, NY 10013; 212-366-6900, ext. 248; e-mail, *subscription_info@nyfa.org; www.nyfa.org/nyfa/fyi/fyi_subscribe.htm.* New York State residents can receive *FYI* free of charge via bulk snail-mail delivery. *FYI* is also available to New York State residents with first-class postage for an annual contribution of $9.99. Out-of-state residents can receive *FYI* with first-class postage for an annual contribution of $11.99. Published quarterly.
- *Sculpture,* International Sculpture Center, 1529 18th Street N.W., Washington, D.C. 20036; 202-234-0555; e-mail: *sculpt@dgsys.com; www.sculpture.org.* $95 membership includes ten issues a year.

Emergency Assistance for Artists

If a serious illness (either physical or mental) or a catastrophe occurs in your life, and you are able to prove your need for financial assistance (with doctors statements, hospital bills, and other documentation), a number of foundations can offer help. They are:

- **Artists Fellowships,** c/o Salmagundi Club, 47 Fifth Avenue, New York, NY 10003; 212-255-7740. They assist painters, sculptors, and graphic artists; the amount of assistance is not specific.
- **Adolph and Esther Gottlieb Foundation,** 380 West Broadway, New

York, NY 10012; 212-226-0581; fax: 212-226-0584; e-mail, *sross@ gottliebfoundation.org; www.gottliebfoundation.org*. They assist painters, sculptors, and printmakers who have been working artists for at least ten years with grants up to $10,000.

- **Artists Now Exhibiting Work (ANEW)**, 3301 N.E. 17th Court, Fort Lauderdale, FL 33305; 954-560-3464; fax: 954-563-6227; *www.anew. org*. ANEW is a membership organization that helps artists of all disciplines with marketing and exhibiting assistance. For emergency assistance, membership is preferred but not required; in emergency situations, membership may be donated.

- **Pollock-Krasner Foundation**, 725 Park Avenue, New York, NY 10021; 212-517-5400; fax: 212-288-2836; e-mail, *grants@pkf.org; www.pkf.org*. They assist painters, sculptors, and artists who work on paper and who demonstrate merit and financial need (which can include illness); grant range is $1,000–$30,000.

- **The Craft Emergency Relief Fund**, Box 838, Montpelier, VT 05601; 802-229-2306; e-mail, *info@craftemergency.org; www.craftemergency.org*. They provide immediate support including loans, booth fee, discounts on materials and equipment to professional craftspeople facing career-threatening emergencies.

- **Change Inc.**, P.O. Box 54, Captiva, FL 33924; 212-473-3742. They provide emergency aid for evictions, unpaid utility bills, fire damage, and other problems. Applications can be processed very quickly (if necessary, within a few days). For all art disciplines. The range of relief is from $100 to $1,000.

- **Ludwig Vogelstein Foundation, Inc.**, P.O. Box 510, Shelter Island, NY 11964. They provide grants to financially needy individuals in the arts and humanities for specific projects. Most grants range from $1,000 to $3,500.

- **Wheeler Foundation**, P.O. Box 3000507, Brooklyn, NY 11230; 718-951-0581; fax: 718-258-1157. This foundation offers emergency grants to visual artists of color living in New York, New Jersey, or Connecticut. Grants are to meet urgent financial needs involving housing, medical, and fire and flood damage.

Funding for Travel Abroad

Many organizations in the United States, such as the NEA, Arts International, the Rockefeller Foundation, the Lila Wallace–Reader's Digest Fund, and the Pew Charitable Trust, offer residencies, international exchange programs, or travel grants. Individuals can apply for some of these grants directly, but a majority of them require a nonprofit organization to apply. The U.S. Information Agency (USIA) curates "Fine Arts Exhibitions" in foreign countries, usually through U.S.

embassies and consulates. These exhibitions are organized by museums, nonprofit organizations, and sometimes by independent curators. To find out where federal money was used, contact the NEA International office and ask for a list of funded fine arts exhibitions in foreign countries. Or use the FOIA to obtain the documents. This might be useful for contacts in both the United States and Europe.

If an artist is invited to exhibit overseas, then The Fund for U.S. Artists makes possible official U.S. representation at leading international contemporary visual arts exhibitions. Projects supported by The Fund feature the work of artists of the highest caliber who reflect the cultural and regional diversity of the United States. Since the program's inception, the United States has been represented at numerous international visual arts events by a series of award-winning solo and group shows.

The Fund for U.S. Artists at International Festival and Exhibitions believes that the interaction among U.S. artists and international audiences is a vital element in the exhibition presentation.

The call for proposals is approximately 12–18 months in advance of scheduled exhibitions. Eligible applicants include U.S.-based nonprofit museums, galleries, visual arts organizations, and independent curators. Contact Arts International, 251 Park Avenue South, 5th floor, New York, NY 10010; 212-674-9744; fax: 212-674-9092; e-mail, *thefund@artsinternational.org*; *www.artsinternational.org*.

Another fund, ArtsLink Projects, provides support to U.S. artists, curators, presenters, and art organizations to work with their counterparts in twenty-seven countries in Central and Eastern Europe and Central Asia. Projects should be designed to benefit participants or audiences in both countries. CEC International Partners, the administrators of ArtsLink, can assist interested applicants in identifying contacts in the region.

In 2003, applications will be accepted from individual artists, curators, and nonprofit arts organizations working in visual (slides are required), design, or media arts. ArtsLink has a cycle of alternate year deadlines, according to discipline. In 2004, applications will be accepted from individual artists, presenters, and nonprofit organizations working in the disciplines of theater, dance, music, and literature.

Support is provided to create new work that draws inspiration from interaction with artists and the community in the county visited; establish mutually beneficial exchange of ideas and expertise between artists, arts organizations, and the local community; pursue artistic cooperation that will enrich creative or professional development, or have potential to expand the community's access to the art of other cultures. Descriptions of past ArtsLink Projects are available on the ArtsLink Web site, *www.cecip.org*. To consult with ArtsLink staff or receive information, ArtsLink, CEC International Partners, 12 West 31st Street, New York, NY 10001; 212-643-1985 ext. 22; fax: 212-643-1996; e-mail, *artslink@cecip.org*.

Finally, the Fulbright Program provides grants for Graduate Students,

Scholars, Professionals, Teachers, and Administrators from the United States and other countries. The Fulbright program has provided more than 250,000 participants—94,000 from the United States and 156,000 from other countries—in the past fifty years. Every year, approximately 4,600 new grants are awarded. Contact the Council for the International Exchange of Scholars (CIES), 3007 Tilden Street N.W., Suite 5L, Washington, D.C. 20008, 202-686-4000; fax, 202-362-3442; e-mail, *scholars@cies.iie.org; www.cies.org.*

If you wish to fund a residency in France, The Foundation Claude Monet has studio space for three visual artists in Giverny, France. For information, contact Foundation Claude Monet, 84 rue Claude Monet, 27620 Giverny, France; 33-32-51-28-21; fax, 33-32-51-54-18; e-mail, *contact@fondation-monet.com; www.fondation-monet.com.*

Artists-in-Education

In order to be considered for an artist-in-education (A-I-E) grant, and then for an artist-in-residency (A-I-R), you must be on a state's artist roster. There used to be certain exceptions for nonroster artists to receive funding, but in this current climate this is no longer true. Once placed on the artist roster, you will be on specialized mailing lists, which allows you to make money from your art skills in an educational environment.

The publicity that you have accumulated should make it easier to get your name placed on these rosters. Reputations do count, as peer artists evaluate these applications. Publicity about the A-I-R is an essential part of the grant, since you will be conducting the residency in a public forum: school, hospital, prison, senior citizen center, or other nonprofit organization.

History

The NEA, created by Congress in 1965 as part of the Johnson administration's Great Society Program, provides national recognition and support to significant projects of artistic excellence, thus preserving and enhancing our nation's diverse cultural heritage. The arts-in-education initiative began as part of the NEA's pilot programs in "new education," which began in 1969. North Carolina had been a leader in arts grants, and they had the first arts-in-education pilot program. In 1974, New York State introduced its own A-I-E program.

The A-I-E programs provide working opportunities for artists in a variety

of educational activities. These include K–12 educational institutions, hospitals, prisons, libraries, senior citizen centers, and any other nonprofit organizations that wish to sponsor an artist.

Publicity and A-I-E

Two art-education publications, which are primarily for art teachers, are a good place for marketing and publicity if you are interested in A-I-E programs. If you can write an article with supporting photographs about your artwork for *School Arts* (Eldon Katter, Editor, 464 Walnut Street, Kutztown, PA 19530; 610-683-8229) or *Arts and Activities* (Maryellen Bridge, Editor, 591 Camino de la Reina, Suite 200, San Diego, CA 92108; 619-297-8032; fax, 619-297-5353), then you have entered the privileged world of art education publishing. These are the publish-or-perish journals for art educators looking for tenure status.

These journals are actively looking for new art techniques or art that can easily be explained and created in the classroom. *School Arts* only pays contributors between $30 and $120 an article, but in the long-term this exposure will allow you to reach the growing art teacher audience. The art teacher's approval is essential because the art teacher has to work directly with the artist. Having an article from these journals in your portfolio should improve your chances of both becoming an A-I-E roster artist and being approved for a residency at an institution.

All the different art disciplines have similar magazines, either consumer or trade. Some other magazines are *Theater Crafts, Dance Chronicle,* and *Dance Page.* Check out other educational trade publications in *Ulrich's Guide;* ask them to mail you the guidelines.

What You Need to Know about A-I-E Applications

A-I-E grants and programs require a two-step process before the artist is eligible for work. For each state, an individual A-I-E grant application must be filled out with the necessary supporting materials: slides, video and audiotapes, letters of recommendation, and reviews or articles. If you are approved, you are placed on that state's A-I-E roster. Usually, a booklet is published with a page about you and your work, and you are listed on the arts council's Web site, (see the artist example at the end of the chapter). Then, schools or other nonprofit organizations interested in having you do a residency must write you into their grant application. This has to be approved by a different grant panel before you are eligible for work. The pay scale is usually from $150 to $250 a day, plus—on occasion—travel, lodging and food per diem expenses. Remember that an artist will always be an independent contactor, and this rate reflects parity with a teacher's day rate.

Every state wants practicing professional artists. The following guidelines taken from the Pennsylvania Guide to the Arts-in-Education program are typical.

Professional artists requesting consideration for residencies in schools and communities or special programs in schools should have a willingness to share their work with young people and adults in a community setting, and be able to relocate if necessary. Priority will be given to Pennsylvania artists. In addition, recipients of Pennsylvania Council Arts Fellowships (Individual Artist Fellowships) are eligible for roster approval. Also, roster artists [meaning approved through this grant process] must be used in all residencies.

Professionalism

There is an intangible quality to the definition of the term "professional." The art councils want to place all work on an equal footing. By correctly following the requirements of the standardized applications, an artist indicates a level of professionalism. The applications require the artist to submit slides, video, or other support materials. The application process is formal and based solely on the work and supporting materials submitted (including credentials in education, training, experience, along with references and recommendations).

The ability to communicate demonstrates your interest and ability in working with young students and adults. In addition, you have to develop and complete a sequential plan for a residency.

Style or discipline of artwork is not an indicator of professionalism. Pluralism in art has been established for over thirty years, and no current school of thought is dictating any particular trend. The roster artists reflect this pluralism, and their styles range from portrait and landscape painters to digital (new media) and performance artists. The organizational sites that hire artists want to choose from the full spectrum of artistic styles. They want the option to decide what the best is for their students.

Artist-in-Education Roster Artist Cindy Snodgrass

For more than thirty years, the internationally known environmental artist Cindy Snodgrass has attracted the attention of educational organizations by weaving environmental activities into community artwork and educational alternatives.

In 2002 she participated in more than two hundred residency days in Pennsylvania and Ohio. Her philosophy on the union of such work is explained in her own words from her artist-in-education statement in the 2002 Ohio Arts Directory.

Curiosity, admiration, and delight in nature activate my energy and creativity. By encouraging observation skills and interest in the natural world, I see others increase their energy and ability to express creative ideas. I work with students and parents to use art and its processes to unite people with the natural world, each other,

Cindy Snodgrass working at the Miller African Centered Academy, Pittsburgh, Pennsylvania, to fit a "Nature Mask" on a third grade student. Photo by Carl Goldman.

and enliven schools. Many environmental projects have connected the school community with the larger community through participatory design and problem solving, often transforming public spaces. The expression of creativity is healthy and uplifting for individuals and communities. Current project themes are water, food, gardens, nutrition, wind, and natural cycles. Materials determined by site and situations, range from large, painted plywood constructions to wind sculpture, installations, ceramics, collage, mask-making, and photography.

Cindy Snodgrass began "collaborating" with nature in the 1970s, working with family and friends. She has produced wind sculptures of architectural scale for more than thirty years. In 1981, she was awarded an Individual Artists Crafts grant through the NEA. This NEA grant funded wind installations for the University of New Mexico in Albuquerque; The Johnson Museum at Cornell University in New York; and the Dayton Art Institute-Experience Center in Ohio.

In 2000, Cindy received $14,500 for *Turtle Vision: A Closer Look at Water from an Aquatic Point of View* from the Mid-

Cindy Snodgrass working at the Osborne Elementary Quaker Valley School District, Pittsburgh, Pennsylvania, making "Nature Flags."

Atlantic Arts Foundation's Artist-as-Catalyst grant. The International Children's Festival (ICF), in collaboration with the Pittsburgh Children's Museum, hosted her residency. Recently, she received a $10,000 2003 Mid Atlantic Foundation: Artists and Communities Grant, for a collaborative, large-scale, fiber-based work, to be included in the summer festival, Kujenga Pamoja (Swahili for Together We Build) presented by the Village of Arts and Humanities, Philadelphia, Pennsylvania. Participants created a large-scale, public artwork that focused the community's attention on issues regarding water. Other grants awarded to Snodgrass include the Heinz Endowment, the Pittsburgh Foundation, the Grable Foundation, the Ohio Arts Council, and the Art Institute of Chicago.

She has worked in many different media; for instance, she engineered and constructed architectural-scale, kinetic, and site-specific wind installations, which have flown between large buildings in New York City, Chicago, Pittsburgh, Atlanta, Miami, Seattle, Dayton, Knoxville, Ithaca, and Duluth. She assembled a video of her work in 1981 that was shown at the *Tenth Biennale Internationale de la Tapisserie*, Musee Cantonal des Beaux-Arts, Lausanne, Switzerland.

Tayamentasachta—never ending waters (a work-in-progress) is a three-story interior collage at the pumphouse of the old Carnegie Steel Mill in Homestead, Pennsylvania. This environmental water installation explains how the lack of clean water creates a precarious ecological situation. It juxtaposes sounds of birds and water to contrasting sounds of military force. The site sculpture includes over seventy colorful cardboard dovetail birds with the gifts of nature (rainbows, fruits, veggies, animals, trees, raindrops, and plants) painted on their wings and backs. They were created with elementary students in an Ohio residency in 2002.

Another 2002 project incorporated and transformed personal images that were taken from nature and the diverse international student population at McNichols Plaza Elementary School in Scranton, Pennsylvania, into an inspiring outdoor installation. Over thirty-nine languages are spoken at this magnet school, and the diversity of perceptions, aesthetics, and expression inspired the students, the art teacher Beth Burkhauser (who collaborated), and Ms. Snodgrass. They created a huge exterior 3D painted mural titled *Nature's Quilt.* The school documented this mural and then published a calendar that is being sold to fundraise future art and garden projects.

These colorful environmental works are created in a collaborative community process. She encourages participants to communicate their skills and ideas to others; not only does this increase participation, but, as Cindy states, "Art making is an act of faith, full of surprises and endless opportunities."

Her vast teaching experience has taken her to numerous college and university campuses, including Syracuse, George Washington, and Carnegie Mellon. She has also delivered lectures at MIT, Rhode Island School of Design, Cranbrook Academy, and the Cleveland Institute of Art (where she chaired the textile department).

Reproductions of her work have appeared in *Whole Cloth* (Monacelli Press, 1997) and *Textile Art* (Rizzoli, 1985). Other publications include three appearances in *Fiberarts,* with a cover in 1979; *Teaching Tolerance Magazine; Miami Herald; Chicago Tribune; Pittsburgh Tribune; American Craft; Textile Art;* and more than a hundred publications.

Cindy has insightful comments about the media; because her works are fleeting celebrations, they are more of a large-scale performance than anything else. "It's news, on the front page. It's part of daily life, and it's not closed off in just the arts section."

From 1983 through 1991, she participated through the Digital Art Exchange (DAX) with artists from Austria, Brazil, Senegal, and the United Kingdom. In the summer of 2002, she and her daughter Erin Beasley worked in collaboration with Lilly Yeh's community arts projects at the Village of Arts and Humanities in North Philadelphia; they plan to return with her younger daughter Aimee for a larger project in 2003.

Recently, she collaborated with Jonathan Eaton and the Opera Theater of Pittsburgh in an eclectic interpretation of Mozart's *The Magic Flute*, which included her monumental "prop" sculptures and unusual flora and fauna costumes. The stage was framed with fifty dovetail birds constructed at the Pittsburgh's Freedom Area Middle School and nature masks were made at a residency with Miller African Centered Academy and Head Start Children.

In 2004, Cindy will be developing international partnerships to create collaborative wind installations that support environmental and peace initiatives.

Currently, she is building a Web site that will show the potential for the blending of arts and environmental awareness to change our urban spaces and human interactions. Contact her via e-mail at *windsphere@hotmail.com.*

Credentials

It is unlikely that an artist fresh out of college will be selected for the artist roster. The grant panels look for applications that demonstrate the ability to work in a classroom situation. The power of the artwork is only one aspect of the applicant's portfolio that will be taken into consideration.

Experience working with students or adults is crucial. In the eyes of the grant panel, a "practicing professional artist" will have: (1) substantial experience teaching, conducting workshops, or demonstrating an aesthetic technique; (2) served on a peer grant panel; or (3) already received an Individual Artist Fellowship from that state. You can gather educational experience by conducting your own art classes, substitute-teaching in your art field, teaching at a community college, or volunteer teaching for churches, after-school programs, libraries, and the YMCA and YWCA. The A-I-E program will not act as on-the-job-training for you to gather classroom experience, unless you come to it through an artist fellowship. This is unfortunate but true. Many artists are rejected due to their lack of experience.

Be aware that some states require fingerprints and do a police check for child molestation and sexual abuse records. (This is only when you are hired for work, not just to be placed on the A-I-E roster.)

Two or three recommendations are usually required. The Pennsylvania

guidelines state that "these should come from sites where recent residencies have been completed or, if you have never done a residency, a recommendation from former teachers or another professional artist familiar with the caliber of your work and your ability to work with students." Read between the lines. I am not trying to discourage anyone from applying, but I would wait a few years after graduating from college. Again, an artist has to have a mature body of work, show a commitment to the field, and have some art, as well as teaching credentials, on her résumé.

A-I-E rosters include artists in these disciplines: architecture, dance, film/video/digital, folk arts, new technologies, poetry/creative writing, play-wrighting/theater, visual arts, and crafts. Subsets of these categories may exist in some states. Contact your local arts council to find out which category you should apply for.

The work samples submitted depend on which media you are using. In general, eight to twelve 35mm slides are required in the visual arts and crafts category. A half-inch VHS is required for dance, film, video, theater, and music. Sometimes, 16mm or Super 8mm film and audiotapes are considered. Writing samples are required for literature, music scores, and theater. These materials should be copies, and not originals (due to potential loss).

The grant panels are made up of your artistic peers, meaning practicing professional artists with education credentials who have recommendations from a host site or colleagues, published articles or books, and a substantial exhibitions record. The panels usually have an odd number of people on them, to avoid any ties when making final decisions. The state A-I-E representatives are present to oversee the process and help when questions arise, but the peer panel decides who is to be on the roster and its decision cannot be appealed.

Not all grant panels include artists. Some panels include a layperson. This is someone who is prominent in the community but not directly involved in the arts: a businessperson, school board member, or self-employed entrepreneur. The panels try to have an even distribution of regions represented as well as men, women, and minorities. Other panelists come from nonprofit agencies such as arts councils either local or statewide, and alternative spaces NAAO. In fact, the A-I-E organizational panels do not have artists on them.

The application must be typed. Depending on the state (there is no standard A-I-E application), the application will ask about your philosophy of teaching, a sample project, and what you plan to create during the residency. Hidden in all of this is the lesson plan. The panel is interested in how you will use the forty-five-minute class time, how that time will be structured, and what will be taught and accomplished. The application does not require a formal lesson plan; however, it is hinted at in the application by a detailed description of what the artist will do in a ten-day residency.

What to Expect

The length of the residency can vary from five to 180 days. Usually the class time is forty-five minutes but there are also double periods. These are two back-to-back forty-five minute classes.

One very important issue is discipline. Roster artists are not supposed to discipline students. It is against the law in some states. If the student becomes unruly, then the teacher (who is supposed to stay in the room at all times) will come to your aid and do the disciplining. An artist-in-residence is not to be considered a substitute or classroom teacher.

In addition to the classroom art activities, sometimes artists conduct assembly programs and in-service seminars. If working with adult populations in prisons, hospitals, or libraries, a different approach is required. However, the majority of residencies are with K–12 grade students.

Assembly programs require artists to see the whole student population. This can be done at one time or over two assemblies (each forty-five minutes). In some cases, if you are doing a daylong demonstration, the entire student population can file through the space in the course of the day. This serves the same function as an assembly program, since each class spends a certain amount of time—about ten to twenty minutes—at the demonstration. Then, whatever is created can be seen by all the students at the end of the day. Either the students return to the classroom with the demonstration or the work is brought to each class. Any variations on this are generally acceptable, but they must be explained to the host site.

Assembly programs should not be considered an official part of the residency. If an outside artist presents an assembly program, the pay scale would be around $400–$500 (for one or two assemblies, forty-five minutes in length). Many times, the host sites will ask the artist to do an assembly for the regular artist's fee. In these cases, artists-in-residence want parity with other professionals who receive a higher fee in a similar situation. This is a case where the rules can be broken. Artists can ask to be paid for two or three days in one, since preparation time and reputation should be considered. The grant funding is 50 percent from the state and 50 percent from the school or site. Remember, the rules are only guidelines allowing for variations for each residency.

The school day for an artist-in-residence is half a day. The other half of the day is to be spent in the school working on your own art. This is the theory, but the practice is far from this. It is possible to work a ten-day residency in five days, if you count full days as working two days in one. But be prepared for very limited or no lunchtime. This is where the assemblies, in-service, or consultant time counts as part of residency payment.

Sometimes sites will try to get you to work longer than what is in the guidelines. If problems arise, refer them to the A-I-E program representatives for guidance.

The host site is responsible for half the fee paid to the artist. These funds can come from PTAs, special fundraisers, additional grants, school budgets, or donations. It is important to know the name of the grant site coordinator for any future questions. Payment should be discussed before the residency. If the host site requires the artist to do pre-residency work, make a site visit, or participate in teacher in-service, ask to be paid. Travel expenses should be reimbursed at the standard rate of $0.365 a mile (IRS mileage rate). Payments usually begin after half the residency is completed, unless other arrangements are made. The final check will be issued on the last day of the residency. School payments have to be approved through the school boards.

Workspace in Schools

The Pennsylvania guidelines state that visual artists-in-residence are to be provided with a workspace or studio that has electricity, a fire extinguisher, running water, and security. A key should be provided. Although this is written in the guidelines, in my experience it has not always been the case. Sometimes, the artist keeps his personal items and materials and supplies locked in a closet.

It is very unlikely you will be able to work on your own art unless the host has a separate space where your things will not be disturbed. Keep the site aware of the guidelines. If there is a problem, ask them to agree to half-days, or ask for two days in one. This is an option that some art councils frown upon and others embrace. Try to work out an acceptable arrangement with the host site before taking problems to the arts council.

Special Projects

Host organizations are sometimes interested in shorter arts education events including performances, master classes, or daylong workshops. These can be from one to three days.

Short-stay company residencies for dance, theater, music, or performance art groups are common. The entire company must participate in a workshop or master class, and the artist's fees are negotiated prior to the application to the arts council. There is no fixed rate, due to the special nature of each company or ensemble.

When the host organization's grant application is first reviewed, it is snail-mailed to the panelists, who do a prescreening. Only the written part of the application is sent to the panelists. Then, the panel meets for one or two days to review the work samples. They take notes during the review process and then decide which sites should be approved. This part of the process is similar to the A-I-E roster artists' panel.

The A-I-E Conferences

A-I-E conferences are not always offered by the states. Sometimes, they hold artists retreats for the new artists on the roster or regional conferences. They are relying more on the Web for host sites to view artists' work and for the artist to find work, since most schools have Web sites that list the principal's or art teacher's e-mail address. Then, the artist can try to solicit work directly.

Pennsylvania has a developing program called Partners in the Arts. Almost all artists who participate with their regional partners can expect to receive residencies. However, not all of the state is covered by Partners, thus prompting a dual approach to seeking work—from both the Partners and direct solicitation.

The conferences are an opportunity to have questions answered by A-I-E state representatives. They offer various A-I-E workshops on topics like publicity, education, future trends, and the law. There are guest speakers, workshops, and the opportunity for artists to show their works to the sites.

The typical conference takes place in a large room with overhead fluorescent lights and banquet tables where artists sometimes display their work. Normally the works of visual artists are combined with dance, theater, video, and music; and overall, the scene resembles a bazaar. The noise level can be high due to the numerous recordings, live performance, people, and sites in the room.

When artists participate at the A-I-E conference, they should prominently display *School Arts* or *Arts and Activities* articles in their portfolio or on a standing table unit. Artists must have materials to give away, such as photocopied articles, résumés, reviews, or brochures. They can have items to sell, such as CDs, catalogs, or videos. If someone is really interested, the artist should give away some items. During these conferences, it is especially important that one presents himself in a professional manner. The portfolios or actual work should reflect this attitude. A VHS deck might be available for community use, but it is best to bring one's own, along with a monitor.

I have found these conferences to be a great place to network, since artists attend from around the state. During the lunches and breaks, artists are able to make the rounds and see what other artists are doing. At this time, tips are exchanged, and first-year roster artists are shown the A-I-E ropes. Some states will pay for travel, meals, or a hotel room.

If a site approaches you and you receive positive feedback, make sure to get complete information about them. You might have to do follow-up calls or letters since the conference is always before the host site's grant application deadline. There are usually a few months before all material is due, and I would send any new articles or reviews that might appear.

Publicity and Its Ramifications

At the A-I-E conferences, a great amount of time is spent on the issue of publicity. There are reasons for this, and they have to do with continued arts support. If an artist receives a positive mention in an article, newspaper, or in a television news clip, the people in the community notice how the school has spent money. When an A-I-E program becomes newsworthy, it may provoke interest and support for the program. Local politicians must be sent this positive media exposure. Hopefully, this will result in an increased state arts budget or, at least, no budget cuts. A certain amount of politics is involved in keeping an arts budget alive, and the state legislators need to be on artists' mailing lists. The politicians may or may not realize how vital the arts are to schools, communities, or libraries. If these politicians are on a significant number of artists' mailing lists and see articles or television news programs (since you will be a master at receiving and disseminating this kind of publicity), it could influence future arts funding. This is not a form of lobbying. It is making people aware of your career. Most state arts councils receive NEA money for their A-I-E programs, and if an article appears, I would send it to your congressperson and senator.

Grant Reporting

After you have completed the project, you and the site are required to formally account for how the time and money were spent. There is another form to be filled out, usually within thirty days after the end of the residency grant. If you do not turn in one of these final reports, it can jeopardize future grants for the site. Without the final report, the grant is considered incomplete, and all grants must be completed before another one is funded.

States Looking for Artists

There are many states that request out-of-state artists since they lack a sufficient pool of diverse talent. Some of these states are Alaska, Delaware, and Montana. There are other states that seem to show no preference between in-state and out-of-state artists, such as Virginia, and North and South Carolina.

By participating in several states, you can be on many roster artist mailing lists and receive various state art councils bulletins. This will help you develop an understanding of trends in arts funding around the country. In addition, you will receive exposure and your name will become familiar to panelists who can influence your future career goals.

Future A-I-E Funding

The federal government and most state governments feel that the art money granted to the A-I-E programs is money well spent, as it contributes to the betterment of the community and is therefore a tangible asset. In the future, it is entirely possible that even more money will be allotted to these programs, as money might be shifted away from other arts programs like re-granting or individual artist fellowships. Congress determines the NEA funding appropriations and can institute legislative changes in how the arts monies are spent.

The arts are often a low priority in education funding and the first to go when budgets need to be trimmed. Without a radical change in education and broad initiatives from the federal, state, or local governments, A-I-E appears to be in a crisis situation, due to its dependency on funding, not curriculum decisions.

However, a change is underway from federal and state art laws mandating art in school curriculums. The prospects for more government A-I-E funding is favorable, because the NEA, either through congressional mandates or shifting priorities, is increasing the money given to A-I-E programs.

If you are interested in the future of art education funding then look into the National Art Education Association, 1916 Association Drive, Reston, VA 22091-1590; 703-860-8000; e-mail, *naea@dgs.dgsys.com*; *www.naea-reston.org*. Membership, which ranges from $20 to $75, is required.

Governor's Schools for the Arts

Almost every state has a Governor's School for the Arts administered by that state's Department of Education (located in the state capital). These are summer art schools that usually run for six weeks and are held on various college campuses. The Governor's Schools have a selection process that offers sophomore and junior high school students the opportunity to learn and create with professional artist teachers and their peers. These selected students have demonstrated an artistic ability through a portfolio or demonstration of their artistic talents. This selection process takes the form of slide submission, videotapes, or an interview process.

Artists can be hired in one of two ways for these Governor's Schools. One, they are hired as teachers. The disciplines in the visual arts can be painting, sculpture, photography, ceramics, drawing, mixed media, graphic arts, design arts, or printmaking. Artists are also hired in dance, music, theater, and literature. If an artist has a reputation and some teaching experience (A-I-E rosters), there is a possibility of being hired. In 1992, the starting Pennsylvania Governor's School salary for first year faculty (I was the photography instructor) was $2,500. If professional artists are unavailable, then graduate art students are hired.

The second way to be hired is to do an artist-in-residency in the visual or performing arts. Sometimes music or dance groups will do a single performance if their schedule does not enable them to do anything longer.

The working hours at the Pennsylvania Governor's School made for a long day, but are, I believe, typical. They try to cram as much information as humanly possible into the students' schedule. The working hours are usually 8:00–11:00 A.M., Monday through Saturday; and 1:00–3:30 P.M. and 6:00–8:30 P.M. Monday through Friday. From 8:45–10:30 P.M., films or student performances are held (the faculty is not required to attend). Occasionally, a scheduled day off is arranged, as some of the classes can be rotated with other teachers. It can be very grueling, and often something comes up that requires additional hours.

The theory behind these schools is to have a working artist-teacher serve as a role model by creating his or her own work during this six-week course. There are no tests or grades; however, critiques, discussions, workshops, and lectures on art history and recent trends in art are encouraged as part of the teaching process. Be prepared for normal educational bureaucracy, faculty meetings, art politics, personality differences, and student behavioral problems all contributing to an exhausting pace.

Artists are hired for one summer, but it is possible to be rehired. Inquire about any faculty opening or artist-in-residencies by contacting the Department of Education in your state. Notices for hiring usually appear during the winter, and the selection is made by the spring. If interviewed, be prepared with a course outline. The instructor decides on the projects and aesthetics to be explored, criticized, and exhibited. Usually at the beginning of the term, the artist/teachers have a group exhibition to introduce the students to their own work. At the end of the course, the students have a group show to demonstrate what they learned.

Partners of the Americas

Established in 1964 as the people-to-people component of the Alliance for Progress, Partners of the Americas is now the largest private voluntary organization in the Western Hemisphere engaged in international development and training. Partners link U.S. citizens with those of Latin American, Caribbean, and South American countries in sixty bilateral partnerships.

Each partnership has volunteer committees on both sides, north and south, that work together at the grassroots level to carry out educational and development projects (including cultural programs). Project assistance funds are available to the partnerships to support community-based projects. These community-based projects take the form of an artist-in-residence, exhibition, or performance. However, these have to be made through a Partners chapter. The average grant awarded is $2,000–$3,000.

If you wish to find out more information, contact Carmen Sepassi, Program Assistant for Education and Culture, Partners of the Americas, 1424 K Street, N.W., Washington, D.C. 20005; 800-322-7844; fax, 202-628-3306; e-mail, cs@partners.net; www.partners.net.

Cruise Ship Employment

Guest entertainers such as lecturers, authors, and arts and crafts instructors are offered job opportunities aboard cruise ships. Payment varies, depending on résumé and reputation. Sometimes, five to ten hours a week are required of art, crafts instructors, and lecturers in exchange for an all-expense-paid vacation. Other times, a strong forty- to fifty-minute, self-contained show caters to a wide diversity of ages. This can be a slide lecture, hands-on demonstration, and so forth.

If you are interested, contact these agencies: Cruise Employment Hiring Agency, 129-2, Suite 19, Brighton Beach, NY 11235; 718-670-7079, *www.cruiseplacement.com*. A $27 processing fee is required, and you can e-mail the application.

Another agency is H.I.R., P.O. Box 852, Hampton, NH 03842; 619-251-8636; *www.cruiseshipjob.com*; there is a $69 fee for an application. It should be noted that I have not verified these two cruise ship agencies, but have listed them for information only.

Chapter 10.

Assembling a Résumé, Portfolio, Letters of Recommendation, and Other Helpful Tips

Once you begin to receive significant publicity, it is important to create a professional résumé and a publicity portfolio. You will need to know how to cultivate professional relationships by using references and letters of recommendation. In addition, you should be on the right mailing lists (see the press agency section in chapter 4), know how to catalog your artwork, and specifically identify material if it is lost or damaged. In case legal problems occur, you should be aware of Volunteer Lawyers for the Arts (VLA), an organization offering free or inexpensive legal assistance. Finally, one of your goals should be having your artwork exhibited in New York City. A number of practical techniques on how to tackle this premier U.S. cultural city are mentioned at the end of this chapter.

The Résumé

An artist's résumé, or curriculum vitae, is a summary of achievements. Now it is possible to have a Web résumé along with the hardcopy résumé. The Web résumé can include pictures as well as the text; however, one's achievements should be listed separately, by category. Within each category, the items should be listed chronologically, with the most recent entry first.

An example of listing by categories are exhibitions in museums or galleries, both solo and group shows; grants received; major reviews and articles in newspapers or magazines; television and radio news items; book publications and catalogs;

LAURENCE GARTEL
INTERNATIONAL

HOME ABOUT COLLECTIONS CELEBRITIES
GIFTSHOP CURRENT EXHIBIT CONTACT

Digital Media Artist

Experimental Television Center, Owego, NY 1973

Born: June 5, 1956

Education: School of Visual Arts, NYC, NY, BFA Graphics 1977

Contact the Artist: gartel@aol.com

Solo Museum & University Exhibitions
Gallery Solo Exhibitions
Museum & University Group Exhibitions
Gallery Group Exhibitions
Selected Collections
Grants & Awards
In Kind Grants
Commissions

Teaching & Lectureships
Articles on Laurence M. Gartel
Books & Catalogs
Book Covers
Television Appearances
Curator
Panelist
Biographies
Professional Organizations
Selected Websites on GARTEL

The splash page of Lawrence Gartel's Web résumé.

lectures, workshops, demonstrations, master classes, and artist-in-education residencies; art collections the work is presently in; and commissions you have received.

An emerging artist can make a résumé appear more significant by using the word "selected." The word "selected" should be used in this way: "selected group museum exhibitions," or "selected grants." It gives the impression either that more is being held back (minor shows or reviews) or that your career is of such length that a lack of space requires you to select the most significant events. It makes the résumé appear professional. Look at famous artists' résumés in museum catalogs and notice the different classifications and how items on the résumé are categorized. Artists with numerous achievements can have a two-sided résumé. This is the maximum length for résumés included with most grant and award applications.

Do not fabricate the résumé. Since an artist is a public figure, it will come back to haunt you at a later date. Be prepared to document everything significant on the résumé. Keep all announcement cards, reviews, grant award letters, publications, and video clips. The résumé should be updated every year. Future information should be included, such as advance notice for articles and upcoming shows. If something falls through, just delete it the following year.

The NEA used to award individual artist fellowships in two categories: emerging and mature. The artist with less than ten years' experience on their résumé was considered an emerging artist, and the one with ten years or more experience a mature (professional) artist. Artists in mid-career, applying for other grants using these categories, may find they have some leeway in determining their status, depending on when they date the start of their career on their résumé. For example, emerging shows at the beginning of a career—such as in restaurants, banks, open studios, or art festivals—could be included or left out to increase or shorten the official length of the career. Call or e-mail the organizations offering grants to try to find out if they prefer emerging or mature artists.

If you are an interdisciplinary artist working in different mediums, you should create several résumés. For example, an artist working in sculpture and dance should have one résumé for dance, one for sculpture, and one for performance art (combining the two). This is because there are often difficulties regarding acceptance (for grants, galleries, or publications) for interdisciplinary work that falls outside of official or perceived categories. The work can be classified as conceptual, visual-based performance, video and new genres, or it can fall between categories. This is one of the hardest disciplines in which to make a living.

Documentation of the work is critical due to the often ephemeral nature of the art. Make sure to document this work in the most professional manner using slides or videos. The documentation supplements the art.

Another reason why interdisciplinary artists should create two or three separate résumés, one for each medium, is that otherwise their work can be interpreted as lacking coherence or unity unless they have a major reputation. Panelists, curators, or gallery owners generally like to follow a single idea, theme, or project, all stemming from one aesthetic. Deviating from this norm, and having it reflected on the résumé, can adversely affect how your résumé is received. Do not try to make the résumé longer just to fill space requirements. The idea is to focus on one topic.

Publicity and Artists' Portfolios

As soon as articles or reviews begin to be published, it is important to establish a publicity portfolio. This is different from a body-of-work portfolio, which should include great quality photographs, sketches, and other materials that accurately represent the artist's actual work.

A publicity portfolio is a record of exhibitions and other events, which might include announcement cards, price lists, reviews, articles, or Web site pages. Many exhibitions can be included in chronological order as they appear on the résumé. It is best to obtain many copies of all published materials in case of lost or damaged portfolios. These materials have to be cut up (if necessary) and arranged in a visually pleasing form in the portfolio.

The layout is important. It should include the masthead from each publication with the issue and date included. Use a glue stick to hold the elements in

place. The review or article should be glued to a white or black sheet of paper (8½" × 11"). These portfolio pages can later be reduced to fit a photocopy for mailings. For longer articles, make a two-sided copy. It is important to use original material in the portfolio but if you only have one copy of a color article, get a color laser photocopy and cut that out. This is especially true for foreign magazines, which can be difficult or impossible to replace. Sometimes a feature article runs for several pages and the layout is peculiar due to ads. It is best to cut out these articles and create a layout that fits the portfolio pages. It will look much better in the portfolio and will be easier to photocopy. Now that Web sites are easily accessible, and if you are included in them, you might want to print the pages of the Web site. Use good-quality digital photography glossy paper made by Ilford (now called Galerie), to include in your publicity portfolio.

The publicity portfolio should be created to stimulate the eye. The best way to ensure this is by grouping vertical and horizontal spreads and keeping the size of the materials consistent. Use a loose-leaf binder with 8½" × 11" plastic sheets in which to place the published material. The first page should be vertically formatted. The following two pages should also be vertical layouts. The next two-page spread could have a horizontal format. It does not look "professional" to have a vertical layout on the left side of a two-page spread and a horizontal on the right side. If the viewer has to turn the portfolio constantly back and forth, it is not visually assuring. This indicates that minimal work has gone into professionally arranging the portfolio. It should take little effort to look at a portfolio, especially if it is a drop-off situation. Curators and art directors have to look at many portfolios, and if they constantly have to turn the binder due to poor placement of material, they might not look through the whole portfolio.

The same rules apply for the body-of-work portfolio; however, it can be larger than 8½" × 11". It might be 11" × 14" or even 16" × 20". You may want to include high-quality color laser copies or computer inkjet copies, which can commonly be made up to 11" × 17" (the equivalent of two 8½" × 11" pages next to one another).

Check prices and size availability for photocopies and color laser prints at the office superstores like Staples or Office Max. They have low prices and excellent-quality equipment. At Staples, the photocopy price can be as low as $0.03 a copy (black-and-white) for fifty or more copies, 8½" × 11" size. For two-sided copies, the total cost for fifty is only $3 plus tax—much cheaper than using your own photocopy machine. However, sometimes they are lazy. If you give them an article laid out that cannot be put through the feeder tray of the copier, sometimes they will show you the first copy only, which looks great. Then they may photocopy the photocopy, and then the quality is almost useless. This is truer for photo-image quality than for text. Make sure that they photocopy the original for every copy needed. Sometimes they complain about doing this because it is time-consuming. Do not leave material with them and come back later. For color, the price for an 8½" × 11" is $0.99; for an 11" × 17" copy the price is $1.68.

Letters of Recommendation and References

In applications for grants, corporate support, job prospects, or even as part of a publicity package, include letters of recommendation and references. Letters of recommendation for fine artists are persuasive suggestions disguised as an objective critique to help one obtain a goal—either money, product, or publicity. Letters are required for artist-in-education grants, some private foundation grants, and emergency assistance. Some organization's applications request the name and address of all potential references. References will be contacted by the organization either by a telephone interview or for a letter of recommendation.

What are the best letters of recommendation, the ones that get you the grants? These are letters from people who are known nationally, regionally, or locally and who know your work on a professional level. These letters should be tailored to the particular project or grant and address specific issues (a general letter is almost useless). The letters should always be positive and mention the artist's strengths and should generally endorse the idea that "the artist gives a rigorous examination to his/her creative discipline." And remember, letterhead counts—the more prestigious the institution or author, the more significant the letter becomes.

Cultivating a group of critics, curators, collectors, and other artists who can be relied upon to write these letters will happen over time. In reality, more often than not, the letters people write for you come at a price. Sometimes they will agree to it, then send you their letterhead and ask you to write the letter yourself and return it to them for their signature. Some people will do it out of respect, while others might want a favor in exchange for a letter (if only to be taken out to dinner).

What I have learned over the years is to stockpile the letterheads of the various institutions with which I have been associated with (galleries, alternative spaces, museums). This way they are readily accessible when the need/opportunity to write letters of recommendation or releases arises. If you have not done this, ask them for their letterhead and explain why. Having blank letterhead on file saves a significant amount of time if you have to write the letter anyway or if you have received a grant application late and are on a deadline. It is important to tell the organizations what you are doing and to get permission whenever you use their letterhead. If you are on good terms with the organization's staff, you can save time and hassles (sometimes even signing their name—with your initials—as long as they know). The consensus is that letterhead counts, since all recommendations say first-rate things: "the preeminent caricaturist of awkward art" or "is a literary impresario of broken English chic."

Always get a copy of any letters of recommendation. These should be photocopied or scanned and used as part of a publicity package whenever you think it would be appropriate. As an example, a release could state: "The work created under the Empty-Minded Grant was supported by Ms. Ina Gutter, the curator of

Whatsa Matta U, whose letter of recommendation is included in this press package for the exhibition of *Sewer Realist Drawings*."

Cataloging Your Artwork

It is beneficial to number and catalog all of your artwork, sketches, slides, photographs, or digital files whether a computer is used or not. It is not the most creative activity but it provides you with a historical record. Indicate the day, month, and year the work was produced; materials used; and if the piece has been sold, who owns it (with name, snail-mail address, e-mail address, and phone number). This way, the artwork can be traced for exhibition loans or to be digitally rephotographed.

When artwork is loaned to museums or galleries for exhibitions, an invoice should be included, giving the title and catalog number of the artwork with the condition noted. This will help to solve any problems such as lost or damaged artworks. When traveling shows are shipped, the receiving institutions must fill out a damage report for each artwork. This is a standard museum procedure.

How to Identify Returned Material

It is annoying to receive slides or a CD back from a museum or gallery via an SASE without a cover letter. Sometimes the postmark can identify the city, but postmarks are not always reliable or readable. It can be impossible to determine from where the materials were returned. This could wreak havoc upon your return filing system. One way to avoid this is to indicate all the necessary particulars somewhere on the SASE. Keep a list and indicate who received slides or artwork and when they were snail-mailed. Then write this information, or a code referring to this information, somewhere on the envelope or mailing flap. For double insurance (in case the return envelope is not used), indicate the significant information on one slide as well. This is a good back-up system, and it helps you avoid having to unnecessarily snail-mail invoices for lost materials at a later date.

Lost Materials

It is beyond the scope of practical understanding how material is lost or even stolen. It does happen, however, and artists have various choices about how to remedy the situation. To begin with, visit a stationery store and buy an invoice book. This is necessary to track lost materials as well as billing museums, galleries, magazines, or newspapers.

Whenever material leaves your premises, whether CDs, slides, photographs, or the actual artwork, it should be notated and listed in your filing system (locate that system somewhere other than your memory). Make a photocopy of the slide sheet to know exactly what was shipped out. This includes any videos, CDs,

black-and-white pictures, catalogs, or photocopies. If the material has been requested, try to send it out FedEx (since they might pay for it). FedEx insures their packages and has a sophisticated tracking system. If you have to send out original slides, it is important to use delivery confirmation, as well as to insure and/or register the package with the post office.

If the site loses the material and acknowledges it, the site should pay for the lost material. Inform the institution or company that lost the material that the going rate for each duplicate slide is $3–$5. (New York City photo labs as well as other custom labs charge this amount.) You will be able to replace the slides for less, but this creates a significant mark-up that will cover phone calls, faxes, postage, and the time involved to either reshoot or duplicate the work. Usually the institution just asks for an invoice, not the receipts. If videotape is lost, charge $20; if a CD is lost, charge $10, which is the going rate for a duplicate video/CD to be made at a commercial business. Because you already know how to duplicate your own video/CD, charging a commercial fee is a hidden way to recoup costs and pay for your labor.

Over the years, I have heard many excuses for lost material and noticed that it happens at every level. Often, the material is misplaced due to a new director or curator who changes the old filing system. If it is lost and they pay for it and then find the material, they usually will send it back to you without asking for the money back.

If, on the other hand, the material is sent out cold, include with the original mailing a SASE postcard confirming that they have received the material. This insures an acknowledgement on their part, which is necessary for future contact if they lose the material. They will understand that you mean business and will usually respond. It does not work all the time, however—invoices for lost material go to the billing department and accountants want to know what is being paid out. This then gets back to a curator or editor who is, hopefully, forced to track the material down.

If original material is lost, especially slides, the amount of restitution depends on the "replacement costs." That is, if it is just documented work and easy to reshoot, it is probably best to ask for a photographer's fee at $25–$50 an hour plus cost of the film and processing. If it was an installation piece or art photography that is irreplaceable, seek out the *ASMP Professional Practices in Photography*, 6th Edition (Allworth Press, 2001). It contains guidelines for lost material. The value of original slides can be $250 a piece by ASMP standards. Stock photo houses sometimes value original slides as high as $1,500 each. If originals are lost, prices can be negotiated. It is a serious situation that sometimes costs people their jobs. Send out duplicates whenever possible to avoid these issues.

To be compensated for the loss of original artwork, one has to prove its value. Insurance floaters from previous exhibitions are important to keep for this reason. If these are not available, use the price list from a gallery or a canceled check from a collector, which will establish the going rate for your work.

It might be helpful to carry your own insurance floater as part of a home-owner's insurance policy. This is commonly available. It can be door-to-door or home coverage. Consult an insurance agent to learn how value is determined and what type of coverage is best suited for your situation. If things get sticky, hiring a lawyer is another option.

Volunteer Lawyers for the Arts

Volunteer Lawyers for the Arts is a national organization of lawyers for the arts, with forty-nine chapters in the United States and Canada. They provide inexpensive legal services (an initial fee is sometimes requested), as well as business assistance, and they can advise you if your artworks are damaged or lost.

The VLA Directory provides updated descriptions of these programs. The directory is useful for artists and arts groups looking for legal assistance in their own communities or in places where their work is being performed or exhibited. The Philadelphia Office is the national office: 251 S. 18th Street, Philadelphia, PA 19103; 215-545-3385; e-mail, *pvla@libertynet.org; www.libertynet.org/pvla*. To find out if your state has an office, go on the Web site and click on links and resources. Currently, there are twenty-five states, plus Washington, D.C., and Canada, represented. Free information pamphlets are also provided online under the Useful Information section, such as *The Visual Artist's Rights Act* and *The Artist as Creditor and Debtor: Collections, Small Claims Court, Bankruptcy and Alternatives to Bankruptcy*. For VLA in New York, contact One East 53rd Street, 6th Floor, New York, NY 10022; 212-319-2787; e-mail, *vlany@bway.net*.

In addition, there are two helpful books by Tad Crawford of Allworth Press: *Business and Legal Forms for Fine Artists*, revised in 1999, includes sample forms and contracts with complete instructions; *Legal Guide for the Visual Artist*, revised in 1999, covers censorship, reproduction rights, contracts, taxation, estate planning, loft leases, museums, collecting, and grants.

Artists usually do not like to think about it, but differences with other artists and clients do happen, and when legal issues arise, it is best to be prepared by having as much written documentation as possible. Small claims court is an option in every state. Lawyers are not necessary as each party can present his or her case and judges or arbitrators hear the cases. The amount of the claims vary from state to state. In New York, a small claim is $3,000 or less. New York has a free publication called *A Guide to Small Claims Court*; it explains the process and how to collect a judgment. For information, visit *www.ci.nyc.ny.us/html/dca/html/smallclm.html*.

Parking in New York City

Artists visiting New York City will find parking a vehicle as daunting as approaching galleries and museums. Especially if you are driving a van or pickup

truck in order to transport artwork, it is important to be familiar with the local parking laws. The situation is not as frightening as it appears, but New York City is notorious (especially since October 2002, when some fine charges doubled) for the high prices of parking fines, towing, and parking lots.

If you own a small pickup truck with either truck or commercial plates (this depends on the state policy), put 3" or larger letters on the driver and passenger doors indicating the name and address of the business. This allows the truck to be parked in designated truck loading and unloading zones. These zones exist all over New York City but are centralized in midtown Manhattan. Many magazines and galleries are located between 90th Street and the area just below Canal Street, a distance of over one hundred blocks, which includes TriBeCa, Chinatown, Soho, the East and West Village, the photo district, midtown, uptown, and Museum Mile.

There is a three-hour limit to parking in truck loading zones, Monday through Friday, 7:00 A.M.–7:00 P.M. This rule applies on all days in Midtown Manhattan—the area encompassed by and including 14th Street, 60th Street, First Avenue, and Eighth Avenue.

Parking Privileges for Commercial Vehicles

New York City traffic rules are not only subject commercial vehicles to some special requirements, but also confer some important parking privileges upon their drivers. Where parking is prohibited, all drivers can stop their vehicles temporarily in order to load or unload packages to and from the curb. In addition, commercial vehicles drivers are permitted to ignore certain posted signs (and in some cases even double park) while making an *expeditious* pickup, delivery, or service call in the following circumstances: when a sign states, "No Standing Except Trucks Loading and Unloading," or, "No Parking"; when a sign requires the deposit of money in a meter; when the commercial vehicle is being double-parked; or when you are parking the commercial vehicle at an angle.

Be patient, because it is entirely possible to drive around looking to park during business hours without success, since numerous trucks are actually loading and unloading merchandise. If you are not actually loading or unloading, this can be obvious to the traffic police. Write a note stating what time you left and where you are going. Place this note inside the car near the windshield on the driver's side.

Sometimes, the commercial vehicle can be left unattended for an hour with a note and still receive a ticket for inactivity. This is a $105 fine. If this happens, get a letter from your appointment on their letterhead stating what caused the delay. Snail-mail this explanation to the traffic court with the parking ticket. This should eliminate the fine for the ticket. Out-of-state vehicles tend to be given more leeway by the police and courts due to their lack of familiarity with the parking laws. You can now request a hearing over the Internet at *www.nyc.gov/finance*.

In New York State, it is possible to own a passenger car with commercial

plates, but you cannot have any back seats. However, in New York, vehicles with commercial plates cannot be driven on parkways. Road signs will indicate "no commercial vehicles allowed." If you have out-of-state plates and use these roads by accident, the police will usually just tell you via car microphone to get off the road at the next exit.

If the commercial vehicle does not have 3" letters (which can be spray-painted, stenciled, attached with stick-on vinyl letters, or attached as a separately made sign, as long as the letters are in a contrasting color to that of the vehicle), and if it is not parked in a commercial zone, the vehicle will be issued a ticket. This happened to my truck, and I was able to avoid the fine by putting these 3" letters on the truck. Pictures of both sides of the doors had to be snail-mailed with the tickets, within a specific time, to the city parking violations bureau.

The fine for an expired meter below 96th Street is $55, and the fine is $35 above 96th or in the other boroughs. For up-to-date information contact the New York City parking violations helpline at 718-422-7800.

On certain days, during either 8:00 to 11:00 A.M. or 11:00 A.M. to 2:00 P.M., it is not possible to park on these streets with or without commercial plates. If you do, the vehicle will receive a ticket or will be towed. The reason for alternate-side-of-the-street parking is to allow for street cleaning. Alternate-side-of-the-street parking is used mostly in residential sections and midtown. If you try to park in a spot just as it becomes available, it is advisable to get to the spot twenty minutes before the allowed time, since the locals are also trying to park. It can become a vicious game.

There is a parking lot on 60th Street and West End Avenue called Central Park (115 West End Avenue, 212-246-4256), which costs $20 for a twenty-four-hour period, $8 for up to twelve hours (if in before 11:00 A.M.), and $15 for twelve hours after 11:00 A.M. This place has good lighting, a fence, security, and free shuttle bus pick-up and drop-off, Monday through Friday, 7:00 A.M. to midnight, from West End Avenue to Fifth Avenue and between 53rd and 70th Streets. It is a bit off the beaten path, but it is extremely reasonable; and if you are worried about leaving the vehicle on the street, this is not a bad location. Remember, this is the big city. Do not leave anything valuable in sight; it will be sure to attract thieves. Try to be street smart and enjoy your visit!

Conclusion—Using Potential Resources

If you were to take all the newspapers, magazines, and television shows in the United States and log the allotted space and time on a chart recording what types of people received publicity, politicians would come out near the top, and fine artists near the bottom.

Politicians use the existing media to receive free publicity and establish a reputation. Imagine what would happen if an artist were to run for political office. In fact, one of the best ways for artists to receive publicity about themselves and their art would be to run for political office. Not only would they receive name recognition and publicity, but also if their art were used as a vehicle to promote their campaign, the artwork would increase in value due to its high visibility. The types of political ads that a truly creative thinker might develop would be unique and undoubtedly interesting. The campaign slogan would be "a picture is worth a thousand words." Politicians speak one thousand words without saying anything concrete. A fine artist could run a political campaign by creating visual artwork on political topics related to the campaign and refuse to talk, letting the artwork speak for itself. There would be two extremes at a political debate. The politician would talk for five minutes or one thousand words (remember the art rap: thirty seconds or one hundred words), and the artworks would be displayed the same amount of time. Then the political commentators would react to it, like a critic reacts to an exhibit.

The example might be far-fetched, but it illustrates how little artists use the media to their own ends—a technique that politicians have refined to the level of fine art.

I remember viewing the *Primitivism in the Twentieth Century* exhibition at the Museum of Modern Art in September 1984. I was struck by some of the indigenous art of Oceania and Africa. The primitive artist was seen as the keeper of the culture and had a position of leadership and power in the community. The art objects had a utility and ritual function, which were an integral part of the group's cultural and spiritual evolution. Although the "primitive" artists might not be the official rulers or leaders of the group, they held tremendous influence on the inner workings of the community at large. Sometimes, the maker of the masks, headdresses, and other ritual objects was also a shaman or holy person; it was not unusual for the primitive artist to be the spiritual leader of the group. Creativity meant the ability to foster a vision, not only to make art, but to influence policy as well.

Today, artists are perhaps seen as visionaries, but never as leaders. There are a few exceptions. Vaclav Havel of the Czech Republic was a playwright, and our own President Reagan an actor. Usually the media portrays artists as bohemians or social deviants. They are sometimes portrayed as unwilling to work at traditional jobs or as con artists. Jeff Koons, a neo-dada artist, is an example. His basketballs in Plexiglas or his "ready-made" vacuum cleaner seem like a rip-off to the media.

Artists take on the role of a cultural pressure valve. This is illustrated by the last few minutes of the 6:00 P.M. or 11:00 P.M. television news. The soft news is usually a cultural item (that commentators often mock if given the opportunity), which buffers the previous twenty-five minutes of ads and serious content. The soft news either makes you feel, think, or laugh, but is not to be taken seriously. This is the cultural pressure valve letting off steam.

What has gone wrong with society? Artists are second-class citizens who have to fight for every nickel and dime. If the collective artist asks to be paid whenever they appear on television or every time a photo of their work is published, either the press will not run pictures, or it will have to pay to use them. As long as artists are willing to give away press photos and not be compensated, they will be taken advantage of.

Sometimes, the events of the world stage inspire artists to create works that transcend aesthetics and become cultural icons. Picasso's *Guernica* is the best example. Its inspiration was the senseless bombing of that civilian town by the fascist general Francisco Franco during the Spanish Civil War in 1937. The painting *Guernica* was a protest—since Picasso was a refugee living in France—and that artwork had a tremendous effect on world opinion. While Picasso was alive, one of his favorite comments was, "I make a political statement every day in New York City." At that time *Guernica* was on temporary loan to the Museum of Modern Art. Artists are inspired to create political art, but it sometimes seems the motivating factors have to be cataclysmic—like World War I for the dada artists—to shock them into action.

The collective media rap for why artists are not paid for their services is, "It's free publicity." If there were an artists guild or union with political power, then

there would be laws or regulations: Every time a photo were used, a certain mini-mum amount would have to be paid for its use; minimum pay standards would be set for labor services such as lecturing, artist-in-residencies, or workshops; and IRS deductions would apply for the actual value of the work, not the material value, if the work were donated to a nonprofit institution.

As it stands now, a deliberate ambiguity exists when artists send out mate-rials blindly to the print media. If an image is published, the artist has to phone the photo editor and ask what is paid for freelancers' photographs, if published. Then an invoice is snail-mailed out. If only a few artists ask for payment, the invoice can be ignored. If many artists ask to be paid, something has to change.

Change is exactly the impetus of this book. If enough artists read this book and start to implement its concepts, something will happen. Artists need to use the resources available to them. Technological advances also create change. Observe how the Internet and e-mailing offer opportunities for artists.

I hope this books peels away the veneer regarding fame and reputations of artists. Artists, like politicians, have the ability to change society: the spiritual/aes-thetic side for artists and the laws and regulations for politicians. I hope that one day they will merge, and the digital mask maker will be the leader of the clan.

Digital Resources

The structure of this appendix enables the fine artist to comprehend the frequent transformations of digital technology. Some manufacturers were reluctant to lend their products for evaluation, because they might not be available at the time of this book's publication. Every nine months (or less), these digital-technology companies either upgrade, introduce a completely new version, or pioneer new technology, most of the time based on customer satisfaction or dissatisfaction.

For the fine artist to understand, interpret, and finally utilize this deluge of ever-changing information is both frustrating (especially to the technically challenged) and exhilarating. I hope these recommendations, which are based on a combination of tangible hands-on usage, opinions of colleagues and artists working in the digital arena, and sound fiscal decisions, will help you to decide on the type of software or hardware necessary to compete in a professional artistic setting.

Internet Security: A Second Computer and Other Protective Measures

Artists use attachments for digital images all the time and are vulnerable to an attachment virus. With a proliferating number of viruses (approximately forty new per day) assaulting your computer, it is advisable to have a second computer. This is necessary especially if you are a PC/Windows user (Mac and Linux systems users have fewer virus problems). When a computer is found in curbside trash, given to you, or purchased cheaply and consequently has a slow processing speed, I

call it "the designated-old-gift," or DOG, as it should be used exclusively for e-mail and Web browsing. The Internet has inherent vulnerabilities because it is so egalitarian to use, allowing a free flow of global communication and information. Ensuring computer privacy means using antivirus and Spyware software and a firewall. However, nothing is completely digitally safe, even with these safeguards, as e-mails and Web security can be compromised.

Therefore, the DOG computer, which should be equipped with at least 32 megs of RAM, hard drive space, a CD (with a possible CD-RW), and the following software programs: at least a Windows 95 operating system, word processing, antivirus, firewall, and Web browsing. If a virus arrives through e-mail, images, and rogue Web sites, it will affect the main computer, requiring a tremendous amount of downtime in finding, fixing, and eliminating it. Then, depending on how much corruption it inflicts, occasionally it will be necessary to reinstall software programs and then, hopefully, salvage files, consuming much more time. The DOG should not contain your work product, just work for your projects. Its programs are designed only for sending and receiving e-mails, Web browsing, and printing. In this way any downloaded file transfers are virus-scanned via a floppy disk or CD.

Anti-Virus Software

Just as software programs are upgraded, virus downloads are also improved and threaten to inflict still greater amounts of corruption. Some viruses attack your e-mail address book, then are re-sent from your computer (without your knowledge) with the potential of infecting more computers. The antivirus programs only offer protection against known viruses. A new virus can slip through any safety measures until programs are written to detect them. If this happens to your main computer, then the "insurance policy" has to be an indefatigable backup. The main problem is not the software programs (as the CD disks can be reinstalled), it is the file documents that have not been burned on a CD backup. Therefore, one should make backups weekly after updating your antivirus program and running a system scan. Or, if you can afford a removable hard drive, this will never be corrupted. If the DOG computer if corrupted, then at least you know it contains minimal software and documents. If there is serious virus corruption affecting the hardware, then discard it and obtain another one. In 2002, in my local area of eastern Pennsylvania, I found three working computers (with CD-ROMs) in curbside garbage, which were salvageable and then put to use. Usually, they have at least the Windows 95 operating system, CD-ROM, modem, and minimal requirements.

Unless one is perceptive and knowledgeable enough to troubleshoot computer problems, having a second DOG computer is all but necessary to avoid serious computer downtime and setbacks. When you're ready to scan your computer, check out Housecall, which is Trend Micro's free online diagnostic virus scanner (*http://housecall.trendmicro.com*).

Firewall

A firewall on a home computer is the first line of Internet security defense, designed to prevent unauthorized hard drive access. It is a security system designed to protect against digital trespassers (hackers) while you are on the Internet. Firewalls cannot stop downloaded viruses, which do not pass through a firewall; therefore, they will not stop an e-mail virus. However, they will stop digital trespassers from reading information on your computer, such as what software programs are installed and which Web sites were visited. A free firewall for individuals and nonprofits is available by ZoneAlarm (*www.zonelabs.com*).

Spyware

If you do not think private companies are tracking your keystrokes and keeping records of what you do online, then you need to know about commercial Spyware that is hidden in your computer. It enters as a cookie that then renames itself to hide in the operating system. It encrypts the keystrokes and then creates a file to track, for instance, your shopping habits (credit card numbers, for example), and then sends this information to whoever sent the cookie. The cookie can be as small as one pixel implanted in an image, Web page, or spam message. Your computer never blocks downloaded images; therefore, if something is an unwanted inclusion, it cannot be detected and will then gather information. If you load the latest version of Ad-Aware, this free removal utility scans your memory, registry, and hard drive for known Spyware components. Contact them at *www.lavasoftusa.com.*

Using the Internet

An ISP dials up to your browser page, which allows you to be instantly connected to the World Wide Web; my local provider is Enter.net. In contrast, America Online (AOL) is an online service provider (OSP), which differs in terms of operations and how they package data that is transmitted over the Internet. ISPs and OSPs compress and decompress transmitted information differently, which results in an e-mail snafu. This is noticeable in Word documents (as problems commonly arise that take the form of seemingly arbitrary symbols) and graphic images (which may be distorted). Also, converting Mac files to PC files poses similar text problems. An AOL 7.0 system requires 147 MB of hard drive space and 32 MB RAM to operate, whereas an ISP like Enter.net requires 20 MB of hard drive space and the same RAM. This means AOL needs more memory, and when you add all its other options, its RAM requirements increase, which makes operations slower if you are running other programs simultaneously. Therefore, stick with a local ISP; it is less expensive and uses less memory and RAM.

Inexpensive Domain Names

Find inexpensive domain names at *www.cheap-domainregistration.com*; the cost is $8.75 a year.

Web Hosting

If the fine artist has a Web site (or is thinking about one), it is necessary to put it online. Goecities and Freeserves.com offer free homepages (both are ad supported) that do not require any knowledge of html (*http://us.geocities.yahoo.com* and *http://freeservers.com*). Remember, you will not have much Web space, and bandwidth and transfer sizes will be limited.

OLM offers reasonably priced Web hosting solutions for $14.95 a month. The Host SE-2 plan includes: 200 MB disk space, 4 GB transfers/month, twenty POP e-mail accounts, a Web-based control panel, and discounted domain name registration. Contact OLM at 800-741-6813; e-mail, *sales@olm.net; www.olm.net.*

Web Site Sizes

If you have a 200 MB Web site, and 1 MB equals about one hundred pages of text and 100 MB equals two thousand images (at 50 Kb), you will have more than enough space, unless you add audio and streaming video.

Web Searches

If you are interested in looking at potential magazines on the Web, then use Google as a search engine for translating foreign languages, including French, Italian, German, Spanish, and Portuguese, into English. Moreover, it is forgiving in terms of misspelled words since it has a search spell checker.

DSL (Digital Subscriber Line)

This is highly recommended over the traditional dial-up landline. The computer is less likely to crash from overloading information such as larger image files that the server is unable to download, plus streaming video, or flash movies. However, DSL speed comes with a price: the computer's ports are always open, due to its 24/7 connection; therefore, a firewall is absolutely necessary. Intruders search the Internet looking for exposed computers; they then try to access your personal information. The price is $39–$49 per month if it is available in your area.

E-mail and Incredimail

When e-mailing a jpeg (or other picture file), its file size should be 35–60 KB for the Web (or 300–400 pixels in size); for magazines and newspapers, images

should be 300 dpi (which makes for a larger file size). A free download of Incredimail (*www.incredimail.com*) offers 3D effects for sending, receiving, and deleting your messages; background sounds; text effects; personal voice messages; on-the-fly spell checker; and other perks.

ICQ

ICQ (I seek you), *www.icq.com*, is owned by AOL. Both ICQ Lite and ICQ 2002a are free downloads that offer instant messaging, enabling you to send a message that immediately pops up on an online contact's screen, allowing conversations in real time, including Short Message Service (SMS) designed to send text messages to and from cell phones, PC-to-PC phone calls, plus other options.

Computer Accessories

This section lets the fine artist know what computer software and hardware is recommended and available to help business run more smoothly.

Memory Management

RAM Idle Standard is a memory management program that will keep your computer running more efficiently, faster, and longer. RAM Idle works by recouping memory wasted by Windows and other applications. It costs $19.95 from *www.tweaknow.com*.

USB 2.0

USB 2.0 will move data at a rate of 80 MBps (Megabits per second) and is fully backward compatible with the first generation USB 1.1, which moves data at a rate of 12 MBps. Fifty-seven multiple peripheral devices can run simultaneously from one port through a USB hub. You must have at least Windows 98 second edition or above to use a USB port, anything below this causes recognition problems.

USB Gear (*www.usbgear.com*) sells a five-port USB 2.0 High Speed PCI Interface Card for $29.95.

The Maxtor USB 2.0 adapter card takes advantage of the speed improvements made possible by the 2.0 standard while preserving compatibility with USB 2.0. The price is $49.95 from *www.maxstore.com*.

Mass Storage Solutions

QPS deals in mass storage solutions, offering a variety of internal and external DVD burners, CD burners, and high-capacity hard drives that meet both Firewire and USB 2.0 standards. The 80 GB Firewire HD 7200 Que! M3 connects

to USB 2.0 or Firewire port. Retail price is $279.99 QPS, 8015 East
Crystal Drive, Anaheim, CA 92807; 800-559-4777; fax: 714-692-5516; e-mail,
sales@qps-inc.com; www.qps-inc.com.

Maxtor is one of the world's largest supplies of hard disk storage products
and solutions. Their 5000LE 80 GB (USB 2.0) features easy add-on storage for
home or office. The cost is $199.95, *www.maxstore.com.*

Graphics Tablet

If your images require precision, then the use of a graphics tablet (which
has more control than a mouse and uses a light pen) that helps alleviate mouse-
and trackball-induced repetitive stress injuries. Manufactured by Wacom, the
Intous ergonomic tablet has a unique 9" × 12" drawing tablet with an active area
that matches the aspect ratio of most monitors (the full tablet equals the full
screen), and includes a transparent overlay for holding artwork and a cordless light
pen. Additionally, a 4D mouse adds more capabilities to image precision. Since the
pen has levels of pressure sensitivity, Adobe Photoshop has nineteen pressure-sensi-
tive tools and a 7.0 brush engine, to allow more control over layer masks, cloning,
color correction, etc. The tablet requires a USB port. Cost is $469.99 from
Wacom Technology Corporation, 1311 S.E. Cardinal Court, Vancouver, WA
98683; 800-922-9463; *www.wacom.com*; the academic discount is $409 from
www.creationengine.com.

Although made for children, the Crayola PC Drawing Tablet has a large
pen stylus and mouse function. The cost is $24.99 from *www.overstock.com.*

Cordless Accessories

Cordless accessories eliminate desktop cord clutter and tangles. I recom-
mend Logitech's Cordless Optical TrackMan and Cordless Keyboard; both use digi-
tal-radio-controlled technology that frees you to place them within a six-foot range
from the computer. The TrackMan records motion optically instead of with
mechanical parts and there is no need for cleaning the ball. The price is $60 for the
TrackMan and $40 for the cordless keyboard; sometimes rebates are offered on var-
ious Web sites.

Digital Photography

The information in this section is provided primarily for artists who have
only a modest knowledge of digital photography and yet understand the necessity
of photographing their artwork. (For information on traditional photography, visit
my book page on the Allworth Web site—*www.allworth.com*—to view chapters
omitted from this edition.)

It is necessary for the fine artist to have a working knowledge of how to

digitally shoot their artwork in both indoor and outdoor situations. However, if you decide not to shoot your own artwork you will be armed with information that you can tell the photographer who will be shooting your artwork.

Digital Camera Recommendations

It is important to have a camera that has a liquid crystal display (LCD), at least two megapixels (allowing you to print an exhibition quality 8½" × 11"), AA batteries, manual controls, fast capture speed (time between shots), white balance, and accessories.

If you can accept the digital technological advancements, then buy at least a two megapixel camera; however, the Sony Digital Mavica MVC-FD83 0.8MB has a simple learning curve, as it uses an inexpensive 3.5 floppy disc. This produces great results for the Web or magazine reproduction, but not exhibition prints. Options include 3× optical zoom, 2× digital zoom, storage of images on a standard floppy disc, rechargeable lithium-ion battery (one is included), plus the battery/AC charger. A second battery costs about $50. The image transfer process is simple; there is no through-the-lens viewing (2½" LCD only), no memory card or other peripherals, and no software to install. A flash is built-in, and the model offers up to one-minute of video with sound, ISO film speed equivalency, and a hundred in-camera special effects—including black-and-white, sepia, negative, and solarized. Prices on Amazon.com are $499.94 for a new camera and $250 and higher for a used model; eBay's selling history is $175–$325 with extras added in the package.

Shooting Artwork Outside

Although there are a variety of ways to shoot artwork indoors, shooting outdoors using natural light is a low-cost, low-tech way of achieving superb results. The materials needed are: a digital camera, tripod, nondistracting background, duct tape, or pushpins.

When documenting artwork, shoot it against a white, black, or gray background. This is considered nondistracting and just concentrates on the artwork. It is possible to use 20" × 24" construction paper if the artwork is small enough, or visit a photo store and buy photographic backdrops (sizes vary from 4' to 10') in white, black, or gray. Or use canvas primed white, gray, or black. Use your creativity. If using cloth, make sure it is ironed first.

If it is possible, shoot artwork outdoors in the shade or when it is evenly overcast. It is much less cumbersome than using studio lights. The color of sunrise and sunset is blue and orange, and if documenting the artwork before 10:00 A.M. or after 2:00 P.M., you may have to wrestle with a blue or orange tint in the completed image. If you have Adobe Photoshop 7.0, Paint Shop Pro, or Corel Photo-Paint 11, then you can make color corrections after the image is in the computer. Whether the artwork is flat or three-dimensional will determine how you

should photograph it. A nail is put into an outdoor wall through the backdrop to hang two-dimensional work, such as paintings, drawings, and photographs. It is necessary to use a table or sculpture stand for three-dimensional artwork. Be careful not to wrinkle the backdrop, cloth, or canvas, because you want it to look pristine. Do not shoot on a very windy day; this can wreak havoc.

The image size of a digital camera is a rectangle, and not all work conforms to this size. Therefore, crop as close to the artwork as possible, and leave a safety zone around the top edges of the frame. When in Adobe Photoshop, you can use the crop tool for the closest looking image.

Try to shoot all artwork without glass in front of the image, since it is another plane that light has to pass through, causing unwanted reflections.

Shooting Work Indoors and in a Gallery Situation

Artificial light has a different color balance than natural light; however, this all can be color-corrected in Adobe Photoshop, Paint Shop Pro, or Corel. Attachments are available for clamp-on lights, such as barn doors, diffusion screens, and flood reflectors, which cut down glare. Mount the lamps on stands and, to reduce glare, direct the light at 45-degree angles to the artwork's surface. Keep the lights back at least a few feet in order to have a wider arc of light illuminate the work.

Sometimes, two lights will be adequate, but at other times four lights are necessary to achieve even illumination. If possible, to achieve consistency from one documentation to the next, set up a permanent space for photography, where lights and backgrounds are not constantly being moved. This will also enable you to document your work quickly and minimize the likelihood of mistakes.

Sculpture and installations pose lighting problems, since there are many different sculptural materials such as ceramic, stone (marble), cement, Dry-vit, various metals (copper or stainless steel), Lucite plastic, and fiber. Different lighting possibilities include direct, flat, back, and cross lighting, the choice of which depends on the material's reflective properties, texture, transparent quality, and size. Photograph sculpture at an angle to show its volume. Shooting it straight on flattens the perspective. Many views might be necessary and each might require different lighting.

Shooting close-ups requires the digital camera to be as close to the artwork as possible without losing focus. If you need to be closer after using the camera's optical zoom feature, either use the digital zoom feature in the both the camera or graphics software program. Remember, optical zoom quality is unsurpassed to any digital zoom. A 3× digital zoom is similar to a 35–105mm optical zoom lens, while a 2× digital zoom is similar to a 35–70mm optical zoom lens in a 35mm format. A 3× digital zoom allows a closer image; however, the picture quality deteriorates when you maximize this function (i.e. the pixels are very noticeable, as it does not increase image detail).

Getting too close to the artwork might interfere with the lighting, so set the camera on its self-timer and move out of the way of the lights. You will achieve the best results if you always keep the plane of the film (determined by the angle of the camera) and that of the artwork parallel; if not, the keystone effect occurs (a trapezoidal distortion caused by a camera either pointing up or pointing down to the artwork). Use a white fill card to reflect the light; this is placed as close to the artwork as possible without it being in the picture. Move it around to see how it best fills in the light. If you run into problems, the local camera store will always offer advice. Take a picture of the setup and show it to a camera store/photographer, if you just cannot get it right.

International Imaging Industry Association (I3A)

CPXe (Common Picture eXchange Environment) is an I3A initiative group of companies that are working together to provide more opportunities for digital camera users to print their images worldwide. For example, you use the Internet to send your digital images to an online photofinisher, and then from a zip code list of service providers you locate a store for pickup. Contact them at *www.i3a.org*.

Graphics Software

The fine artist should have the necessary digital tools to effectively compete for shows, publicity, grants, and awards. Adobe Systems offers a variety of software for graphics, multimedia, and Web applications, including the flagship Photoshop 7.0, which builds on earlier versions, plus it integrates with all other Adobe software; however, fine artists should concern themselves with Adobe Illustrator® 10.0, and Adobe After Effects® 5.5. This bundle arms the fine artist with expanded creative options. If a reproduction of a painting needs digitizing, then their toolset rises to the challenge. The picture package tool offers four images with text that can fit when printed on an 8½" × 11" sheet. This new version has a Healing Brush, which assists in the process of retouching images, a file browser that quickly locates, organizes, and visually manages images, as well as view EXIF digital camera information. The cost is $600 from *www.bhphotovideo.com*; or $289 if you qualify for an academic discount for schools, faculty, and students from *www.creationengine.com*.

Adobe Illustrator 10

This program defines the future of vector-graphics software (3D) (raster graphics rely on an x and y-axis, while vector graphics rely on an x, y, and z-axis), with creative options and powerful tools for publishing artwork via Web and print. It allows you to produce superb Web graphics, explore creative ideas with live dis-

tortion tools, publish in record time with dynamic data-driven graphics, and perform other related operations. The cost is $400 from *www.bhphotovideo.com*; or $99 if you qualify for an academic discount from *www.creationengine.com*.

Adobe After Effects 5.5

This newest version delivers a comprehensive set of tools to efficiently produce motion graphics and visual effects for the Web, film, video, and multimedia. Explore unlimited creative possibilities with precise control in a 2D or 3D compositing environment. It can manipulate any object in real time in 3D in terms of motion, position and lighting. If you are using a desktop PC, its video animation is unsurpassed. Adobe After Effects offers unparalleled integration with other Adobe products. The cost is $700 from *www.bhphotovideo.com*, or $289 if you qualify for an academic discount from *www.creationengine.com*.

CorelDRAW® Graphics Suite 11

Included in this suite is CorelDRAW 11, Corel PhotoPaint 11, and Corel R.A.V.E.™ 2. This suite offers comprehensive solutions for artists who place a high value on quality and ease of use. It offers graphic design, page layout, and image editing and vector animation software all in one package.

One of the features of CorelDRAW 11 is enhanced text linking and wrapping which is great for Web graphics and your résumé.

Corel PhotoPaint 11 offers new tools for creating Web elements and editing photos. These new features include CutOut tool, Image Slicing, and Rollover creation and the red-eye removal tool.

Core R.A.V.E. 2, the second version of Corel's vector animation tool, focuses on lowering file size and extending functionality. New features include support for symbols, more interactive behaviors, and new tweening capabilities. The cost is $417 from *www.softbuyweb.com*; or $139 if you qualify for an academic discount from *www.creationengine.com*.

Jasc Paint Shop Pro Seventh Anniversary Edition

Although not as comprehensive as Adobe Photoshop 7.0, it is a complete photo and Web graphics editor. Some of its photo editing applications are easy to use and superb. There is the automatic photo enhancement features, such as color balance, hue, saturation and contrast. Plus, there are special effects, Web graphics, picture restoration, dust and red-eye removal, and color balance, etc. In addition, this programs offers optional, extremely simple border abilities: go to Image, then add borders or picture frame to choose a selection. The cost is $100 plus shipping (in addition, there might be a rebate available) from *www.bhphotovideo.com*, or $85 if you qualify for an academic discount (see *www.creationengine.com*).

Image Doctor

This is a set of powerful image-correction filters for Adobe Photoshop, Paint Shop Pro, and other image editors. It magically removes blemishes, defects, quickly repairs overcompressed jpegs, and seamlessly replaces unwanted details and objects.

The cost is $100 plus shipping from *www.bhphotovideo.com*, or $58 if you qualify for an academic discount from *www.creationengine.com*.

Printers, Ink, and Paper

Inkjet and laser printers have made such technological advances that they rival conventional photochemical printing (if you use premium photo paper). If you visit an office supply store, sometimes there are such reduced prices on inkjet printers that it seems like they are giving them away (in some cases they are). The companies that make the inkjet cartridges make the greatest profit off the inkjet cartridge, not the cost of the printer. Home printers range from the standard 8½" × 11" to the wide-format 11" × 17". The fine artist must decide on its usage, whether for exhibition purposes or for good text and image quality. If you are home-printing for exhibition purposes, then it is essential to own a printer that can print at 2400 × 1200 dpi. In order to obtain this high resolution, the work must also be printed on premium photo paper. It should be archival (acid free) paper; Galerie (made by Ilford), Epson, and HP all make fine-art computer printer paper. Epson makes archival ink, which is necessary for collectors and museums. Currently, Photo inkjet printers, which use premium photo paper, outrival laser printers for exhibition-quality prints. The prices for inkjet and laser printers now rival one another in terms of the base price.

Although laser printers use four cartridges, inkjet is ten times more expensive than laser. An inkjet printer just using black ink gets 500–900 pages per black cartridge and 200–500 pages per color cartridge—at the highest color settings 100 pages or less are realistic. Meanwhile, laser could reach 2,500 pages per cartridge.

The initial, high cost of the four-cartridge laser printers ultimately saves on toner versus inkjet. Prices begin at $800 for the Minolta Magicolor 2200. Unless you buy a $10,000 Epson laser printer, no archival ink cartridges are available for laser printers.

If you are fed up with the high cost of inkjet cartridges, then there are remanufactured cartridges and ink refill kits. The Magnuson-Moss Warranty Improvement Act legislation does not void the warranty on printers that use refilled cartridges.

Epson uses piezo-electric technology, and when used with its Premium Glossy or Matte Photo paper, the result is a great quality print. The Epson 1280 inkjet printer is capable of printing 13" × 19", allowing for an enhanced resolution of 1440 × 720 dpi. It uses a black cartridge and a five-color single cartridge con-

taining cyan, light cyan, magenta, light magenta, and yellow. The printer costs $439 at *www.buydig.com* (rebates are sometimes available). Archival black cartridges are $22, and color are $27, from *www.inkjetart.com*. It is advisable to stick with Epson archival inks to maintain high standards for exhibition prints. The reason: experienced Epson printer users or those who have the patience to make the needed color control adjustments should only use third-party inks. However, Luminous, Lyson, MIS, and Generations make archival inks for Epson inkjet printers.

I own the Lexmark X83 all-in-one copier-scanner-printer, which has a 2400 × 1200 dpi, accepts 8½" × 14", and costs $169. The price at Staples for a two-color cartridge pack costs $60; a black-and-white pack is $54. Refurbished color cartridges are $18.50 and $16 for the black-and-white at *www.supermediastore.com*; a refill kit for color is $10.50 and black-and-white is $7.50 at *www.topinkjet.com*.

Premium Photo Papers

If the fine artist does not use archival ink, then it is not an archival print. Currently, Epson is the only company that makes printers *and* archival paper and ink.

However, for text and general image use, most papers are adequate, and the price per sheet for 8½" × 14" paper ranges from $0.005 (regular bond) to more than $1 for the premium (acid free) photo paper.

The Wilhelm Imaging Research examines the permanence of prints made with large format and desktop printers, new inks, and papers. As the rapid changes (nine months in my opinion) in inks, papers, and printers occur they will be tested and posted in articles on his Web site (*www.wilhelm-research.com*).

Inkjetart.com (*www.inkjetart.com*) offers a helpful glossary of archival terms, watercolor paper printing tips, loading thicker paper tips, besides selling Arches, Concorde Rag, Eclipse, Hahnemüle, Lyson, Lanaquarelle, Osprey Giclée, Red Tail, Somerset Velvet, and Waterford. This is not a complete list, since it does not mention Galerie (made by Ilford) and Epson archival papers.

Creative Digital Printmaking by Theresa Airey (Watson-Guptill, 2001) provides the fine artist with the necessary information about creating prints from a home printer. This up-to-date guide begins by discussing the equipment needed, covering everything from computer platforms and printers to storage media and scanners. Then papers and inks are treated in detail, and a chapter on hand-coloring digital prints provides tips and techniques.

Print-on-Demand (POD)

Sometimes, it is necessary for the artist to pay for professional development. This can take the form of a seminar, conference, travel to a museum opening, or limited-edition catalog or book. The phrase "you have to spend money to make money" is pertinent, providing the artist can afford it.

Unless you are going to take on the additional costs of copyediting the manuscript, formatting the images, and then merging them together in layout program such as PageMaker or QuarkXPress, in the end, you have to create the look of a monograph or catalog with an introduction, title page, table of contents, plus index (which has to be paginated). Then the book is sent to a POD printer who digitally stores the files on a database. The only time an order will be filled is when it is requested.

The Internet publishing companies described below do not usually own any equipment (due to the high cost of the machines); they outsource to POD printers (whose advanced digital technology allows the use of toner in lieu of printing plates); digital printers (the next lower class of printing, using toner and no printing plates); or traditional offset printing (which uses ink and plates and costs much more for limited press runs). The drawback of these companies is that the return policies depend completely on the wishes of the Internet publisher. Moreover, if there is no book inventory or warehousing, then unless special arrangements are in place, no physical bookstore will carry the book.

A POD book (without images) must be a minimum of 108 pages. While there is no stipulated minimum for digital printing, you should compile a volume that is at least sixty-four pages long. This figure is the minimum page count required for perfect binding—the cheapest method of creating a sturdy spine. A traditional bookstore will not carry a book without a sturdy spine, as it cannot be vertically shelved; featuring books horizontally is usually reserved for best sellers and local authors (a limited market).

While POD and other new technology creates new opportunities, the traditional book distribution channels are not able to absorb this new availability. A Barnes & Noble superstore carries 200,000 books. Every year, approximately three thousand new titles become available. While not all new books are physically placed in these stores, most of them are, and then older books are removed. The life span of a new book is only a few years—unless it becomes a classic or a reference book—because new books clamor for physical shelf space. Although POD books do not go out of print, don't expect the Internet suppliers to blindly sell significant numbers, without the publicity help of an influential article or review about the book. The Internet is too "virtual" to isolate and find any one title.

Please note that the Library of Congress does not assign a Library of Congress Number (LCCN) if your catalog or book is fewer than fifty pages, unless it is a children's book. However, an ISBN (International Standard Book Number) and UPC barcode are assigned. These are absolutely necessary for a listing in R. R. Bowker's *Books in Print*, which allows any book retailer to order the book, especially the two largest online bookstores *Amazon.com*, and *BarnesandNoble.com*. All of these listings for books help libraries, schools, booksellers, and others search for titles.

Xlibris

Xlibris offers a complete, full-color picture book publishing service, for books twenty-four to eighty pages, with a manuscript maximum of 20,000 words; the company has a strategic partnership with Random House Ventures, an investment subsidiary of Random House publishers.

For the fine artist considering a short-run catalog or book, Xlibris offers three services: Basic service for $999, Professional service for $1,499, and Custom service for $2,499. (The company outsources to digital offset printers.)

Here is an example of the Custom service, since it has the best comprehensive arrangement. Every month, the publisher offers different specials, either 25 percent off production costs ($625) or thirty-five additional books. The package includes one hundred images (or fifty, if image enhancement is necessary); overall assistance through production and post-production, including access to a staff of graphic designers; twenty free books; and a CD archive.

So, imagine you have chosen the Custom service, opting for the 25 percent discount on production, and you plan to publish an eighty-page book. Once your $1,875 is paid (providing you do not need optional services), the issue of royalties arises. Xlibris pays the author a royalty whenever a new copy of the book is sold to anyone other than the author. Because of the big discounts paid to distributors and retailers, the royalty is smaller when the book is sold through a bookstore than when the book is sold directly through Xlibris. For this reason, Xlibris pays a royalty of 10 percent of the book's retail price on copies sold through booksellers and a royalty of 25 percent on books sold directly through Xlibris. Note that on copies you purchase yourself, instead of paying you a royalty, Xlibris gives you a steep discount of 30–46 percent off the retail price (when you buy 100 copies or more).

Let's say you decide to purchase 100 copies of your book, and the discount in your case is 46 percent. The retail price is $26.99, so each book will cost you $14.57. If you sell these books at art openings, seminars, lectures, and book signings, you will enjoy a direct royalty of $12.42 per book. You have spent a total of $3,332 for 120 books (remember the twenty that came free upon publication). If you sell out of these books, you'll receive $3,238.20 (just short of breaking even).

What Xlibris or other book retailers sell is unknown. If sales are made through Xlibris directly, royalties will be $6.75 per copy. For sales made through a bookseller, you'll receive royalties of $2.70 per copy. So you really won't break even or make money unless you directly sell two hundred books yourself. Total cost for 200 books is $4,789; if you sell out, you'll receive $5,398. Shipping is approximately $1 per book, bringing your profit to $409.

If you include a limited-edition print, you can increase the final price of the book and, more importantly, increase the sales price of your artwork.

Obviously, not everything in the creation of a POD book can be comprehensively covered. For complete information, contact Xlibris at 436 Walnut Street,

11th floor, Philadelphia, PA 19106; 888-795-4274; e-mail, *info@xlibris.com*; *www.2xlibris.com.*

Bookpublisher.com

In chapter 2, I gave an example of a two-hundred-page color monograph that costs $42.50 apiece; this was a quote from Bookpublisher.com, which has both an offset printing division and a digital and POD division. The retail price of this book is $75; the artist who sells 115 books will break even at $8,625. Moreover, should all two hundred books sell for $15,000, then the artist will receive a $6,500 profit. Again, if limited-edition prints are included, the profit increases.

However, you must supply the copyedited text and images for this price (based on a quote of $8,500 for two hundred books). Bookpublisher.com does not publish a price list, since each project requires it own mix of services. The quotes are for the whole package and are not itemized. They generally do not offer any of their services piecemeal (by the hour or task). The layout charges are included in this price (approximately $500 is for layout, plus setup charges of approximately $1,200); 70–80-lb. coated stocks are used, and the prevailing cost of paper determines the cost of a printing job. Small, color book printings are on traditional offset press (if they are hardcover). If they are paperback, then they can be digitally or offset printed. The author receives five copies of the book and a 40 percent discount off retail prices, plus shipping and handling. However, the author may require special contract provisions and can therefore negotiate whatever exceptions are needed to meet individual author needs.

A typical royalty is 20 percent to the author on Publishers Print Receipts for each copy of the work sold. Bookpublisher.com is a hybrid between traditional book publishers and POD because it accepts book returns. The company has arranged distribution in physical bookstores through Ingram Book Group, which is the largest book wholesaler in the United States. Ingram supplies books to physical bookstores, museums, libraries, and other book buyers, so it is an important advantage to have your book listed in Ingram's database and in its highly regarded quarterly publication *Advance*. The online stores *Bookpublisher.com, Amazon.com.* and *BarnesandNoble.com* will also carry your title.

Again, not everything in the creation of a POD book, can be comprehensively covered, so contact Bookpublisher.com at 610 East Delano Street, Suite 104, Tucson, AZ 85702; 888-934-0888; e-mail, *editor@bookpublisher.com*; *www.bookpublisher.com.*

Professional Magazines

One of the best print magazines to help the artist decipher technology is *.net* magazine. Every month, *.net* magazine brings you the best of the online world. It is entertaining, informative, and provides news, reviews, features, and guides that

are relevant, practical, and readable. All of the features and reviews are written by experts who show you how to get the best from the Net and existing (and soon-to-be-developed) technology. Each issue of *.net* comes with a cover disc packed with the latest Internet software to improve your online time, to clean up your PC/Mac, and to make your own Web sites as exciting as possible. There is also a comprehensive and clear section for Web builders, beginners and experienced alike, with tips, tricks, and tutorials on how to create or improve your own sites.

Their Web site also allows you to download software on a trial basis. The $99 U.S. subscription rate includes all cover CDs and airmail delivery. Contact *.net* magazine at Future Publishing LTD., Cary Court, Somerton, Somerset, UK TA11 6BR; e-mail, *mailus@netmag.co.uk*; *www.netmag.co.uk*.

Another magazine, *Wired*, is the journal of record for the future. It speaks not just to high-tech professionals, but also to the forward-looking and the culturally astute. Subscriptions are $10 for twelve issues, plus subscribers receive the exclusive *Wired* screensaver. For a subscription, call 800-769-4733; or e-mail, *info @wiredmag.com*; *www.wired.com*.

About the Author

Julius Vitali is an author and digital artist who has experimented with oil painting, sculpture, photography, fashion, and music. The *New York Times* has said of his work, "With modern technology and bold innovation, Mr. Vitali stands apart as a kind of one-man frontier for the avant garde. It has been easy to regard him as someone who is pushing the limits of art in a very positive way."

While working with techniques that are often considered "experimental," Vitali has consistently received coverage in the mainstream media. He is the originator of "Puddle Art," which uses the reflective qualities of water as a liquid canvas and has been featured on the *David Letterman Show* and in numerous national and international magazines.

Vitali's *Visual Music*, using musical notes in graphic patterns, has received prominent attention on CNN and in music journals. Some of his surrealistic fashions have appeared in international magazines such as *Panorama, Stern,* and *Elle,* in domestic magazines such as the *Village Voice, New York Post,* and the *National Enquirer,* and in the prestigious traveling international exhibition *Fashion and Surrealism.* Other organizations that have supported his work include the NEA, NYFA, Pennsylvania Council on the Arts, Polaroid, Kodak, Artists' Space, Experimental TV Center, Meet the Composer, Adolph and Ester Gottlieb Foundation, and the Puffin Foundation.

Currently, Julius Vitali is one of the principal curators and artists of the seminal exhibition *Ground Zero,* which is a national traveling exhibition about the effects of 9/11. The media coverage of this show continually grows, receiving first notice in *Wired.*

Julius Vitali's intelligent use of the media has bolstered his career, helping him to secure numerous artist and educational residencies, receive corporate support, and exhibit in the United States and Europe, placing artwork in public institutions and private collections, such as the Library of Congress, Bibliothèque Nationale, and the Polaroid Collection. He can reached via e-mail at *juliusvitali @hotmail.com,* or, visit his Web site at *www.juliusvitali.com.*

Index

 Books from Allworth Press

The Quotable Artist
by Peggy Hadden (hardcover, 7½ × 7½, 224 pages, $19.95)

An Artist's Guide—Making It in New York
by Daniel Grant (paperback, 6 × 9, 256 pages, $19.95)

The Business of Being an Artist, Third Edition
by Daniel Grant (paperback, 6 × 9, 352 pages, $19.95)

How to Grow as an Artist
by Daniel Grant (paperback, 6 × 9, 240 pages, $19.95)

The Artist's Guide to New Markets: Opportunities to Show and Sell Art Beyond Galleries by Peggy Hadden (paperback, 5½ × 8½ , 252 pages, $18.95)

Licensing Art and Design, Revised Edition
by Caryn R. Leland (paperback, 6 × 9, 128 pages, $16.95)

Legal Guide for the Visual Artist, Fourth Edition
by Tad Crawford (paperback, 8½ × 11, 272 pages, $19.95)

The Artist Gallery Partnership, Revised Edition
by Tad Crawford and Susan Mellon (paperback, 6 × 9, 216 pages, $16.95)

Business and Legal Forms for Artists, Revised Edition by Tad Crawford
(paperback, 8½ × 11, 160 pages, includes CD-ROM, $19.95)

Caring for Your Art: A Guide for Artists, Collectors, Galleries, and Art Institutions, Third Edition by Jill Snyder (paperback, 6 × 9, 256 pages, $19.95)

Artists Communities by the Alliance of Artists' Communities
(paperback, 6¾ × 10, 256 pages, $18.95)

The Artist's Complete Health and Safety Guide, Third Edition
by Monona Rossol (paperback, 6 × 9, 416 pages, $24.95)

Please write to request our free catalog. To order by credit card, call 1-800-491-2808 or send a check or money order to Allworth Press, 10 East 23rd Street, Suite 510, New York, NY 10010. Include $5 for shipping and handling for the first book ordered and $1 for each additional book. Ten dollars plus $1 for each additional book if ordering from Canada. New York State residents must add sales tax.

To see our complete catalog on the World Wide Web, or to order online, you can find us at *www.allworth.com*.